FASHION ARTIST

DRAWING TECHNIQUES

TO

PORTFOLIO PRESENTATION

— **second edition** —

Sandra Burke

email: sandra@burkepublishing.com
website: www. fashionbooks.info
website: www.burkepublishing.com

Fashion Artist - *Drawing Techniques to Portfolio Presentation* (2nd Edition)

Burke, Sandra

ISBN: 9-780958-2391-7-2

Reprinted:	2011
Reprinted:	2010
Reprinted:	2009
Reprinted:	2008
Reprinted:	2007
Second Edition:	**2006**
Reprinted:	2005
Reprinted:	2004
First Published:	2003

Copyright ©: Burke Publishing
Email: sandra@burkepublishing.com
Website: www.fashionbooks.info
Website: www.burkepublishing.com

DTP:	Sandra Burke
Cover:	Simon Larkin
Cover Sketch:	Lynnette Cook
Printed:	Everbest, China

ISBN: 9-780958-2391-7-2

 Dedication........to my husband and skipper, Rory, who inspired me to write Fashion Artist, and project managed me through the complete process. And to my parents who supported and encouraged me to join the world of fashion and gave me the education I needed to get there.

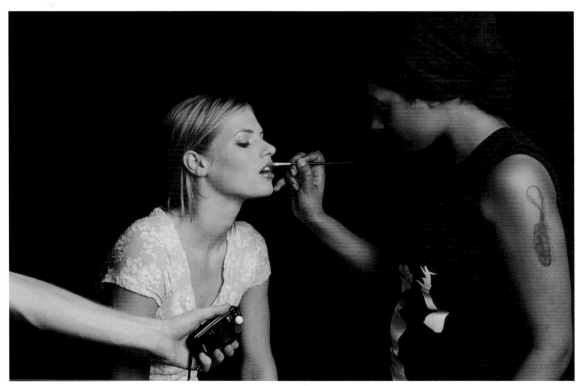

Make-up, lights, camera! Esther being made up for the fashion shoot by hair and make-up artist Miranda Raman

Fashion shoot team: Special thanks to Louise Davies (photography) and Esther Simmonds (model), Miranda Raman (hair and make-up artist) and Davies (assistant and lighting).

Esther clothed by World - courtesy of Francis Hooper and Denise L'Estrange

authors note

Many of us dream about becoming a famous fashion designer with all the glamour, lights and panache that it entails. Names like Dolce and Gabbana conjure up images of stunning models strutting down the catwalks at the London, Paris, Milan and New York fashion shows in the most amazing creations. Glossy fashion magazines and street fashion also inspire our desire to be creative. However, if you wish to bridge the gap between fantasy and reality, you will need to learn how to draw professionally - an integral part of a designer's portfolio of skills.

Fashion Artist - *Drawing Techniques to Portfolio Presentation* has been designed as a self-teaching book both for the novice and those who wish to enhance their drawing and design skills, and communicate their designs ideas on paper as part of the design process. Fashion Artist progressively guides you through a comprehensive set of fashion drawing and presentation techniques, an integral part of this is the development of several popular fashion poses which become your fashion templates. Starting with very basic shapes and figure drawings, you will quickly progress along the learning curve to produce visually exciting illustrations and a professional fashion design portfolio - the passport to your career. The text is supported with explanatory drawings and photographs to clearly demonstrate the drawing techniques, together with plenty of drawing exercises and examples from designers and illustrators around the world.

In writing this book I have combined my career in the fashion and manufacturing industry along with my lecturing and educational experience – each discipline supporting the other. The result is a combination of the educational requirements of fashion degree programmes with the practical application of drawing and design techniques used internationally in the fashion world.

The fashion industry is a challenging and competitive business, so it is essential to be well equipped with professional drawing skills. The aim of Fashion Artist is to inspire you to develop these drawing skills and communicate your creative and innovative ideas on paper. To be a successful designer you will need to work hard to develop your talent, believe in your own judgement, and have a certain amount of chutzpah! I wish you every success in the world of fashion.

Sandra Burke
M.Des RCA (Master of Design, Royal College of Art)

"You cannot teach a person anything; you can only help him find it within himself."
Galileo

foreword

Paul Rider, M.Des RCA is a consultant in fashion design. Internationally he has worked in Milan, London, Sydney, Moscow and Cape Town. He enjoys an international reputation as an educationalist and academic assessor with visiting lectureship (roles) including Central St Martins School of Art, and institutes of Fashion and Textiles throughout the U.K., Eire, South Africa, Australia and New Zealand.

This unique book has been produced to induce a wealth of experimentation, ideas, methods and proven formula within the illustrative context. Illustration has in previous years been marginalized, particularly in magazines and fashion journals, but a renaissance lately brought about by a genuine interest in the creative values of using mixed media by illustrators such as Colin Barnes and Antonio, and an interest in using fashion illustration by such notable designers as Manolo Blahnik, retailers such as Barneys, New York and Harvey Nichols, London, magazines like Wallpaper have imbued fashion illustration and drawing with a new 'cool' raison d'etre.

Sandra has drawn on all the techniques and formula available, utilised her deep knowledge gained within both the fashion industry and as an educator at numerous fashion departments across the world to compile this dynamic and vibrant book. By reading and absorbing its contents you will be inspired, and become aware of fashion illustration in its historical and contemporary context and utilize its structural formulas and processes to encourage better use of this form of 'art'.

Jan Hamon, MA (Fashion and Textile Design, De Montfort), is a Principal Lecturer at Auckland University of Technology. She has a background in the apparel industry, in costume design for television and theatre, and operated her own business in both fields for several years. She has been involved in curriculum development for fashion programmes and lecturing in costume design and costume history for twelve years.

If only I had this book somewhat earlier in my fashion career, my fashion illustrations would have progressed dramatically!

Fashion drawing is an important part of a fashion programme and this book shows how fashion drawing, design and illustration can be effectively integrated into the fashion design curriculum. It also ensures that this area is embraced by the students and cemented in as a linchpin of a fashion design programme.

It is no surprise to me that Sandra has chosen to write a book about Fashion drawing and illustration. Given her international experience in the fashion design industry and in fashion education – who better? I would like to commend this book to fashion students, fashion educators, and designers as an essential text for your bookshelves. Its structure, embracing a point-by-point learning system, lends itself perfectly to self-directed practice or to integration within a fashion programme. It has certainly taken away the fear, for me, of putting my concepts on paper!

acknowledgements

The research for the second edition of Fashion Artist - *Drawing Techniques to Portfolio Presentation* has taken me to some of the most influential fashion schools and companies around the world and provided the link between education and industry. Writing this book has been a team effort. Initially I wish to thank all those who discussed the development of fashion drawing skills and their commercial application. The sharing of ideas, encouragement and support from talented fashion designers, fashion illustrators, lecturers, students, colleagues and friends from around the world has been absolutely incredible. I would never have been able to write this book without them. My sincere thanks to you all. And in particular:

America: Jevon Ruis, Karen Scheetz (FIT and Parsons), Linda Logan (Fashion Designer), Parsons School of Design, Renaldo Barnette (Fashion Designer and FIT), Tim Gunn (Parsons), Ricki and Aviva Wolman (Citron) Steven Stipelman (FIT, Woman's Wear Daily),

Britain: Alexis Mason (Designer), Amber O'Keeffe (Costume), Ann-Marie Kirkbride (Illustrator), Anne Rees (Designer), Beales (Tim Rathbone and Judy Cimidins), Carl Baybut (and the Fashion Design Faculty, Southampton Solent University), David Shilling (Creative Director), Ellen Brookes (Designer Illustrator), Felicity Wade (BHS), Frances Shilling (Knitwear Designer), Jason Toron Nielsen (Designer Mulberry), Gislene Amegeshi-Brown (Designer), Jonathan Kyle Farmer (Illustrator), Kashmir Kaur (Designer), Lorraine Boyle (Costume), Lucy Jones (UEL, University of East London), Lynnette Cook (Illustrator) (and the Illustrators Group Mark Risdon, Jacqueline Bisset, Jason Brooks, Rosalyn Kennedy, Judith Cheek, Hamza Arcan, Stephen Worth, Neil Greer), Maggie Doyle (Illustrator), Maria Leeke (Marks & Spencer), Melika Madani (Illustrator), Naomi Austin (Illustrator), Paul Hammond (R.D.Franks), Paul Rider (M.Des RCA), Vera Chursina, Professor John Miles (Bath Spa University College), Salmone Wilson (Designer/ Illustrator), Sarah Beetson (Illustrator,) Sheila Morantz (London College of Fashion), Steven Leeke (Courtaulds, British Home Stores), Stuart McKenzie (Illustrator), Val Fisher (Bournemouth Arts Institute), Wendy Dagworthy (RCA),

And not forgetting the Royal College of Art and Harrow (University of Westminster) for giving me a fabulous education in fashion design.

Paris: Frances Howie (Designer/Lanvin)

Canada: James Fowler and Michele Ovellet (IAD, Toronto)

Australia: Amanda Lang (Gerber Technology), Bindi Learmont (Designer/Illustrator), Karen Webster and Janet Medd (RMIT, Melbourne), Tang (Illustrator/Cartoonist), Val Horridge and Eric Hogan (University of Technology Sydney), Bronwyn Taylor (Costume Designer)

New Zealand: Alissa Stytsenko-Berdnik (Designer/ Illustrator), Bev Furness (AUT), Jan Hamon (Costume), Jo Giddens, Linda Jones (Designer/ Illustrator), Lyle Reilly (AUT), Mandy Smith (Knitwear), Mark Koenen, Peter Lambe (Gordon Harris), Megan Simmonds (Designer), Miranda Raman (Make-Up Artist), Pumpkin Patch (Childrenswear), Sarah Burren (Costume Designer), Sharon Evans-Mikellis (Knitwear), World (Francis Hooper and Denise L'Estrange), Yvonne Badcock (Lectra Pty Ltd.)

South Africa: Angus Buchanan (Graphic Designer), Cecil Beekman (Cape Underwear), Christa Drews (Fashion Designer), Christian Vincent Botha (Cape Technikon), Foschini (Peter Flowers, Simon Bowley), Laurie Dreyer and Debbie Minné (Chelsea West), Melanie Casper (Munko), Philippa Kethro (Natal Technikon), Sally Moinet (Fashion Designer), Ian Moinet (Graphic Designer),

Hong Kong: Connie Chan, Hong Kong Institute of Vocational Education (IVE), Joyce Taylor (Fashion) Anna Tso Yee Kwan (Fashion)

Singapore: Gladys Theng (La Salle, SIA), Debbie Hoyle (Fashion Stylist)

Students of Fashion Design/Illustration: A big thank you to all the students and educational establishments whose work has been presented in Fashion Artist, these include: Aase Hopstock Storeheier, Alex Ravenhall, Cathy Hansby, Jason Ng, Jenny Huang, Joseph Kim, Kellie Hepple, Kristin Goodacre, Loranie Ford, Mira Jukic, Prayha Vasan, Sharon Jennings, Vera Tukuleva, Veronica Frankovich

FIT (US), Parsons (US), Royal College of
Art (UK), Central St Martins (UK), London
College of Fashion (UK), Ravensbourne
College (UK), Colchester Institute (UK), CIAD
(Cleaveland College, UK), Bournemouth
Arts Institute (UK), Bradford College (UK),
Edinburgh College of Art (UK), Heriot-
Watt University (UK), MMU (Manchester
Metropolitan University), Southampton
Solent University (UK), Northbrook College
(UK), Nottingham, New College (UK),
International Academy of Design, Toronto
(Canada), Hong Kong Institute of Vocational
Education (IVE), AUT (Auckland University
of Technology, NZ), to name but a few.

DTP: Writing this book was one challenge,
but setting it up on InDesign was another.
Particular thanks to Alan Taylor for
guiding me through the fashion drawings
on CorelDRAW, and manipulating the
photographs in Photoshop. Thanks also to
Brian Farley, Bert and the rest of the team for
their technical input.

Cover Design: Simon Larkin

Front Cover Sketch: Lynnette Cook

Back Cover Sketch: Courtesy of Colchester
Institute

Photography: Louise Davies (Designer/
Photographer)

Model: Esther Simmonds

Esther's clothing: Courtesy of Francis
Hooper and Denise L'Estrange, World

Proof reading: Thank you to my proof
reading team; Rory Burke, Jan Hamon,
Mandy Smith, Bronwyn Taylor, Linda Jones
and Sharon Evans-Mikellis.

Forewords: I particularly wish to thank Jan
Hamon (Costume Designer and Lecturer,
New Zealand), and Paul Rider (Fashion
Designer and Consultant, UK) for their
inspirational forewords.

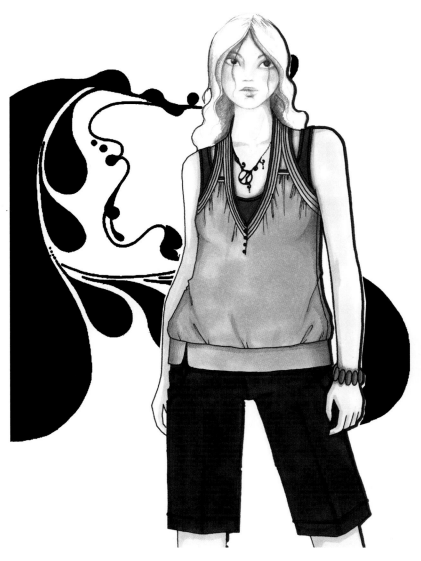

Illustration: Ellen Brookes, the Bureaux, London, fashion
designer and illustrator

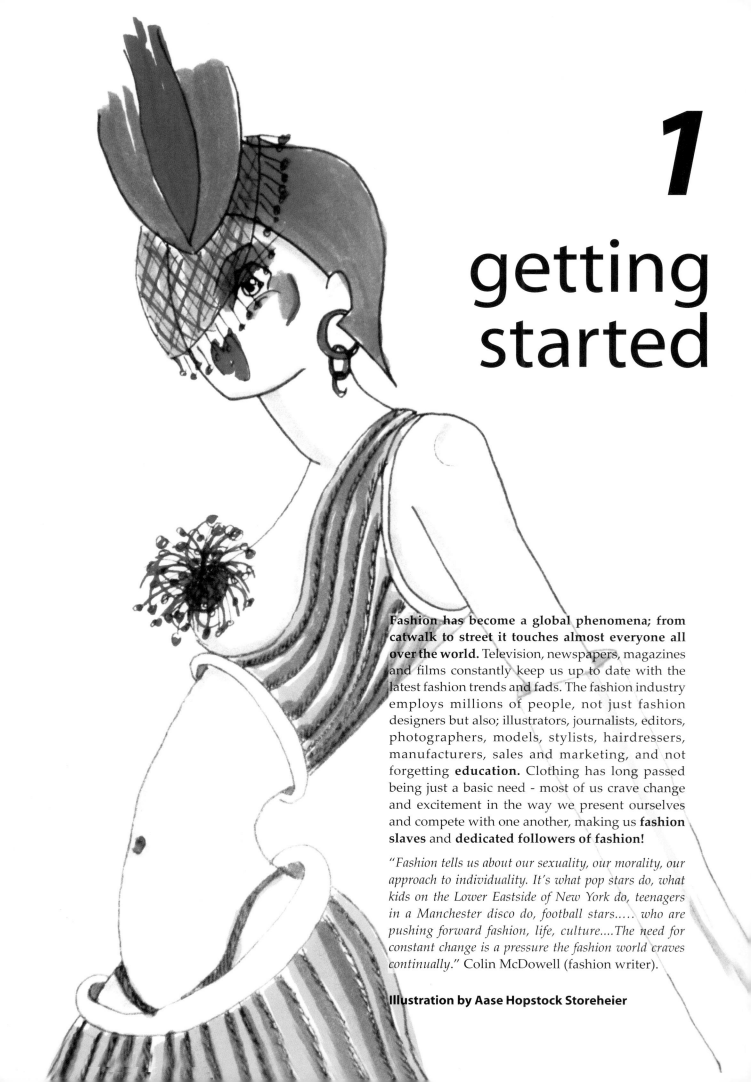

1

getting
started

Fashion has become a global phenomena; from catwalk to street it touches almost everyone all over the world. Television, newspapers, magazines and films constantly keep us up to date with the latest fashion trends and fads. The fashion industry employs millions of people, not just fashion designers but also; illustrators, journalists, editors, photographers, models, stylists, hairdressers, manufacturers, sales and marketing, and not forgetting **education.** Clothing has long passed being just a basic need - most of us crave change and excitement in the way we present ourselves and compete with one another, making us **fashion slaves** and **dedicated followers of fashion!**

"Fashion tells us about our sexuality, our morality, our approach to individuality. It's what pop stars do, what kids on the Lower Eastside of New York do, teenagers in a Manchester disco do, football stars..... who are pushing forward fashion, life, culture....The need for constant change is a pressure the fashion world craves continually." Colin McDowell (fashion writer).

Illustration by Aase Hopstock Storeheier

who should use this book

Fashion Artist - Drawing Techniques to Portfolio Presentation is for designers and illustrators alike, from fashion, costume to graphics; teachers, professors, lecturers and those who just want to simply draw fashion for a hobby. Whether you are a novice or already have a certain amount of talent, *Fashion Artist* will give you the basic drawing and design skills to enter the world of fashion (Fig. 1.1, Drawing Skills Continuum).

drawing skills

Fashion drawing is a practical skill that needs practise to master your hand-to-eye co-ordination. A skill may be defined as an ability or aptitude to perform something well. Just like learning to play the piano or learning to dance, fashion drawing skills need to be learnt and practised over and over again until they become second nature.

The drawing skills continuum (Fig. 1.1) outlines a range of potential abilities from the novice who has paper fright to the artist with natural drawing flair. As with the person who dances with two left feet or the singer who is tone deaf - the paper fright novice needs highly structured guidelines to follow, almost like painting by numbers. Meanwhile, at the other end of the continuum, the artist with natural flair also needs certain guidelines to present their art work to the accepted industry standards. It is these drawing skills and standards that will be developed in *Fashion Artist.*

Figure 1.1: Drawing skills continuum
From the novice to the fashion artist with flair

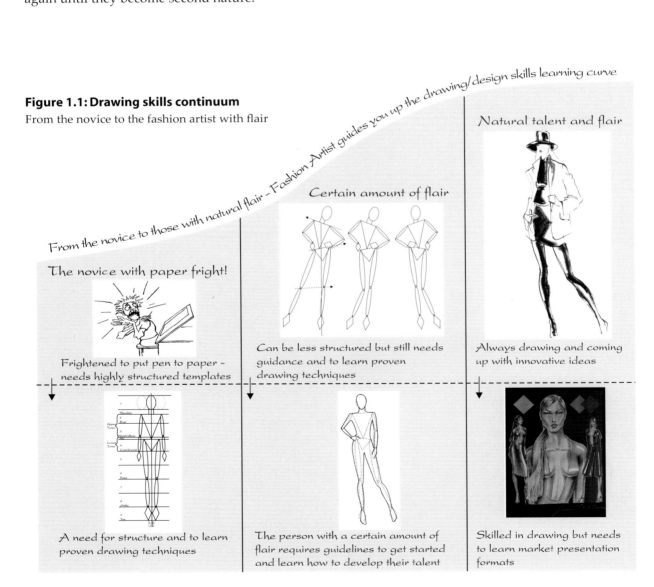

...up the drawing/design skills learning curve

From the novice to those with natural flair - Fashion Artist guides you...

Natural talent and flair

Certain amount of flair

The novice with paper fright!

Frightened to put pen to paper – needs highly structured templates

Can be less structured but still needs guidance and to learn proven drawing techniques

Always drawing and coming up with innovative ideas

A need for structure and to learn proven drawing techniques

The person with a certain amount of flair requires guidelines to get started and learn how to develop their talent

Skilled in drawing but needs to learn market presentation formats

designers and illustrators

Most fashion trends stem from the creative talents of designers and illustrators who use their skills to express the language of fashion to manufacturers and the media. They transfer what is seen in real life to a concise drawing on paper. But there are some distinct differences in the drawing skills that a designer and an illustrator require and these should be clarified.

Fashion Designers design and sketch garments to communicate their ideas to a design team - pattern makers, sample machinists, and buyers. They need to be able to draw well to make their designs understood, but they do not necessarily need to excel in the more stylised art of fashion drawing. The fashion designer discusses the designs with the pattern maker, patterns are drafted and sample garments produced. After various meetings and corrections to the designs, these garments are shown to the buyers for final approval before manufacturing (see my forthcoming book *Fashion Designer - Design Techniques, Catwalk to Street*, and website: *www.fashionbooks.info*).

A designer must always be aware of the latest clothing, colour and fabric trends and be able to interpret these into styles for a particular customer and target market, for example; *Winter sportswear for teens, Summer suits for career wear*, and most importantly design clothing that, once in store, the customer will buy. Consequently, although a designer needs to be able to draw well, the emphasis is on the commercial design of the garment and not so much the artistic illustration.

Fashion Illustrators, by contrast, give a signature style to a *fashion designer's* creation. Using their creative drawing skills, they build on and enhance these basic fashion sketches. Their art work may be used for: a fashion design presentation, an advertisement, a marketing presentation or as a journalistic visual representation, presenting not only the illustration of the garment design but the total concept. Fashion illustration is a commercial art form in its own right, a way to express and accentuate a fashion design to present to a client.

how to use the book

Fashion Artist will teach you how to draw and present fashion figures and designs, and give you an insight into how your drawing skills can be applied in the world of fashion. The chapters have been set out in a logical learning sequence to guide you through the fashion drawing techniques, along with self-explanatory worked examples.

Chapters 2 and 3: Discuss the art kit and sketch book which are the tools of the trade. The starter art kit is a fundamental artist's tool kit which can be progressively built-up as you learn the drawing techniques throughout the book. Each chapter begins with an art box of items required to complete the exercises in the chapter.

Chapters 4 to 15: Take you through the fashion drawing skills. To encourage you to put pen to paper you initially learn to sketch a basic nine head figure template using the oval and triangle technique, then progress to drawing several popular fashion poses using this technique (Figure Matrix page 13).

The **Figure Matrix** is a summary of key fashion poses, templates 1 to 7, and sets out the sequence of drawing techniques in each chapter. You work closely with this matrix throughout the book as you flesh out the figure, draw clothing, render fabric, learn the techniques of presentation, and finally develop a design portfolio. In addition, we look at drawing men, children, costume and drawing from life, and using the computer as a design tool.

Glossary of Terms: Internationally, companies and educational establishments use different words for the terms in art, fashion and clothing. These will be explained in the glossary and also within the chapters.

Each chapter includes a gallery of visuals from numerous designers and illustrators around the world, along with explanations. These visuals set out to inspire you, and help your creativity and understanding of the techniques. The methods of drawing, the instructions and measurements described are given as guidelines and a means of building confidence in drawing. There are few strict rules and experimentation is widely encouraged to enhance personnel and professional style.

Poses	Figure Pose	Oval/ Triangle	Fleshing Out	Clothed	Rendered
Front Facing Template 1 (Nine Heads)					
High Hip 1 Front Facing Template 2					
High Hip 2 Front Facing Template 3					
High Hip Slight Turn Template 4					
High Hip Turned Template 5					
Turned (side) Template 6					
Back Turned Template 7					

Figure 1.2: Figure Matrix

The Figure Matrix shows the progressive development of drawing skills
and will be referred to throughout *Fashion Artist*

© Fashion Artist - Sandra Burke 13

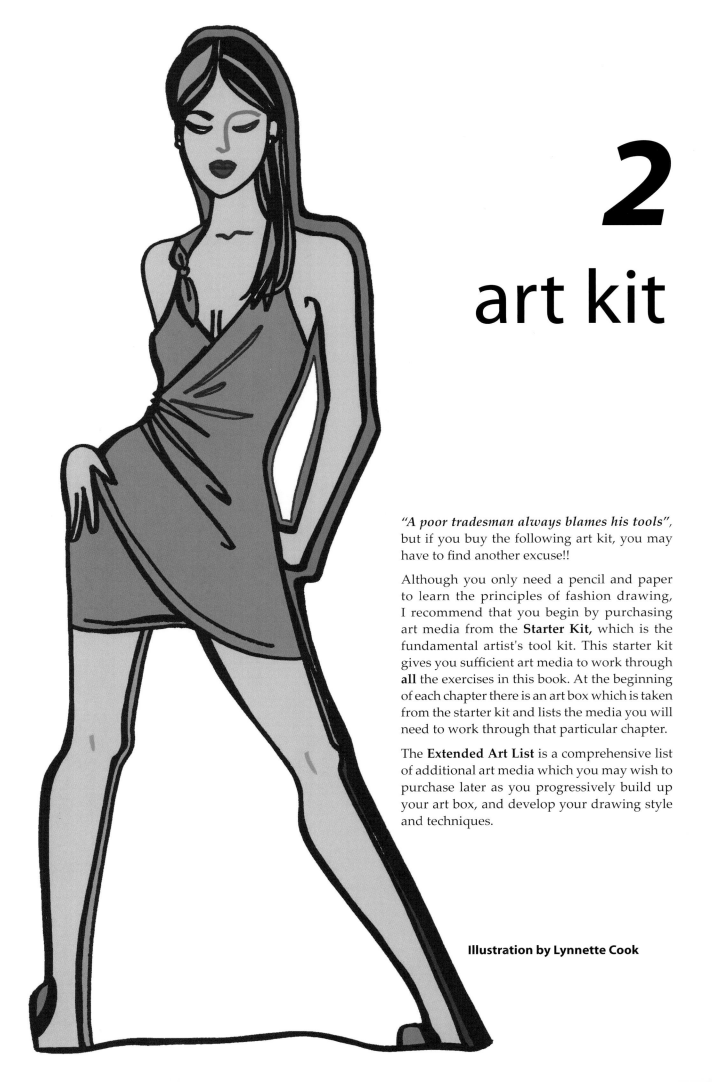

2
art kit

"A poor tradesman always blames his tools", but if you buy the following art kit, you may have to find another excuse!!

Although you only need a pencil and paper to learn the principles of fashion drawing, I recommend that you begin by purchasing art media from the **Starter Kit,** which is the fundamental artist's tool kit. This starter kit gives you sufficient art media to work through **all** the exercises in this book. At the beginning of each chapter there is an art box which is taken from the starter kit and lists the media you will need to work through that particular chapter.

The **Extended Art List** is a comprehensive list of additional art media which you may wish to purchase later as you progressively build up your art box, and develop your drawing style and techniques.

Illustration by Lynnette Cook

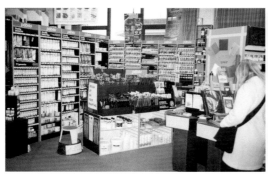

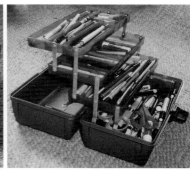

the art shop

The range of products available in art shops can be overwhelming. I suggest you start by buying only what you need from the starter kit and from the definitive list at the beginning of each chapter.

- Take a look at everything from colouring media to paper and portfolios to get a feel for what is available.
- Ask the experts, in store, for guidance.
- Ask for tester samples of media to try before you purchase.
- A brochure is often available for proprietary products, especially colouring media.
- Ask for student discounts.

student and artist quality

Media is often available in both **student** and **artist** quality.

- Student quality is less expensive so ideal for practising and developing drawing skills.
- 'Artist' or 'Professional' media use superior pigments and materials; colours last longer, are more true to colour, will not streak in mixing or when laid onto the paper. Use this for your final and best artwork and for presentations.

the starter kit

art box: Ideally, you should keep drawing and colouring media together in a plastic tool box that is compact and portable. The best boxes to keep media in order, are those with cantilever trays that raise with the lid, when opened (see photo).

drawing media

- **Graphite pencils**: H, HB, 2B and 6B – the degree of hardness is printed on each pencil; **H** gives a hard line (use for technical drawings), **HB** gives a medium strength line, **2B** gives a soft line, **6B** a very soft line (use for sketching, shading, drawing from life).
- **Black ink fine liners / pigment liner**: Size 01, 03, 05 and 07 - **01** for **fine lines,** through to **07** for **bold lines** .
- **Charcoals:** Stick and pencil type – these are required in the *Drawing from Life* chapter.
- **Rollerball ink pens (silver and white)**: Use for highlights and working over black and dark colours.

colouring media

Sets (boxes) and single items: Small sets of colouring media contain a basic selection of the most commonly used colours; larger sets may include colours you will rarely use. Decide what is best for you:

- Only certain media is available in sets.
- Additional colours can be purchased separately.

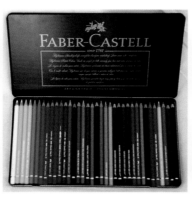

- **Markers:** Are commonly used for fashion drawings in the design studio as they are quick to use and give an acceptable representation of fabric and colour. Certain brands of markers have three or four felt points in one pen; broad, medium, thin and fine, the broad one being retractable for refilling. Purchase a flesh tone, a blonde and a brunette colour for hair, plus a pale grey for shading, and build up as required for your projects. Water based markers can give watercolour effects.
- **Colour pencils** (water soluble): Use with or without water, use more water for a watercolour effect.
- **Colour pastels** (water soluble): Stick and pencil type - sticks are excellent when *drawing from life*, and pencils are good for fashion artwork. Use fixative to prevent the chalky dust spreading (unnecessary when used with water).
- **Brushes** (for paint and water-soluble media): Round brushes No. 1 (fine), No. 7 (medium) and No. 15 (thick): Price and quality are dependent on the fibre and size of the brush tip – synthetic is less expensive than sable.
- **Brush holder:** A tube with a lid to keep brushes together and help prevent tips from being damaged - always clean and protect your brushes to extend their life.

paper

I encourage students initially to draw their fashion figures on **A3 (14x17 inch)** paper. This scale of work stimulates confidence and creativity. When *drawing from life* it is best to draw on even larger sheets of paper to gain more freedom of expression - use at least **A2 (18x24 inch)** paper.

- **Semi-transparent paper/bank/layout pad:** A3 (14x17 inch), 80 gsm – great for sketching and tracing, but not suitable for final artwork because it is too light in weight and will not take a lot of colouring media (wrinkles with when water is applied). Copier paper may be used, but it is not so transparent for tracing.
- **Cartridge paper/general all-purpose pad:** A3 (14x17 inch), for pencil and markers - if using a lot of water/paint the paper will wrinkle.
- Newsprint, brown paper, sugar paper: Use in the *Drawing from Life* chapter - any colour, plain, textured; use inexpensive paper as there will be a lot of waste.

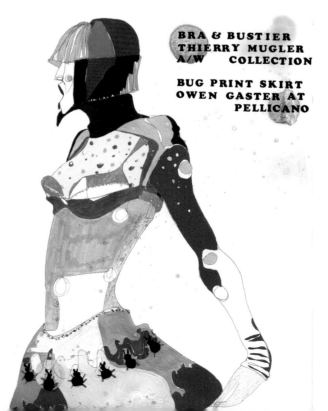

BRA & BUSTIER
THIERRY MUGLER
A/W COLLECTION

BUG PRINT SKIRT
OWEN GASTER AT
PELLICANO

Right: Illustration by Sarah Beetson
Media: Mixed media, edited in Photoshop

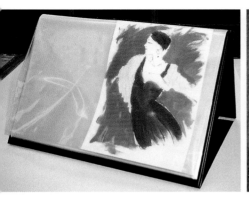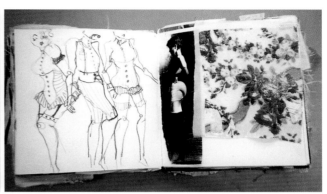

sketch books and resource files

- **Sketch book:** Pocket size for shop/store reports, street reporting and capturing ideas on the run.
- **Sketch book:** A5 (5x7 inch) and/or A4 (9x12 inch) as a general design ideas book.
- **Sketch book:** A3 (14x17 inch) for design development, drawing fashion figures or croquis (croquis is a french word for a small rough sketch of the figure).
- **Folders/Files:** A4 (9x12 inch) for collating visual resources - magazine clippings, fabrics, photographs etc. and to keep them in order for quick retrieval.
- See Chapter 3, *Sketch Book*.

portfolio

Portfolio: Size A3 (14x17 inch) or A2 (18x24 inch). A portfolio will protect your artwork and is ideal when making a design presentation. The various styles of portfolios are:

- A simple box type folder.
- Portfolios that are zipped along three sides with a ring binder to hold the work in place using acetate sleeves.
- Display portfolios that can be folded to make a stand alone display (see photo above).

If you are serious about your work, it is worth purchasing a quality portfolio as it should last you a lifetime. A portfolio:

- Protects your work, keeping it clean and preventing it from being damaged.
- Keeps your work in order.
- Is an excellent way to present work - a practical and professional solution, ideal in an interview situation or for showing work to clients.
- **Clear acetate sleeves:** These are available in various sizes to fit all portfolios - purchase separately.
- For more see Chapter 15 *Design Portfolio*.

Visuals left to right:

'Display' portfolio - sketch in acrylic by Linda Jones

Resource file by Linda Logan - magazine cuttings

Sketch book by Lorraine Boyle - design development sketches and fabric swatches

extras and optional

- **Eraser:** Plastic for graphite; putty erasers for charcoal and pastels to lighten and blend.
- **Fixative Spray:** Fixes charcoal and pastel drawings preventing the dust spreading and smudging the paper.
- **Full-length mirror:** Use to observe the balance of your body and poses; especially useful in the *Oval and Triangle Technique* chapter.
- **Knife/scalpel:** With break-off blades to release a sharp, new edge - cuts paper, card and mounting board, sharpens pencils.
- **Masking tape and drawing board clips:** Holds paper in place on the drawing board.
- **Metre (36 inch) metal ruler:** Use when cutting card or thick paper; a knife will not cut into the metal as it would plastic or wood. Use **300 mm (12 inch)** for smaller work.
- **Pinking scissors:** To *pink* (make zigzag cut) edges of fabric and prevent it from fraying.
- **Scissors:** Paper and fabric - use cheaper scissors for paper - do not use fabric scissors to cut paper as it will blunt expensive blades.
- **Sharpener:** Some artists prefer a knife to sharpen a pencil.
- **Stapler and staples:**
- **Adhesive/tape:** Use to adhere paper and fabrics to presentations.

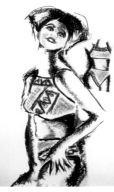
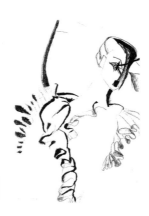

Left to right:

Author at portable lightbox

Pastel life drawing by Vera Tukuleva

Sketch by Aase Hopstock Storeheier - brush marker and graphite; note the use of line from fine to thick, clean and smudged

- **Spray adhesive:** Use a good quality, it leaves no lumps like a stick glue could, adheres immediately on contact, use carefully (if you make a mistake it is very difficult to pull apart without tearing the artwork and backing paper), spray over large pieces of scrap paper or the over spray will get everywhere, expensive so suggest using on presentation work only.
- **Adhesive sheets:** Good even adhesion and without the fumes that accompany sprays.
- **Paper glue, PVA glue:** Use for paper, card and fabric; the cheapest is not always the best as it may not bond well, may not spread smoothly and therefore could ruin a presentation.
- **Double sided tape:** For securing fabric etc.
- **Drawing board:** I recommend using an angled drawing board. The benefits are:
 - Essential for comfort - you are not hunched over your work and therefore you draw much better and freer.
 - Conducive to sitting back to assess work.
 - A flat, sturdy surface to work on.

Drawing boards range from:
 - Portable board (off cut from timber merchant and sanded smooth).
 - Portable plastic angled drawing board and mini lightbox combined (see photograph above).
 - Boards with an adjustable, angled surface.
 - Easels with or without a seat.

This completes the starter art kit.

extended art list

You may use this list to build up your art kit later and as your drawing skills develop. Note there are various new art and craft products continually coming onto the market.

drawing media

- **Propelling pencil and leads:** Use for technical work.
- **Ballpoint and rollerball:** Available in black, blue etc. and fine, medium and thick nibs.
- **Rapidograph pen/Rapidomatic/Rotring:** Use for detailed, technical work.
- **Indian ink and inks:** Use with a brush or pen for drawings and calligraphy.

colouring media

- **Brush felt marker:** Water based markers, e.g. Tombo, produce a wash effect when used with water.
- **Marker blender:** Use for blending the colour to prevent streaks, use immediately before the colour dries on the paper.
- **Gouache:** Available in tubes, can be used opaque or, with more water added, to look like watercolour, colours change as they dry, good for flat areas of colour but not easy to use for colour blending techniques.
- **Acrylics:** Use as a thin watercolour wash or use less diluted and thicker, dries in minutes, waterfast, can over paint, gives a more vibrant finish than gouache, use to add texture.
- **Watercolour paints:** Available in tubes, in a palette or as single pans (small cube of pigment - store carefully to avoid damaging).
- **Poster paint:** For a bold painting technique - water based.
- **Oil pastels:** Give thick and bold effects - dilute with solvent for washes.
- **Wax crayon:** Waxy, difficult to use with other media but good for certain effects.

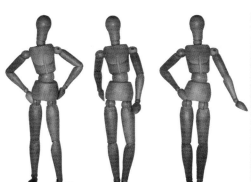 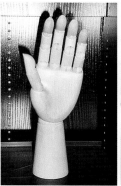 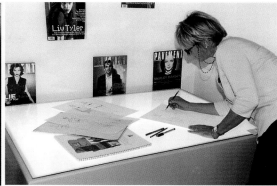

paper and board/cards

- **Marker paper, Zeta paper:** Superior in quality compared to bank/layout paper, slightly more expensive but excellent for marker pens as they will not bleed.
- **Tracing pad:** An alternative to bank and layout paper, can be purchased as loose sheets.
- **Watercolour paper:** Can be quite heavily textured, prices vary, use for watercolour paints and pencils – if you are totally covering the paper with paint then you will need to stretch the paper or purchase pre-stretched.
- **Presentation papers, card and board:** Coloured paper, textured papers, decorative papers, buy only when needed as there are so many colours and finishes to choose from ranging from matt to shiny, hand made paper looks, grainy surfaces etc., plus various weights.
- **Mounting board/cards:** Various colours and types for presentations, buy as needed.

extras

- **White out marker or correction fluid**: White liquid, use as highlight on compatible media.
- **Masking fluid or film:** Apply to areas to be masked preventing colour being applied over the particular area, erase when finished.
- **Palette/mixing dish:** Use for mixing paints and inks.
- **Q tips, baby buds:** Use to clean up and for blending media on paper.
- **Turpentine:** Use with a baby bud working into a painted area to create a variety of tones (use on heavy weight paper).
- **Candle (wax):** For a wax resist layer, rub a candle onto the art paper and colouring media will not adhere to it.

- **French curves, set square:** Useful when drawing flats/working drawings.
- **Lettering:** Computer generated or dry transfer lettering, for titles, themes and text for presentation work.
- **Mannequin:** Miniature wooden figure with movable joints, useful for displaying body positions, proportions and perspective (see photo above).

useful items

- **Light box:** Use for tracing a sketch onto the drawing paper (aides transparency), commercial and portable light boxes are available (see photo above). Or make your own using books to support a piece of acrylic, and a powerful light underneath.
- **Cutting mat:** Provides an excellent cutting surface and ensures the knife cuts cleanly through paper or board while protecting the surface underneath.
- **Digital Camera:** Photograph ideas for resource files, photograph your own work to keep as a backup, use images for presentations.
- **Computer:** Greatly enhances your design and presentation options. See my book, *Fashion Computing - Design Techniques and CAD*.
- **Colour printer:** Print - artwork, rendered illustrations and fabric designs; the size limitation is usually A4 (9x12 inch), use a service bureau for larger artwork.
- **Scanner:** For scanning images.
- **Photocopier:** Use a copy service - resize images, reproduce work, recolour fabric and drawings.

Now you are ready to grab your art box and work through the drawing exercises outlined in the following chapters.

3
sketch books

Fashion seeks **inspiration** everywhere; from the **catwalk to the street.** As a designer you need to be continuously on the lookout for innovative ideas and trends to inspire you to create original and marketable designs. When you see an interesting design concept you should automatically capture it in your sketch book - never rely purely on memory as some details are bound to be forgotten. **Sketch books** are ideal for quick rough sketches and for developing fashion ideas, while **resource folders** are ideal for collating magazine clippings, photographs and fabric swatches.

As you develop your sketch books and resource folders they will become your **data base** of valuable design information. At the concept phase of your design projects, they will provide excellent visuals to help jog your memory but, as explained in this chapter, they do need to be logically structured to aid quick retrieval.

Sketch by Cathy Hansby

art box

- Sketch books and folders - see Chapter 2, *Art Kit* for details
- Graphite pencil 2B
- Sharpener/knife
- Black fine liners
- Coloured pencils or markers (no mess, quick and easy to use when capturing ideas)
- Double-sided tape, PVA glue, stapler
- Scissors - paper/fabric
- Pinking scissors - useful for fabric swatches
- Camera - useful

▼design inspiration

Design inspiration is derived from both tangible and global influences, past, present and future, using a mixing pot of ideas to create innovative designs. Fashion design, for example, is not just about drawing fashionable clothing. It embodies a much wider context touching all areas of art and design.

- Seek inspiration from catwalk to street, from ethnic cultures to art, from music to movies, even from architecture and food.
- Keep up-to-date with the latest trends from the most elaborate *Haute Couture* creations to the more commercial street fashions.

Source your ideas from:
- Fashion magazines.
- Fashion shows and exhibitions.
- Fashion retail shops.
- Street fashion - what the public are wearing and the way they put it together.

Be aware of the total look; not just clothing trends but also:
- Accessories - from shoes to bags, hats, jewellery.
- Hair and make-up.
- Fabrics - textures, design and print.
- Colours - fashion colours, colour stories (the range of colours or colour palette for a particular design presentation or design collection).

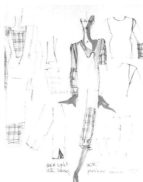
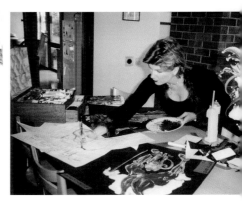

sketch book

Fashion design sketch book, also called, *fashion journal, fashion diary, work book and croquis sketch book,* are internationally recognised names for drawing books used for sketching ideas and designs. Sketch books are your visual reference data base and a valuable source of information for your design projects.

- Sketch everyday, and become a doer, not just a doodler.
- Always have a sketch pad and a camera handy, make notes, quick sketches and take plenty of photographs.
- Put pen to paper and cure paper fright. A sketch book is a great confidence builder - draw a few lines and you are away.

Use your sketch book to:
- Document your thinking and design ideas.
- Demonstrate colour/fabric sensitivity.
- Sketch clothing design ideas
- Develop designs, use colour to render the fabric.
- Keep a small sketch book handy for store reports - visit the stores and take note of what is happening, what styles are in the shops and what is selling or not selling, and the most popular colours, styles, fabrics etc.

resource folders

Design resource folders, also called, *cutting files, clipping files, swipe files, picture files and personality files,* are internationally recognised names for folders collating all visual references. These visuals, used in conjunction with sketch books, are sources of inspiration for design development through to presentation. Collect:

- Clippings from magazines.
- Photographs.
- Postcards - reproductions of paintings, textiles, architecture.
- Fabric swatches.
- Colour swatches.

Research and gather information from:
- The arts - theatre, opera, film, music, dance, ballet - clothing and costume, cultural, period costume, think: *Moulin Rouge, Grease, West Side Story, Carmen, Madam Butterfly, Gladiator, Lord of the Rings, Star Wars.*
- Art galleries - note the styles and techniques used, the media, the colours, concepts, figures, from baroque, impressionism, surrealism, to sculpture - think: *Salvador Dalí, Gustav Klimt, Michaelangelo, Picasso, Egon Schiele, Andy Warhol.*
- History of fashion - note costume design, fabric, trims, hairstyles, shoe styles - think: *corsets, Chanel suits, 60s, 70s, 80s, 90s.*

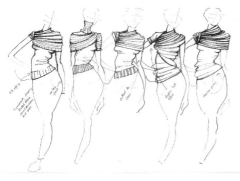

- Museums - note historical and ethnic costume, textiles and cultural influences - think: *Chinese paper prints, African tribal dress, Kilim rugs.*
- When travelling overseas, take note of national dress as well as street fashion - think: *Indian saris, Japanese kimonos, Pacific prints, Arabian Kaftans, the colour of Indian spices.*
- Photography - visuals and techniques, trends and concepts - think: *Mario Testino, David Bailey, Cecil Beaton, Patrick Demarchelier, Helmut Newton, Man Ray.*
- Television - past, present and future, cultural, historical - think: *Star Trek, Dr Who, MTV.*
- Sport - styles of clothing, fabrics and colours, trends in sport influence lifestyle and influence design - think: *snow boarding, aerobics, swimming.*
- Architectural and interior design - influence lifestyle, colours, shapes and patterns for print ideas, fabric and presentation - think: *minimalist, Gothic, Japanese styling.*
- The world of gastronomic delights - trends in food can influence lifestyle and so influence design and inspiration of clothing - think: *French, Italian cuisine, organic.*

In fact everything around us touches us and inspires our thoughts and attitude to design.

filing your visuals

For an organised, quick retrieval method, consider subdividing your resource folders into the following:

- Looks/concepts/moods/themes.
- The figure - female, male, children - as references for figure drawing and poses.
- Clothing - dresses, skirts, shirts, tops, trousers, jackets, day/casual wear, sportswear, evening wear.
- Fabric and trims - fabric designs, textures, prints, lace edging, buttons, braids.
- Colour - good colour stories, interesting mixes and concepts.
- Historical clothing - era or period.
- Costume design - characters, concepts.
- Ethnic Dress - sort by country.
- General design - fonts, theme headings, graphics, presentation layout ideas.
- Style Icons that have influenced trends, for example, actresses and musicians - *Madonna, Marilyn Monroe, Grace Kelly, Jackie Kennedy Onassis, Clarke Gable, Queen, Gwen Stephani.*

With your sketch books and resource folders in hand, you are now ready to go in search of ideas and inspiration.

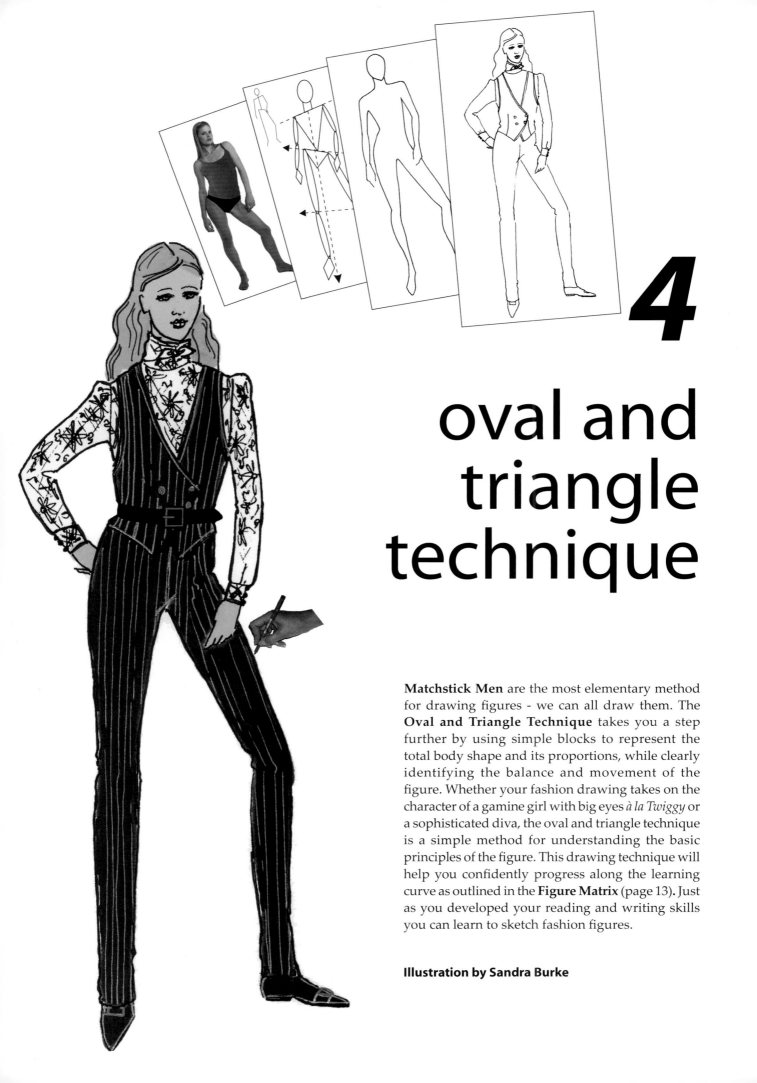

oval and triangle technique

Matchstick Men are the most elementary method for drawing figures - we can all draw them. The **Oval and Triangle Technique** takes you a step further by using simple blocks to represent the total body shape and its proportions, while clearly identifying the balance and movement of the figure. Whether your fashion drawing takes on the character of a gamine girl with big eyes *à la Twiggy* or a sophisticated diva, the oval and triangle technique is a simple method for understanding the basic principles of the figure. This drawing technique will help you confidently progress along the learning curve as outlined in the **Figure Matrix** (page 13). Just as you developed your reading and writing skills you can learn to sketch fashion figures.

Illustration by Sandra Burke

1 ▼

fashion figure proportions

The typical female fashion figure is illustrated as young and slender with elongated legs and square shoulders. Fashion figures are measured in **head lengths** and **head widths** which is the simplest measurement for checking body proportions.

• The **female** figure measures **seven** to **eight** head lengths in height (Fig. 4.1). In contrast, the female **fashion** figure can measures **nine** to **ten** head lengths or more (Fig. 4.2).

art box

- 2B Graphite pencil
- Sharpener/knife
- Black fine liners
- A3 (14x17 inch) semi-transparent paper
- Full length mirror
- Fashion magazines
- Portfolio or folder to keep work protected

• Fashion figures retain the basic proportions of the human form from the head through to the crotch. **Extra length** is added to the **legs** to give a more dramatic, stylised look and to give clothing designs more dynamic appeal (Fig. 4.2).

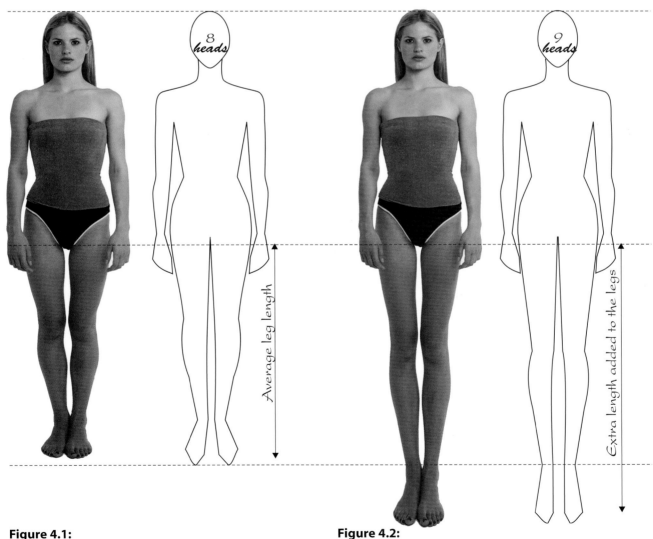

Figure 4.1:
*The **Female Figure** measures **seven** to **eight** heads*

Figure 4.2:
*The **Fashion Figure** measures **nine heads** or more (model's legs have been stretched using Photoshop)*

2 ▼▶

the NINE heads template

The *nine heads template* is a front facing, symmetrical fashion figure, measured in head lengths and widths, and drawn as ovals and triangles. The *Nine Heads template* is a simple starting point for drawing all fashion poses. It will be used here as a guideline for body proportions.

drawing exercise:

Roughly divide the drawing paper into nine head lengths as follows (Fig. 4.3 and 4.4):

a. Draw ten, evenly spaced horizontal lines. Each division represents one **head length.**

b. Number the sections 1 to 9.

c. Draw the intermediate lines for the shoulder and the hip (dashed).

d. Name the lines.

e. Draw a vertical line - this forms the **Vertical Balance Line (V/B)** and the **Centre Front Line (C/F)** of the body.

Note: CorelDRAW (drawing software) has been used to present clarity of line, but it is expected the exercises be drawn quickly by hand and do not have to be as precise.

Draw the *Oval and Triangle Fashion Figure* (Fig. 4.4) as follows:

a. Draw the head as an oval to fit section one.

b. Draw the neck from the oval to the shoulder line.

c. Draw the upper torso as a large inverted triangle: Shoulder to hip - the shoulder is approximately two head widths across.

d. Draw the lower torso as a smaller inverted triangle: Hip to crotch - the hip is approximately one and three quarters head widths.

e. Draw each arm as two elongated ovals:
Upper oval - shoulder to elbow.
Lower oval - elbow to wrist.

f. Draw the hands as diamond shapes - three quarters of a head in length.

g. Draw each leg as two elongated ovals:
Upper oval - hip to knee.
Lower oval - knee to ankle.

h. Draw the feet as diamond shapes - one head length.

i. Name your drawing **Template 1.** This is your basic **nine heads** template that you will flesh out in the next chapter and develop further as you work through the chapters.

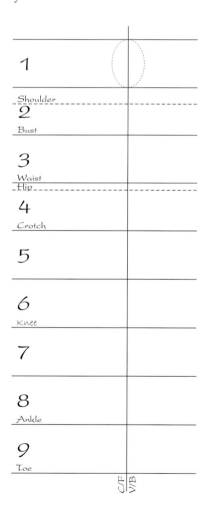

Figure 4.3:
*The drawing paper is divided into **nine heads***

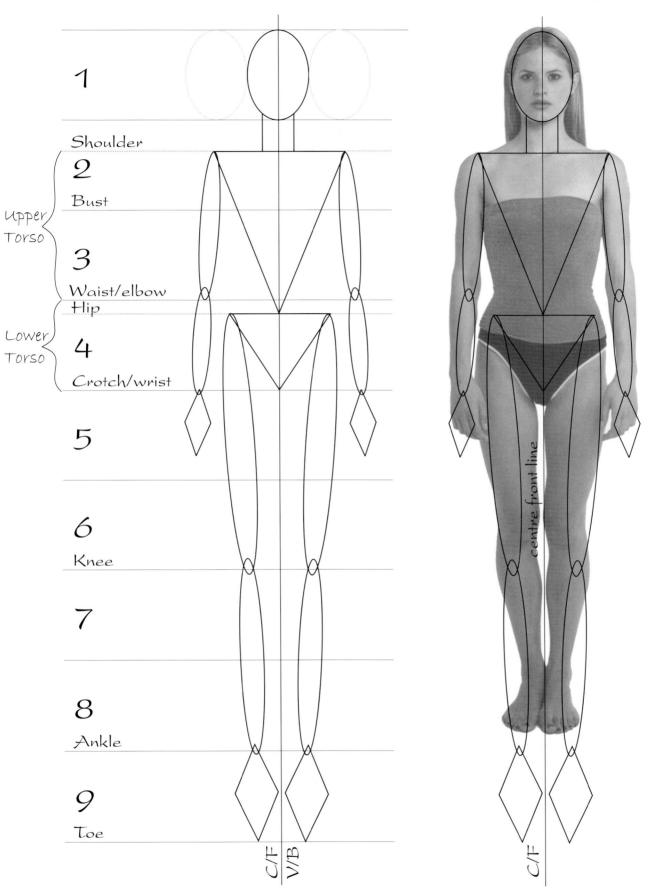

1

Shoulder

2

Bust

Upper Torso

3

Waist/elbow

Hip

Lower Torso

4

Crotch/wrist

5

6

Knee

7

8

Ankle

9

Toe

C/F
V/B

C/F

centre front line

Figure 4.4: Template 1 (figure matrix)

*The **Nine Heads** template is drawn using the measurement of head lengths and widths, and as ovals and triangles*

Figure 4.5:

Demonstrates how the human form is subdivided using the oval and triangle technique and how the legs are elongated for a fashion drawing

3 ▼ ▶

balance and movement

vertical balance line (V/B)

To add **life** to the basic fashion pose it is imperative to understand how the body balances. The **vertical balance line** (V/B) is an extremely useful guideline to ensure a figure drawing is well balanced and never appears to be falling over. The V/B line drops vertically from the pit of the neck to the ground. It never bends - it hangs like a builder's plumb line.

To understand this clearly, check your own **vertical balance line** by using a full length mirror:

- Stand with your weight evenly balanced between both feet - your shoulders, waist and hips will naturally be level. Visualise the vertical balance line dropping from the **pit of your neck directly to the ground.** In this evenly balanced pose the line falls through the centre of your body to the ground, equidistant from each foot. (Fig. 4.6)

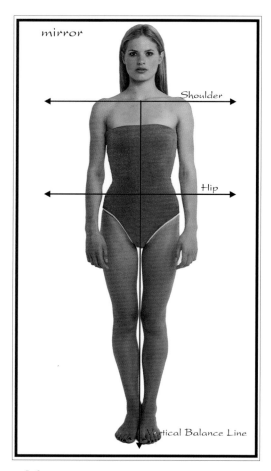

Figure 4.6:
Basic Standing Pose - weight evenly balanced between both feet, the shoulders, hips and waist are level

v/b line and high hip

Transfer your body weight onto one leg as per Figure 4.7. The V/B line now lies from the pit of the neck dropping vertically to the leg bearing the weight. Your shoulders and waist take on opposing angles - there is now *movement* and *life* in your pose.

The leg taking all the weight is called the **weight bearing leg (1).** Your other leg, which is carrying little or no weight, is called the **balance leg (2).**

Note:
- The **vertical balance line (3)** drops directly through the weight bearing leg.
- The hip and shoulder **(4 & 5)** are now asymmetrically angled over the weight bearing leg - the hip **(4)** is higher and called the **High Hip.**

Change your weight to the opposite leg and see how the angles reverse to become a mirror image (Fig. 4.8). The vertical balance line now drops directly through the opposite leg.

- Move your balance leg and observe how you can place it in many positions and still stand comfortably on the weight bearing leg.
- Notice how you can move your arms to different positions and that the vertical balance line from the pit of the neck remains over the weight bearing leg.

body movement ▶

Analyse this selection of poses (Fig. 4.9) demonstrating how the V/B line responds to movement.

Note:
- In all relaxed poses the V/B line drops from the pit of the neck to the point where the most body weight lies.
- The shoulders naturally slant on an **opposite plane** to the waist and hips.
- High hip and shoulder slant poses give your fashion poses a more dynamic appearance.

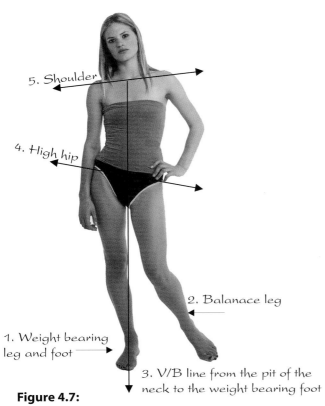

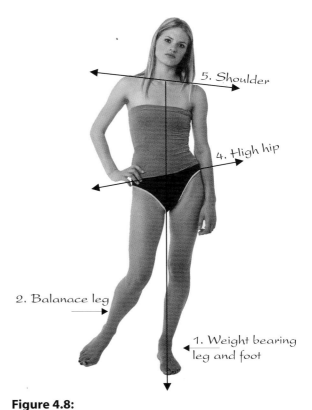

5. Shoulder

4. High hip

2. Balanace leg

1. Weight bearing leg and foot

3. V/B line from the pit of the neck to the weight bearing foot

Figure 4.7:
The V/B line passes through the weight bearing leg

5. Shoulder

4. High hip

2. Balanace leg

1. Weight bearing leg and foot

Figure 4.8:
The V/B line now passes through the opposite leg which has become the weight bearing leg

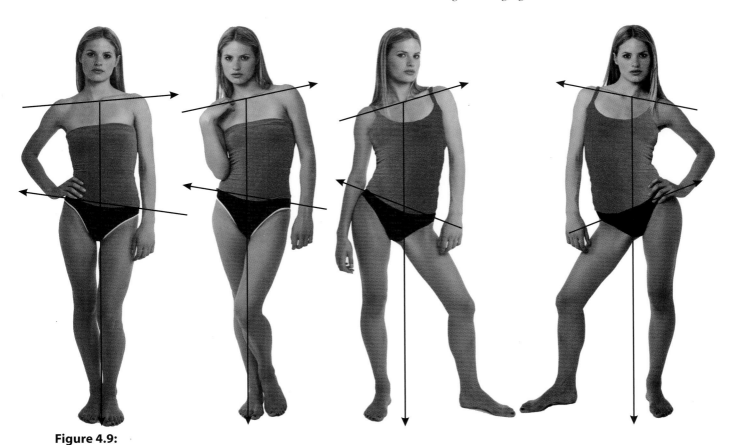

Figure 4.9:
These poses demonstrate the movement of body weight from one leg to the other, and show how the vertical balance line from the pit of the neck always drops to the point bearing most weight

4 ▼ ▶

body perspective

Understanding body perspective will also help you draw the correct proportion of the figure in various poses. In this section we look at the **Arc Figure,** the movement of arms and legs and the **Centre Front Line** (Fig. 4.10 to 4.12).

the arc figure

As the arms and legs of the front facing figure move sideways on an arc, their length remains constant. The arc figure demonstrates this movement (Fig. 4.10). In contrast when the arms and legs of the model/figure are bent and move towards or away from us they appear foreshortened (Fig. 4.11).

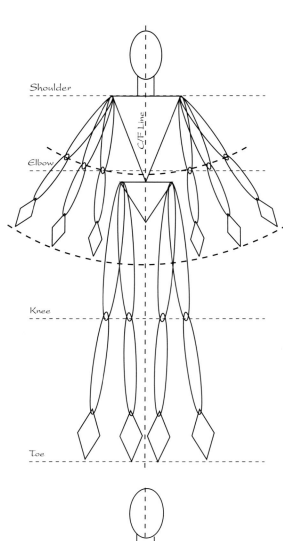

Figure 4.10: ▶

Arc Figure - the arms and legs remain the same length as they follow an arc

Figure 4.11: ▶

As the model walks towards us with arms swinging, the legs and arms are foreshortened. Note the angled lines indicating the shoulders, hips and knees

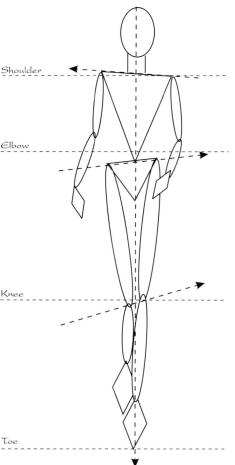

centre front line

The **centre front line** (C/F) is another extremely useful guideline which will help you draw the body and clothing in perspective as the model moves into her fashion poses. In this front facing basic pose (template 1), the centre front line divides the model symmetrically into two equal parts (Fig. 4.6). As the model turns so the C/F line rotates with it following the models supple body shape and giving an asymmetric perspective (Fig. 4.12).

Figure 4.6 (repeat): ▶

In this basic front facing pose, the centre front line divides the model vertically into two equal parts

Figure 4.12: ▼

As the model turns, the C/F line rotates following the models supple body shape giving an asymmetric perspective of the figure

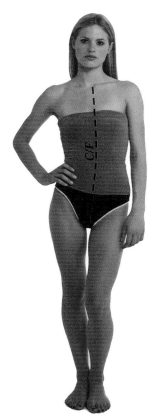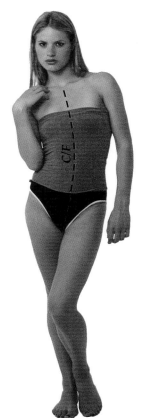

5 ▼▶

popular fashion poses

As the styling details of most garments are on the front, the preferred poses to display the clothing are **forward facing** or **slightly turned,** (Fig. 4.13 to 4.19). Therefore, side (profile) and back views are not drawn as frequently unless required. Back views are more commonly drawn when designing wedding or evening garments as the back is often highly styled (Fig. 4.20 to 4.22).

The key to fashion drawing is to start by perfecting a **number of standard poses** as outlined in the Figure Matrix (page 13). From this platform, a wider selection of poses can then be developed by simply varying the arm, leg and head positions. Reverse the drawings and you have more variations.

The following poses are a variety of some of those most frequently used in fashion (Fig. 4.13 to 4.22). Quickly sketch them and their variations using the oval and triangle technique - note they do not have to be perfect, simply capture the poses and movement.

Several of these sketches have been selected to be used as templates and developed throughout the book (Templates 1 to 7, Figure Matrix). Name the drawings as per examples and keep them protected in a folder or portfolio. They will be developed in Chapter 5, *Fleshing Out.*

Note:

1. As the body turns, the perspective changes, therefore you will need to slightly distort the triangle and oval shapes as can be seen in Fig. 4.20.
2. Check the figure is well balanced by using the vertical balance from the pit of the neck.
3. Check the shoulder and hip angles.

When you have finished drawing these poses, practise sketching poses from magazines. The model should be wearing fitted garments so that you can see the body shape.

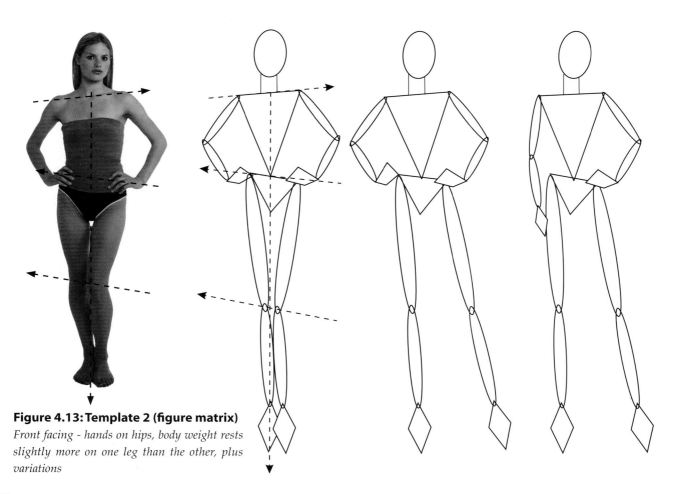

Figure 4.13: Template 2 (figure matrix)
Front facing - hands on hips, body weight rests slightly more on one leg than the other, plus variations

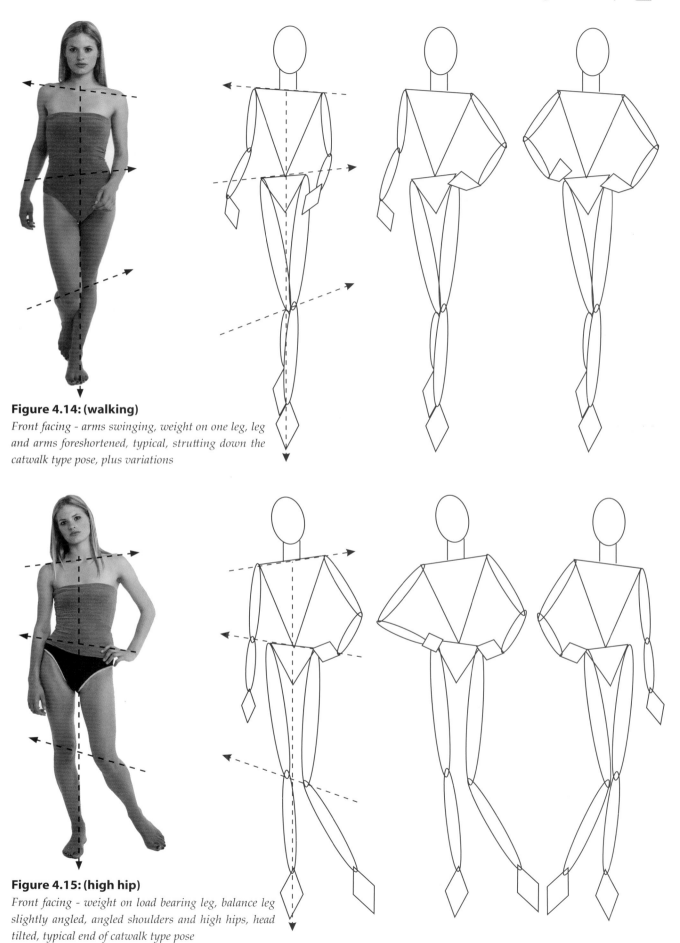

Figure 4.14: (walking)

Front facing - arms swinging, weight on one leg, leg and arms foreshortened, typical, strutting down the catwalk type pose, plus variations

Figure 4.15: (high hip)

Front facing - weight on load bearing leg, balance leg slightly angled, angled shoulders and high hips, head tilted, typical end of catwalk type pose

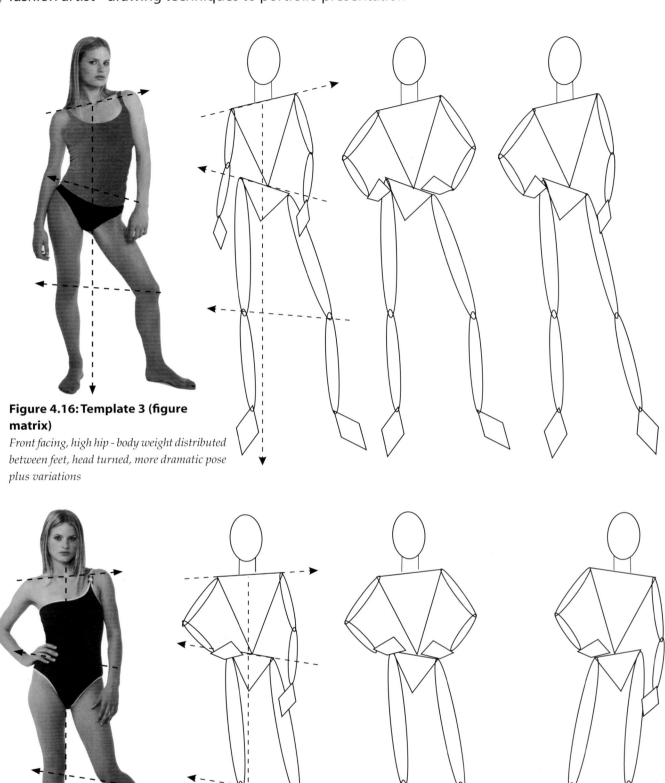

Figure 4.16: Template 3 (figure matrix)

Front facing, high hip - body weight distributed between feet, head turned, more dramatic pose plus variations

Figure 4.17: Template 4 (figure matrix)

Front facing, high hip - body weight on load bearing leg, balance leg knee bent inwards, cute pose, plus variations

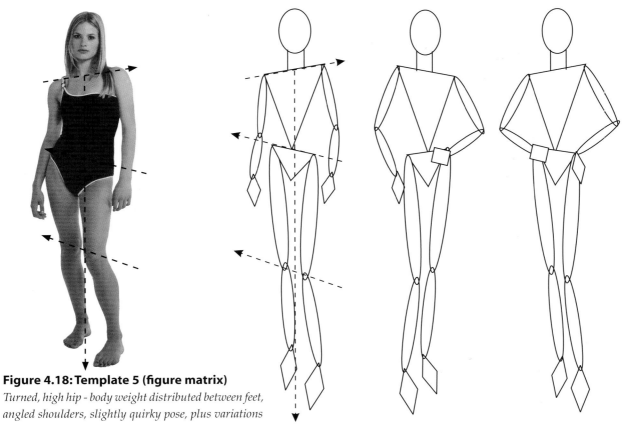

Figure 4.18: Template 5 (figure matrix)
Turned, high hip - body weight distributed between feet, angled shoulders, slightly quirky pose, plus variations

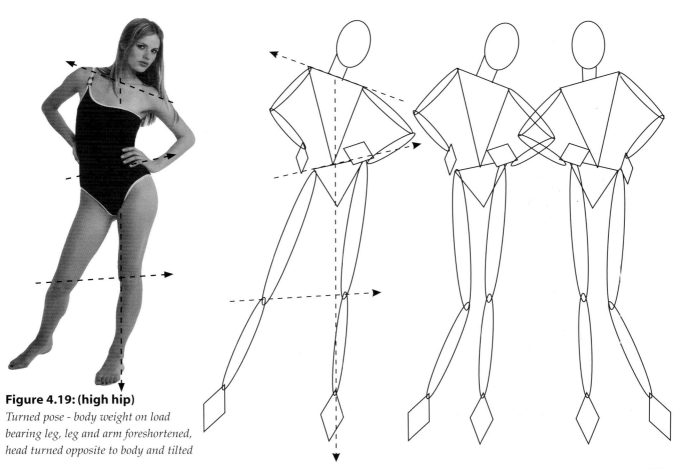

Figure 4.19: (high hip)
Turned pose - body weight on load bearing leg, leg and arm foreshortened, head turned opposite to body and tilted

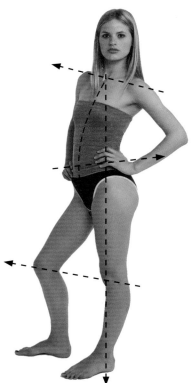

Figure 4.20: Template 6 (figure matrix)

Side pose - hip thrust forward accentuating the model's supple body, the arm furthest away is foreshortened, body weight on load bearing foot (foreground), interesting side pose and variation

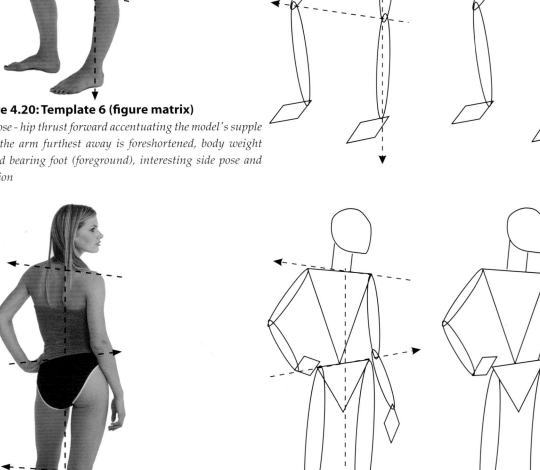

Figure 4.21: Template 7 (figure matrix)

Back pose - head in profile, an interesting asymmetrical back view and variation

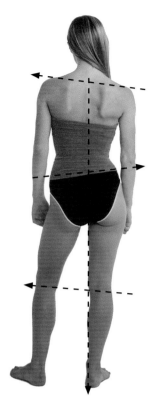
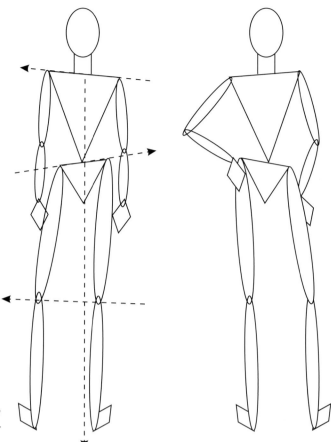

Figure 4.22: (back view)

Back view - body weight more on one leg than the other, high hip and angled shoulders make this an interesting back pose rather than a symmetrical back view and variation

concluding comments

- The female fashion figure drawing measures *nine heads* or more.
- The key to a successful drawing is balance - check the *Vertical Balance Line* and the *Centre Front Line*
- High hip poses, with angled shoulders give movement and life to fashion figures.

The oval and triangle templates, 1 to 7, form the basis of the Figure Matrix. The next chapter, *Fleshing Out*, will explain how to add body shape to these very basic figure drawings. These fleshed out 'bodies' will give you a range of fashion poses on which to design clothing and use in design presentations.

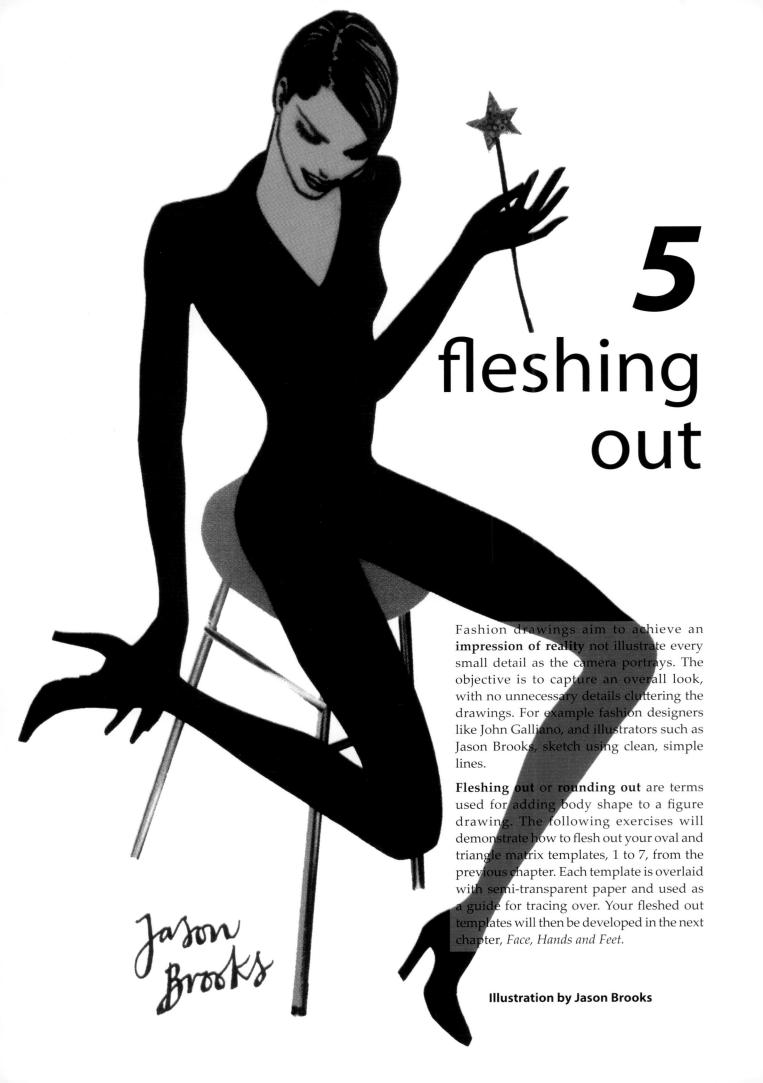

5
fleshing out

Fashion drawings aim to achieve an **impression of reality** not illustrate every small detail as the camera portrays. The objective is to capture an overall look, with no unnecessary details cluttering the drawings. For example fashion designers like John Galliano, and illustrators such as Jason Brooks, sketch using clean, simple lines.

Fleshing out or **rounding out** are terms used for adding body shape to a figure drawing. The following exercises will demonstrate how to flesh out your oval and triangle matrix templates, 1 to 7, from the previous chapter. Each template is overlaid with semi-transparent paper and used as a guide for tracing over. Your fleshed out templates will then be developed in the next chapter, *Face, Hands and Feet*.

Illustration by Jason Brooks

art box

- Your oval and triangle templates 1-7 from the previous chapter
- Black fine liners
- A3 (14x17) semi-transparent paper
- Portfolio/Folder

1 ▶

eleven body parts

The fashion figure drawing can be broken down into eleven basic body parts (Fig. 5.1).

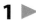

Draw these body parts to familiarise yourself with the components of the figure as it will help you flesh out your oval and triangle templates.

1. Head: Egg-shape

2. Neck: Cylinder shape

3. Shoulders: Smooth wedge or coat hanger shape

4. Upper torso: Like a tapered box from the underarm positions to a small waist

5. Lower torso: Shorter tapered box narrower at the waist to slightly wider at the low hips to the top of the thighs.

6. Thigh to knee: A tapered cylinder

7. Lower leg: A shaped cylinder tapered both ends

8. Foot: Elongated diamond shape, with slightly more definition for the toes and ankles

9. Upper arm: Narrow tapered cylinder

10. Lower arm: A shaped cylinder tapered both ends

11. Hand: Diamond reshaped to indicate the fingers.

Figure 5.1: Eleven Basic Body Parts
The fashion figure drawing can be broken down into eleven basic body parts

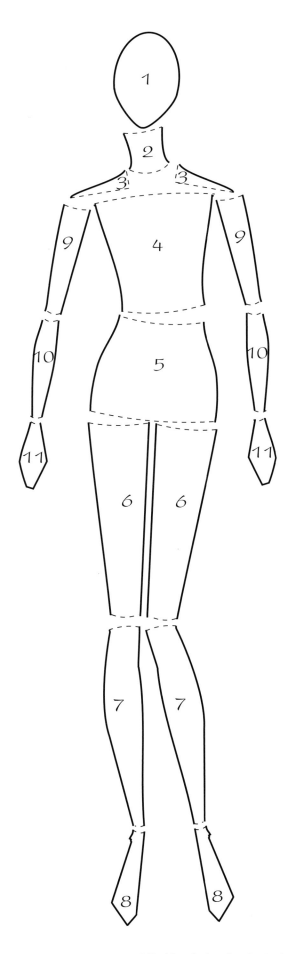

2 ▶

fleshing out template 1

This exercise demonstrates how to flesh out your basic oval and triangle figure, **template 1 (figure matrix)**, that was drawn in Chapter 4. As you flesh out your template, bear in mind the eleven body parts that you drew in the previous section.

Fig. 5.2.

1. Overlay your template with semi-transparent paper.

2. Using a fine liner, smoothly trace over your oval and triangle template 1, (page 27), as you flesh out the body shape.

3. Work from top to bottom, and side to side as you draw, e.g. one shoulder then the other.

 a. **Head**: Redraw the oval as an egg shape with the pointed end forming the chin.
 b. **Neck**: Draw a cylinder shape.
 c. **Shoulder**: Continue a smooth line from the neck making a wedge/coat hanger shape, curve gently over the shoulder edge.
 d. **Upper torso and lower torso**: From the underarm position (just above bust line), taper to the waist and out to the hip and top of the thigh (lower torso).
 e. **Thigh to knee**: From the thigh taper to the knee; draw the inside leg from the crutch tapering to the knee.
 f. **Lower leg**: From the knee, the outer edge of the leg curves out to the wider calf muscle and tapers to a narrow ankle; from the knee, the inside leg indents then curves out for the calf muscle before tapering to a narrow ankle.
 g. **Feet**: Refine the diamond as example.
 h. **Upper arm**: Draw the narrow tapered cylinder from the shoulder to the elbow joint, and from the underarm to the elbow.
 i. **Lower arm**: Draw the shaped cylinder from elbow joint to wrist, gently identifying the arm muscles.
 j. **Hand**: Continue from the wrist and refine the diamond as per example.

Note: You may need to retrace your figure several times, continually improving your last sketch, until you have a fleshed out figure template you are satisfied with.

Figure 5.2a, b and c: Template 1 (figure matrix - left to right)

Fleshed out, basic fashion figure showing the original oval and triangle template; side and back views

1

Shoulder

2

Bust

Upper Torso

3

Waist/elbow

Hip

Lower Torso

4

Crotch/wrist

5

6

Knee

7

8

Ankle

9

Toe

C/F V/B

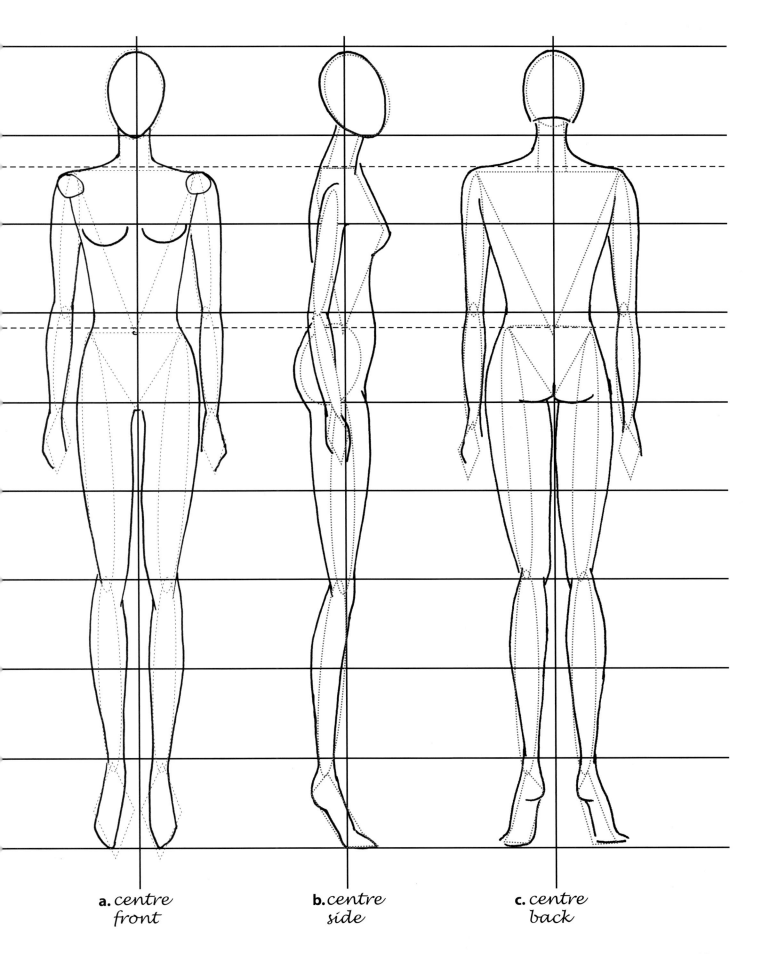

a. *centre front*

b. *centre side*

c. *centre back*

3 ▶

fleshing out templates 2 to 7

This section will demonstrate how to flesh out templates 2 to 7 (Fig. 5.3 to 5.8).

Note:

- Figures 5.3 to 5.8 show a fleshed out body line over the oval and triangle templates which are indicated as dotted lines.
- Your drawing does not have to be an exact copy of mine - your personal style will be developing as you work through the exercises.
- All measurements and shapes are guidelines - they do not have to be strictly adhered to.
- Adjust your drawing as many times as necessary; move the paper up, down, sideways and correct lines, improve the shapes (slim down the figure, reshape muscles), retrace until you have a fleshed out line drawing that you are happy with.
- At this stage you may decide you wish to elongate your fashion figure to ten heads or more by adding length to the legs.

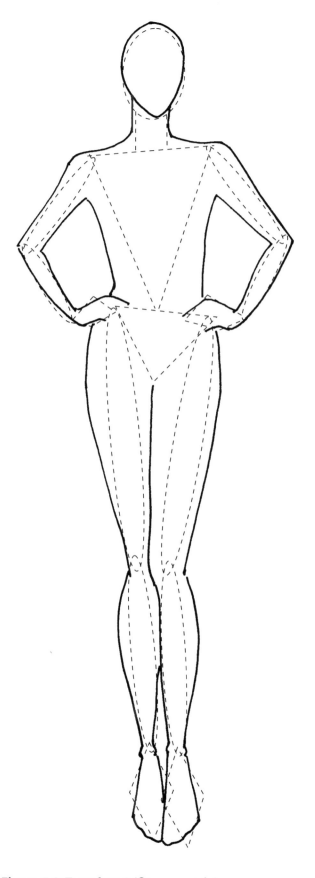

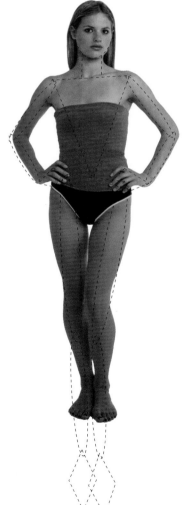

Figure 5.3: Template 2 (figure matrix)
Fleshed out front facing - hands on hips, body weight very slightly more on one leg than the other

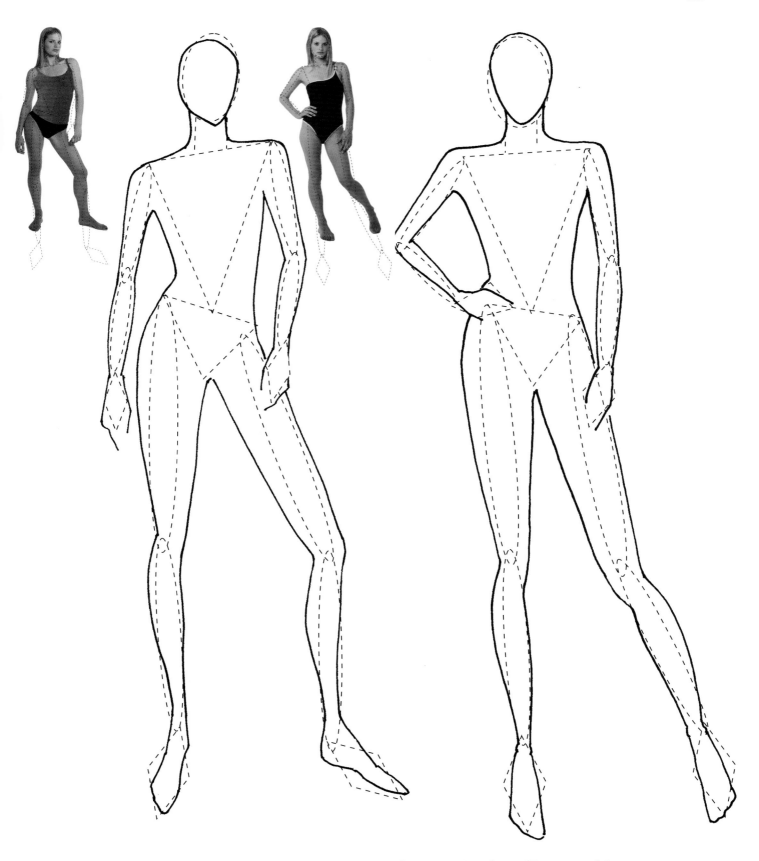

Figure 5.4: Template 3 (figure matrix)
Fleshed out, front facing, high hip - body weight distributed between feet, head turned, more dramatic and exaggerated pose

Figure 5.5: Template 4 (figure matrix)
Fleshed out, front facing, high hip - body weight on load bearing leg, balance leg knee bent inwards, cute pose

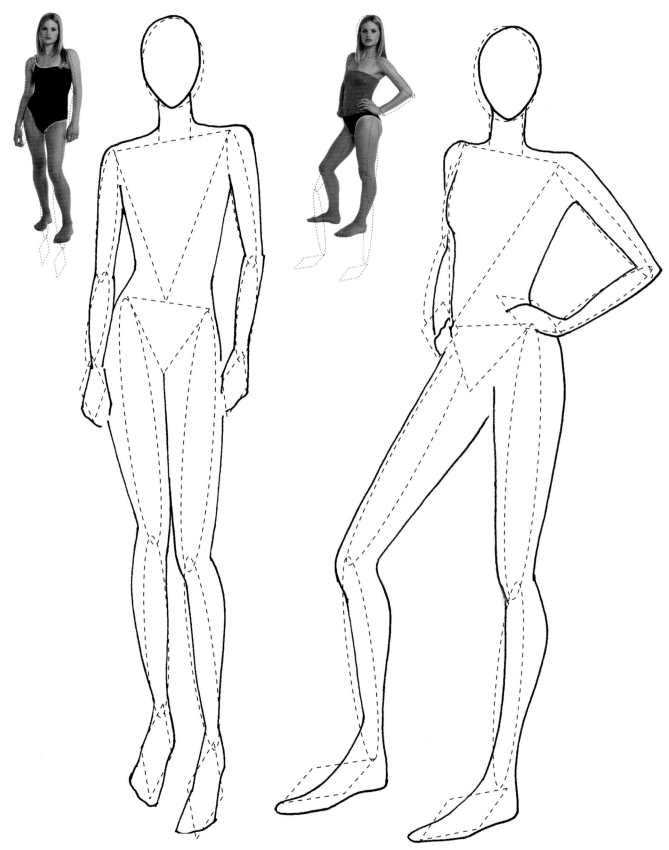

Figure 5.6: Template 5 (figure matrix)
Fleshed out, turned pose, high hip - body weight distributed between feet, angled shoulders, slightly quirky pose

Figure 5.7: Template 6 (figure matrix)
Fleshed out, side turned pose with hip thrust forward accentuating the model's supple body, the arm furthest away is foreshortened, body weight on load bearing foot in the foreground, interesting side pose

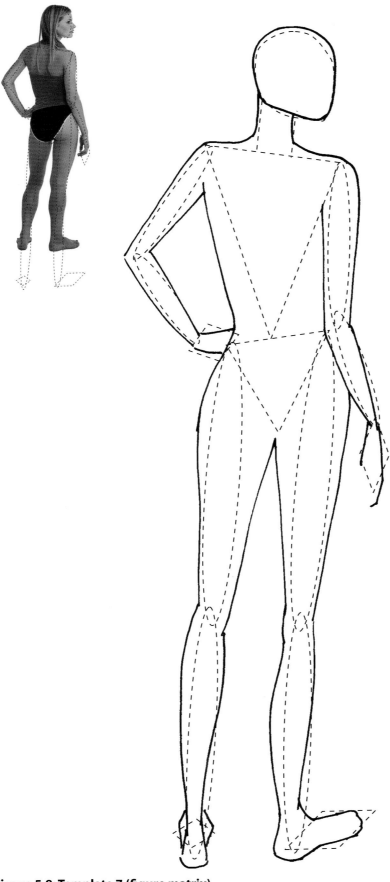

Figure 5.8: Template 7 (figure matrix)
Fleshed out, back turned figure with head in profile, an
interesting asymmetrical back view

4 ▽ ▶

common drawing problems

Never be afraid to experiment and make mistakes; mistakes often become the creative design solution you were looking for.

I have taken **Template 3 (Fig. 5.4)** as an example to illustrate a few common fashion drawing problems, Fig. 5.9 to 5.12.

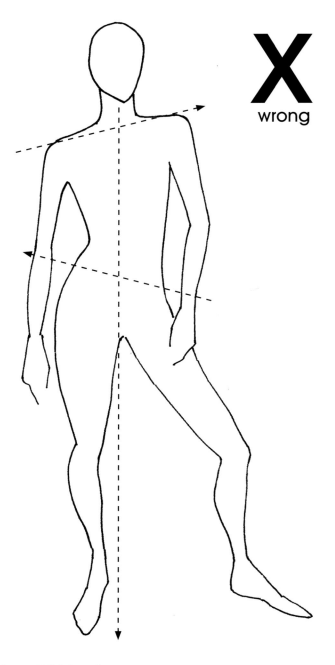

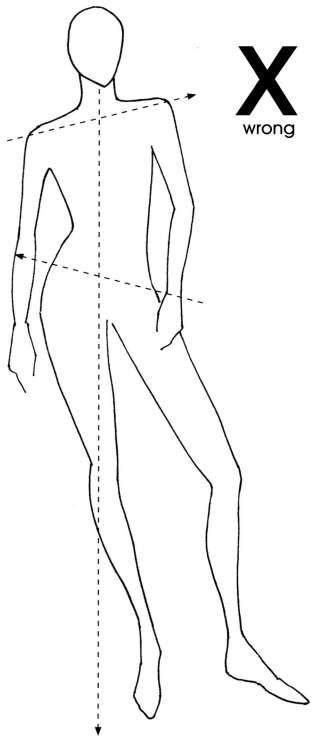

Figure 5.9 (above):
The figure looks dumpy because the legs are too short - adding extra length to the legs will make the figure drawing look more elegant and stylish. Note: never draw the legs short just because there is not enough space at the bottom of the drawing paper, rather redraw using a smaller head (the guideline for the body) or use a larger sheet of paper

Figure 5.10 (left):
The figure appears to be falling over because the vertical balance line is incorrect - the weight bearing foot is not under the pit of the neck. By redrawing the leg position correctly the figure will look balanced

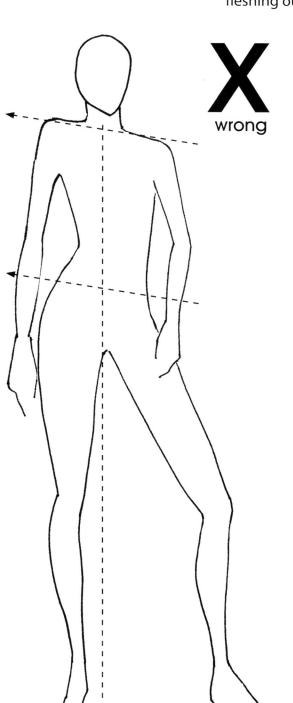

X wrong

X wrong

Figure 5.11 (above):
The figure looks slightly masculine and a bit like a boxer because the neck is too wide. The neck can be redrawn thinner to perfect the drawing

Figure 5.12(above right):
The drawing looks awkward and unbalanced, as if the figure has a hunchback - this is because the high hip and shoulder are on the same plane. The shoulders and hips should be on an opposite plane.

concluding comments

- The fashion figure is best drawn from the head down - this is your measuring tool to proportion the rest of the body.
- Redraw as many times as necessary, continually improving your latest sketch.

In the next chapter we will look at drawing the face, hands and feet. Once these techniques are applied to your fleshed out templates 2 to 7, a more complete and professional look will be achieved.

6
faces, hands, feet

The aim of a fashion drawing is to capture the design of a garment and the **overall look** of the fashion figure of which, facial features and hair styles play a major part in projecting the fashion image. Just a few simple lines can portray a great deal about the sex, age, ethnic origin, character and mood of the fashion figure. Drawing the face, hands and feet will give the fashion figures a professional look. All these features are sketched using understated lines so that they do not dominate a drawing but simply give an impression of completeness.

As with the fashion figure, you can learn fail safe drawing techniques to help you sketch the face, hands and feet confidently. As you become accustomed to drawing them you will naturally develop your own style. In this chapter, we begin by drawing the features separately before sketching them on the fashion figure templates in the next chapter, *Figure Templates*.

Illustration by Karen Scheetz

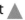

art box
- 2B Graphite pencil
- Sharpener/knife
- Black fine liners
- A3 (14x17 inch) semi-transparent paper
- Full length mirror
- Fashion magazines
- Portfolio/Folder

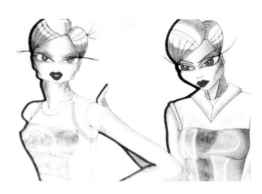

1 ▲ ▼

faces, hands and feet

These features can be drawn using various line thickness, and even just an impression of a line to produce an array of different expressions, styles and characters. Observe the line work and shading techniques these artists have used to express the fashion face, hands and feet.

Figure 6.1:

Fashion faces, hands and feet illustrated by: (top left to right) Foschini, Alissa, Anne Rees, (below) Alissa Stytsenko-Berdnik. Note the different line effects and shading techniques to produce these stylised features

2 ▼ ▶

the face

Drawing the face can be a daunting prospect for the novice - one small line in the wrong place could ruin the artwork. Fortunately, there are a number of easy solutions to this problem, as demonstrated in the following exercises. Just as you used guidelines, basic shapes and templates to draw the fashion body, so a similar approach can be used when drawing the face.

This chapter will take you progressively though the techniques used to draw the face from the front view, turned perspective and profile.

drawing the face: front view

First, note how the front view of the human face shows all the features symmetrically (Fig. 6.2). Draw the front view of the face following the instructions below and the point-by-point example opposite (Fig 6.3).

- **a. Head and guidelines:** Draw an egg shaped head and the guidelines for the centre front (c/f), eyes and mouth.
- **b. Eyes:** Draw as slender almond shapes over the eye guideline – allow an eye's width between the eyes and half an eye's width at each side of the face.
- **c. Eyelids:** Draw lightly as a curved line above the top of each almond.
- **d. Eyeball:** Draw the two opposite sides of a ball in the almond - drawing a complete ball would make the eyes look like they are staring at you.
- **e. Eyebrow and eyelashes: Eyebrow** - draw a thicker, elongated, curved line above the eyes. **Eyelashes** - draw the top edge of the almond slightly thicker and extend the line slightly. Rarely will you need to draw individual lashes as this gives too much focus on the eyes.
- **f. Mouth: Top lip** - above the mouth guideline, draw an extended 'M'. **Bottom lip** - below the guideline, draw a full, curved line. **Mouth opening** - draw a squashed 'M' on the guideline.
- **g. Nose:** Draw two tiny, understated curved shapes either side of the C/F line above the mouth.

- **h. Ears and hairline: Ears** - draw the ears from the eye guideline to finish above the mouth guideline. **Hairline** - on the C/F, approximately a sixth down from the top, draw a curved line towards the ears.
- **i. Redraw and hairstyle:** Overlay with semi transparent paper and retrace the complete face, leaving out the guidelines, but adding the hairstyle and neck. Hairstyles whether long or short, straight or curly are defined by drawing a soft outline shape. Then several tendrils of hair are drawn together to emphasise the style lines.

drawing tips:
- If you want to draw a perfectly symmetrical face fold the drawing paper down the centre front line, draw one side of the face and trace through for the other.
- Never over work the details of the face as it moves the focal point of the drawing directly to the face instead of the clothing. If you make a mistake and need to erase, do so carefully, otherwise redraw.

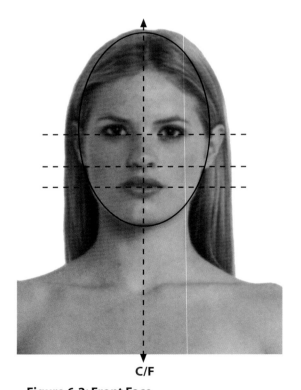

C/F

Figure 6.2: Front Face

The front view of the model's face displays all the features symmetrically

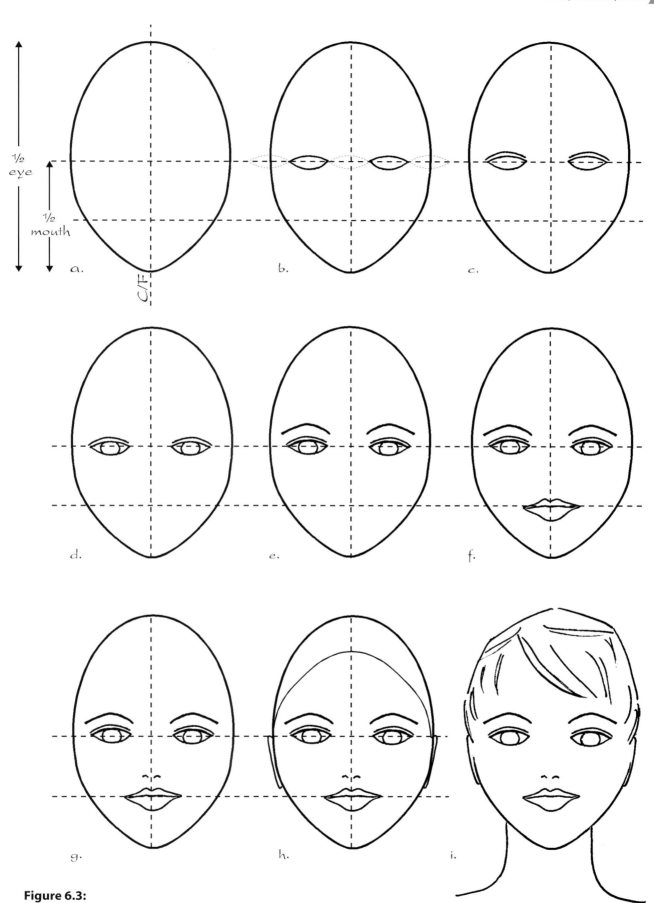

Figure 6.3:
Face: Front view - showing point-by-point development

3 ▼ ▶

face: turned

As the head turns, the C/F line of the face turns with it and the outline of the face and the features no longer appear symmetrical (Fig. 6.4 and 6.5). The far cheekbone becomes more defined, and the features that are further away look slightly smaller than those closer. To help you understand this perspective study your own face in the mirror.

drawing the face: turned or 3/4 perspective

Draw the turned view of the face following the instructions below and the point-by-point example opposite (Fig 6.6).

a. Head and guidelines: Draw an egg shaped head and the guidelines as before (Fig 6.3a).

b. Head turned: Redraw the head as it rotates and turns to a 3/4 perspective; the chin (pointed end of the egg shape), will move to one side of the C/F.

c. Head and C/F: Draw in the new C/F line.

d. Eyes (eyelids and eyeballs): Draw the eyes - the eye furthest away is smaller in width than the one nearest to you. There is approximately a 3/4 eye width between them to allow for the nose, and a small space between the furthest eye and the far side of the face.

e. Eyebrows and lashes: Eyebrows - draw the brows lightly as curved lines above the top of each eye, the furthest brow is drawn shorter. **Eyelashes** - draw a thicker line along the top edge of the eye extending at the outer edges.

f. Mouth: The lips are drawn shorter on the far side as they disappear from view.

g. Nose: Draw a line indicating the length and shape of the nose on the far side of the C/F and on the nearest side draw a small curved shape for the nostril.

h. Face shape, neck and ears: Face - on the furthest side, reshape from the eyebrow to the eye and out to the prominent cheekbone curving down towards the mouth and chin; continue up to the jaw bone; extend the back of the head. **Neck** - draw slim and elegant. **Ears** - draw the ear between the eye and mouth guidelines.

i. Redraw and hairstyle: Overlay with semi transparent paper and retrace the complete face, leaving out the guidelines, but adding the hairstyle.

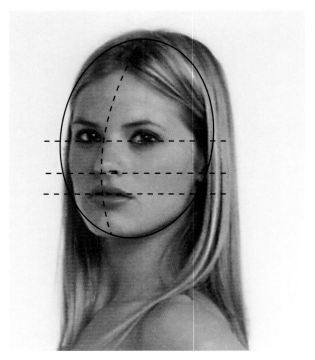

Figure 6.4: Face Turned

As the model begins to turn her face her features change shape and are no longer symmetrical; notice her jawbone and cheekbone become more prominent

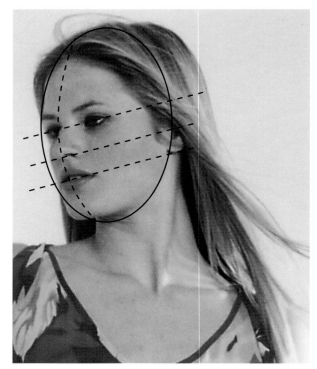

Figure 6.5: Face Turned 3/4 Perspective

As the model turns her face to a 3/4 perspective her features continue to change shape and are no longer symmetrical; her chin is now more prominent

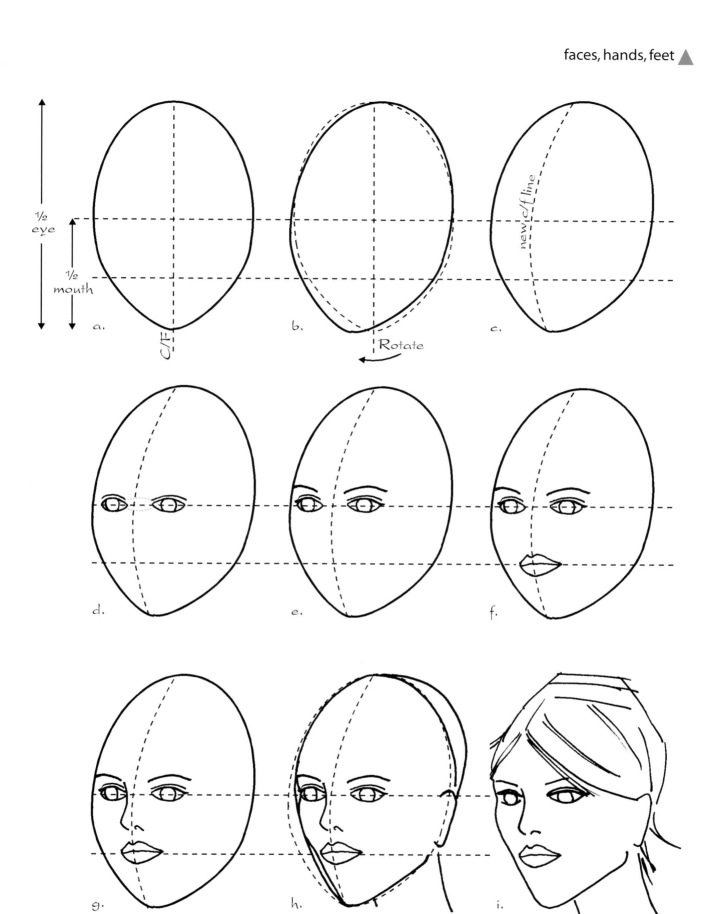

½ eye

½ mouth

C/F

a.

Rotate

b.

new c/f line

c.

d.

e.

f.

g.

h.

i.

Figure 6.6:
Face: Turned or 3/4 perspective view - showing
point-by-point development

4 ▼ ▶

face: profile

With the view of the head in profile, the drawing guidelines remain the same but the shapes of the features are distinctly different (Fig. 6.7).

drawing the face: profile

Draw the profile view of the face following the instructions below and the point-by-point example opposite (Fig 6.8).

a. Head and guidelines: Draw an egg shaped head and the guidelines as before (Fig 6.3a). Draw a rectangle around the head. The left side of the rectangle will become the C/F line front, and the right side will become the centre back line (C/B). The original C/F will become the side face/ear guideline. Divide the left portion of the box in half lengthwise - this is the eye guideline for the edge of the eye.

b. Eye: Draw the eye, eyelid, brow and lashes.

c. Nose: Draw the nose line protruding outside of the box and the nostril inside it.

d. Forehead, mouth and chin: From the top of the head, draw a gentle curved line down and in towards the eye and out again, forming the profile nose shape. From the nose curve in and out to form the pouting lips and prominent chin.

e. Back of head and neck: From the top of the head draw a curved line towards the back of the head extending over the rectangle; continue down to form the back neck and finish with the angled front line of the neck.

f. Ear: Draw the ear on the guideline, between the eye and mouth guidelines.

g. Hair: Draw in the hairline.

j. Redraw and hairstyle: Overlay with semi transparent paper and retrace the complete face, leaving out the guidelines, but adding the hairstyle.

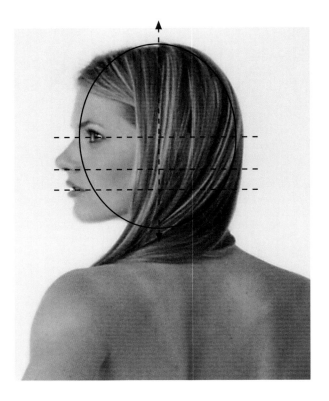

Figure 6.7: Profile

As the model turns her face to a profile view so her features change; only one ear and eye can be seen; the forehead, nose, chin and jawbone become more prominent

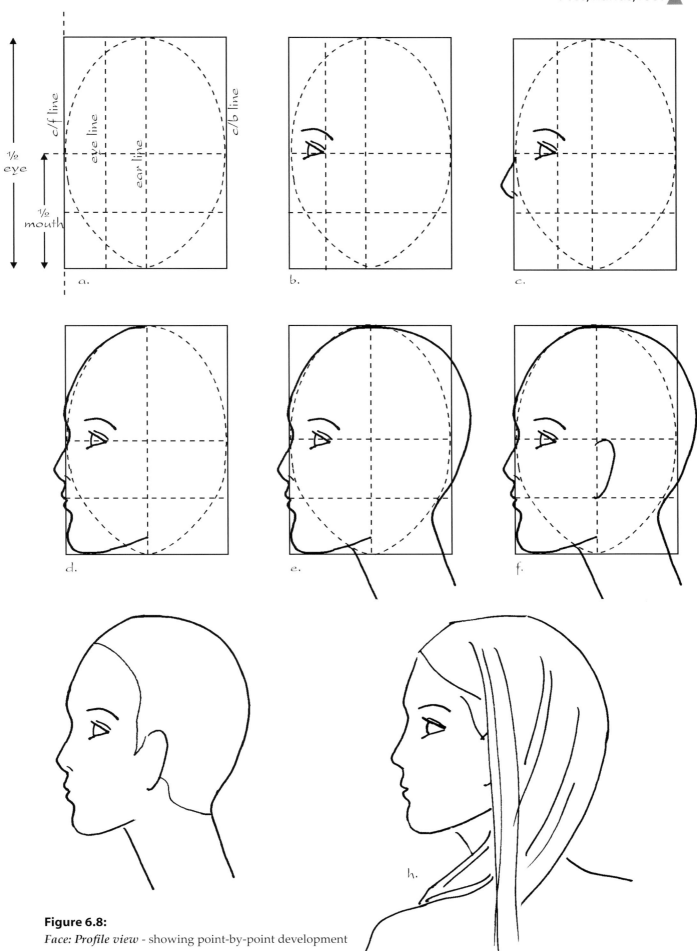

Figure 6.8:
Face: Profile view - showing point-by-point development

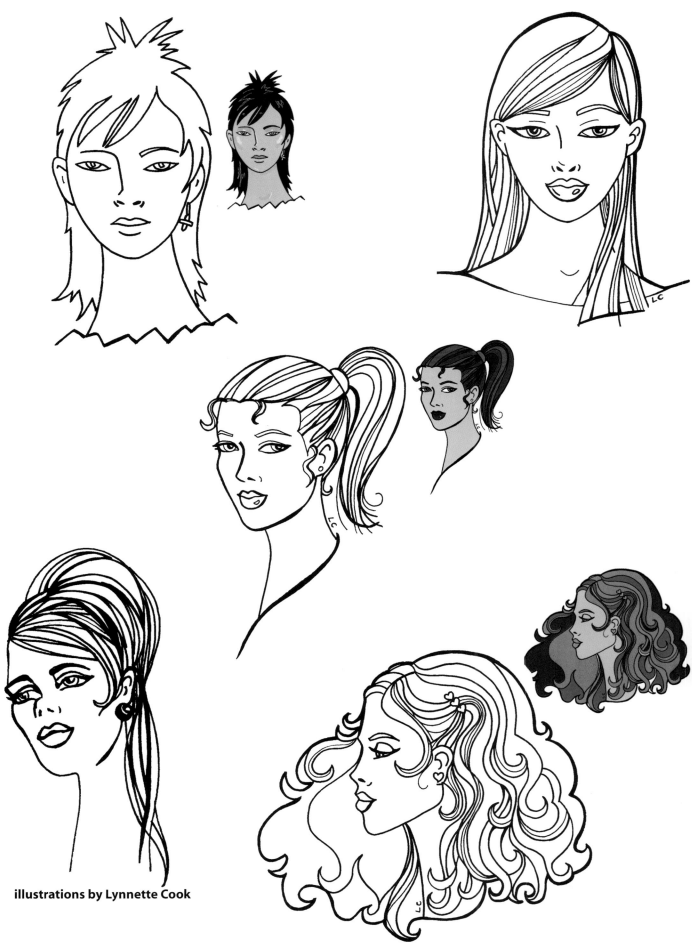

illustrations by Lynnette Cook

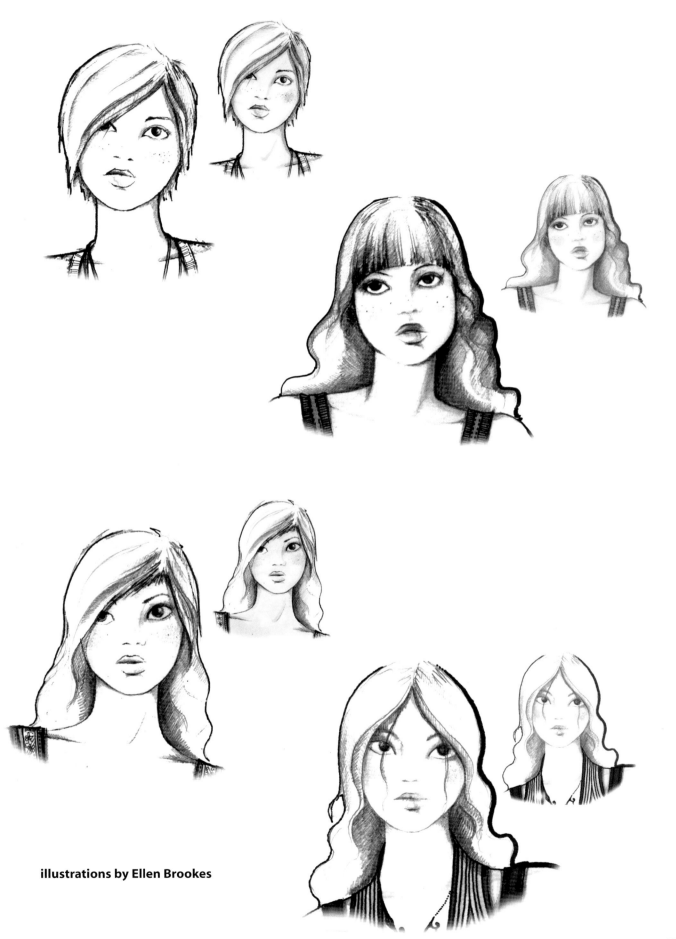

illustrations by Ellen Brookes

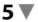

5 ▼

hands

Female fashion hands are presented as slender, elegant and understated. An outstretched hand is approximately 0.75 of a head depth; a common mistake is to draw them too small (see Chapter 4, *Oval and Triangle Technique*).

To help you familiarise yourself with the shape and *'bendy bits'* of the hand; fingers, knuckles and finger joints, complete the following exercises.

a. (Fig 6.9a): Place your hand flat on the drawing paper and, using a fine liner:

- Draw around your hand beginning and ending at your wrist.
- Draw sweeping curved lines over the joints and knuckle positions to familiarise yourself with the points where they bend.

b. (Fig 6.10a): Place your hand flat on the paper, extend your forefinger and thumb, clench the other fingers under your palm. Draw around your hand.

c. (Fig 6.9b and 6.10b): To make your sketches look more like *'fashion' drawing hands*, overlay with semi-transparent paper and redraw the shapes slightly narrower while smoothing the lines and making the hands more elegant.

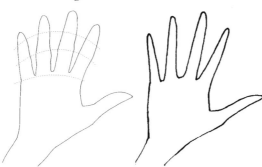

Figure 6.9a and b:
Draw around your outstretched hand, then redraw more elegantly for the fashion hand

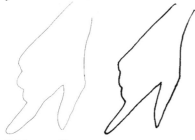

Figure 6.10a and b:
Draw around your hand (forefinger and thumb extended, three fingers clenched), redraw more elegantly for the fashion hand

6 ▼ ▶

drawing fashion hands

These photographs show some of the most popular hand positions for fashion design. Hands may be partly hidden, for example, in trouser pockets, or by the sides of the body - knowing these techniques is especially useful when learning to draw.

Practise sketching hands by following the drawn examples Fig. 6.11 to 6.15.

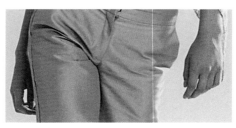

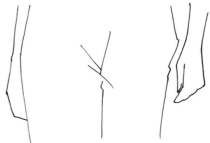

Figure 6.11:
The model's right hand is partly hidden, her left hand fingers are grouped together and bent

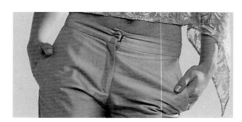

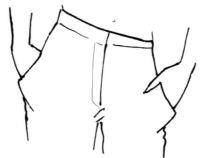

Figure 6.12:
Hands in pockets

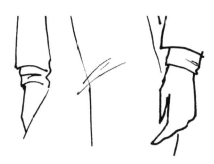

Figure 6.13:
The model's right hand is almost hidden behind her legs while the fingers of her left hand are in a relaxed position with fingers bent and the thumb showing

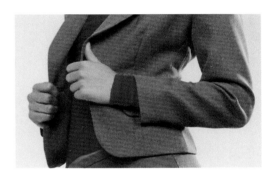
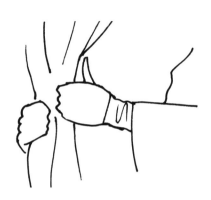

Figure 6.14:
The model grips her jacket with both hands - only the outline of each hand is drawn

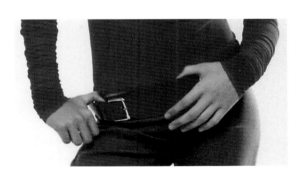
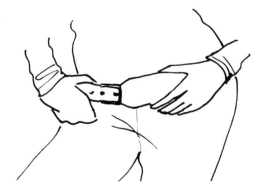

Figure 6.15:
The fingers of the model's right hand can be drawn, grouped together, as a bold outline, but with the thumb extended. The fingers of her left hand are more spread out and are drawn individually

7 ▼ ▶

feet and shoes

Although fashion figures are rarely drawn without shoes, learning to draw the bare foot will help you understand the perspective and shape of the foot and consequently make it easier to draw footwear. Like the hand, the female fashion foot is drawn **long** and **slender**. It is approximately the same depth as the head (see Chapter 4, *Oval and Triangle Technique*). Note: the higher the heel of the shoe, the longer the front view of the foot appears.

These photographs (Fig. 6.16 to 6.23) present typical positions of the foot. Note the rough guidelines to initially outline the foot's shape and how they are developed and redrawn.

Practise drawing the fashion foot: Front, side and back views.

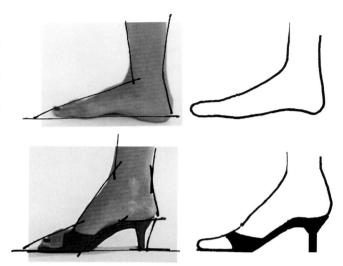

Figure 6.16:
Side foot with and without shoe - drawn more slender for the fashion foot, the higher the heel, the higher the instep

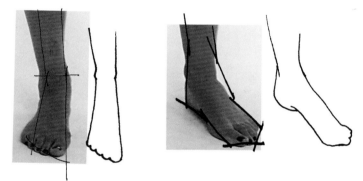

Figure 6.17:
Front and turned bare foot - the fashion foot is drawn long and slender

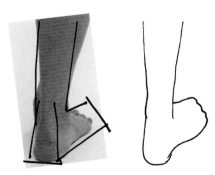

Figure 6.18:
Back foot, 3/4 view without shoes

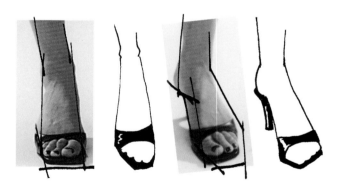

Figure 6.19:
Front and slightly turned foot with shoe - the fashion foot is drawn long and slender, the higher the heel, the longer the foot appears

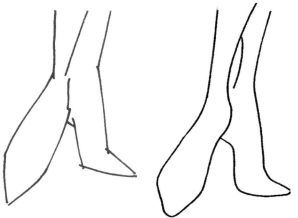

Figure 6.20:
Feet together - front view (left) and 3/4 view (right)

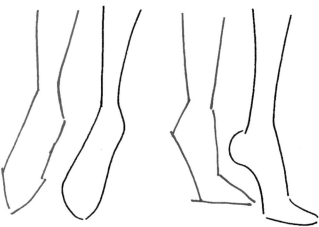

Figure 6.21:
Feet apart - slightly turned (left) and side view (right)

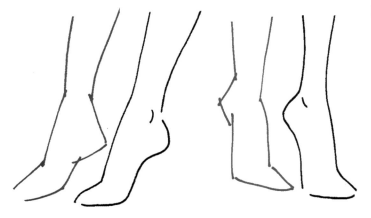

Figure 6.22:
Feet apart - Side foot (left) and 3/4 view (right)

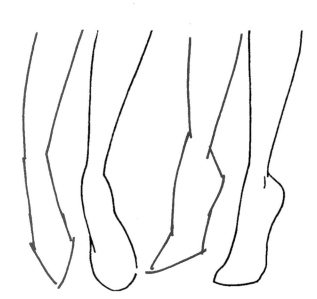

Figure 6.23:
Feet apart - Angled in front view (left) and angled in 3/4 view (right)

8 ▼ ▶

fashion artist's gallery

These photographs demonstrate a selection of artwork from designers and illustrators worldwide. Note the different styles and how the artists draw the face, hair, hands and feet and put it all together. As you master the basic fashion drawing techniques, like these artists, you will naturally develop a style of your own.

Illustrations by Stuart McKenzie

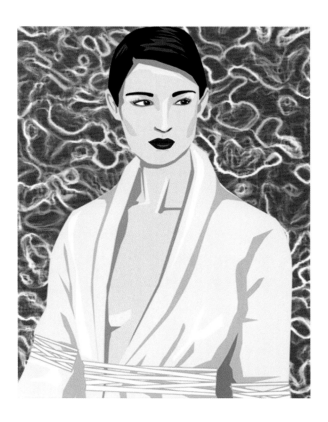

Illustration by Naomi Austin

Illustration by Aase Hopstock Storeheier

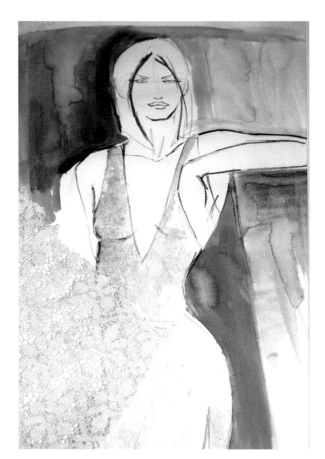

Illustration by Loraine Ford

Illustration by Anne Rees

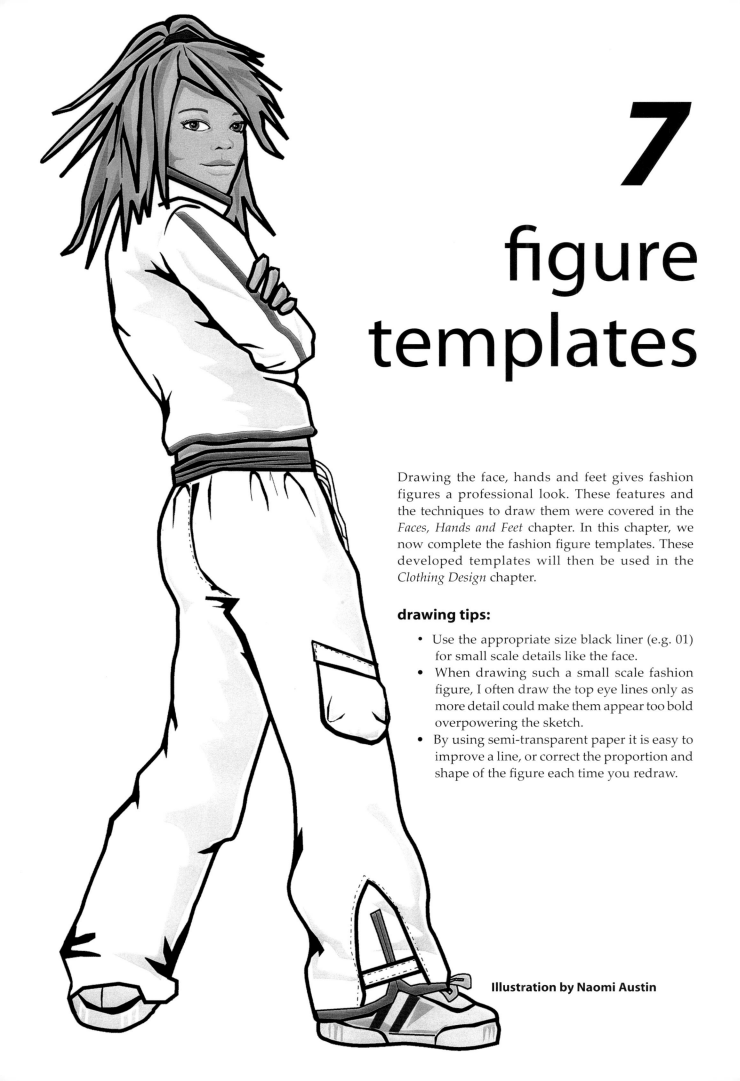

7
figure templates

Drawing the face, hands and feet gives fashion figures a professional look. These features and the techniques to draw them were covered in the *Faces, Hands and Feet* chapter. In this chapter, we now complete the fashion figure templates. These developed templates will then be used in the *Clothing Design* chapter.

drawing tips:

- Use the appropriate size black liner (e.g. 01) for small scale details like the face.
- When drawing such a small scale fashion figure, I often draw the top eye lines only as more detail could make them appear too bold overpowering the sketch.
- By using semi-transparent paper it is easy to improve a line, or correct the proportion and shape of the figure each time you redraw.

Illustration by Naomi Austin

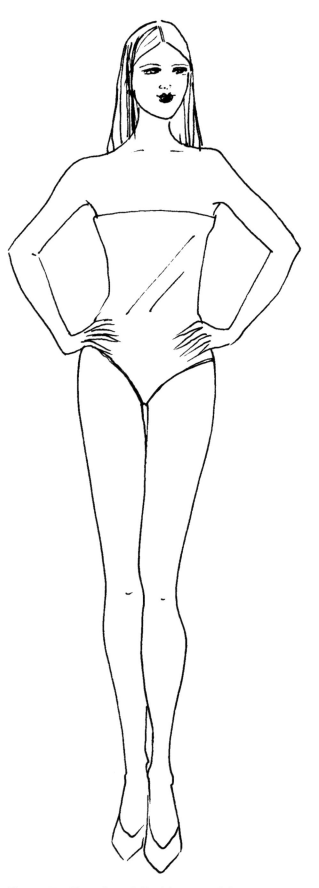

art box

- Your fleshed out fashion templates 1 to 7 from the *fleshing out* chapter
- 2B Graphite pencil
- Sharpener/knife
- Black fine liners
- A3 (14x17 inch) semi-transparent paper
- Full length mirror
- Fashion magazines
- Portfolio/Folder

1 ▼

fashion templates: faces, hands, feet

Using semi-transparent paper, overlay each of your fleshed out templates and complete your fashion figure by drawing the face, hands and feet (Fig. 7.1 to 7.6). Follow my sketches as examples and redraw your own fashion templates until you are happy with your style and figure.

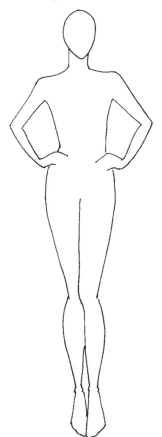

Figure 7.1: Template 2 (fashion matrix)
Fleshed out front facing - hands on hips, body weight very slightly more on one leg than the other

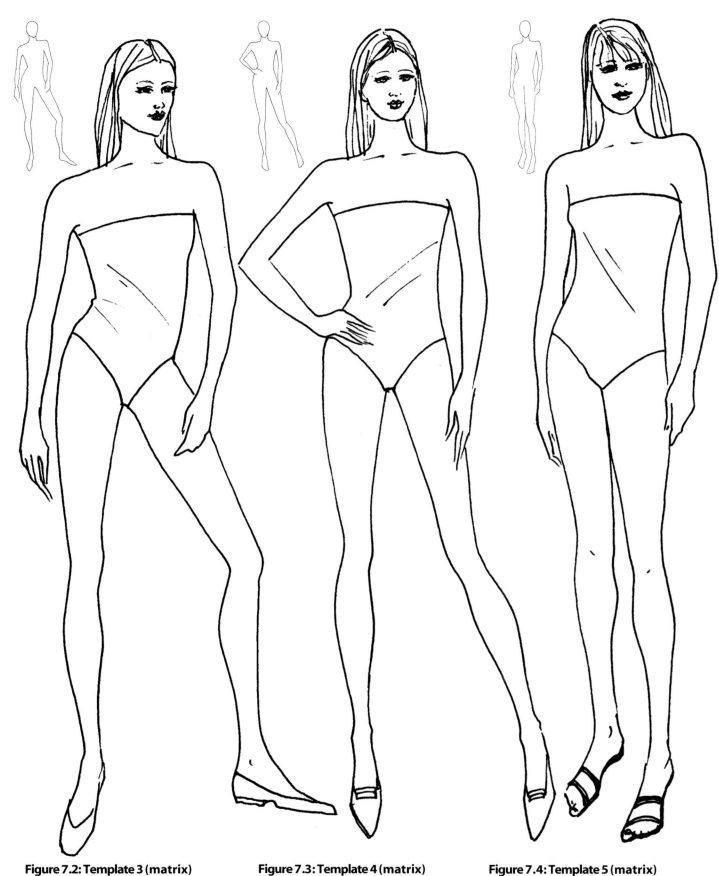

Figure 7.2: Template 3 (matrix)
Fleshed out, front facing, high hip - body weight distributed between feet, head turned, more dramatic pose

Figure 7.3: Template 4 (matrix)
Fleshed out, front facing, high hip - body weight on load bearing leg, balance leg knee bent inwards, cute pose

Figure 7.4: Template 5 (matrix)
Fleshed out, turned pose, high hip - body weight distributed between feet, angled shoulders, slightly quirky pose

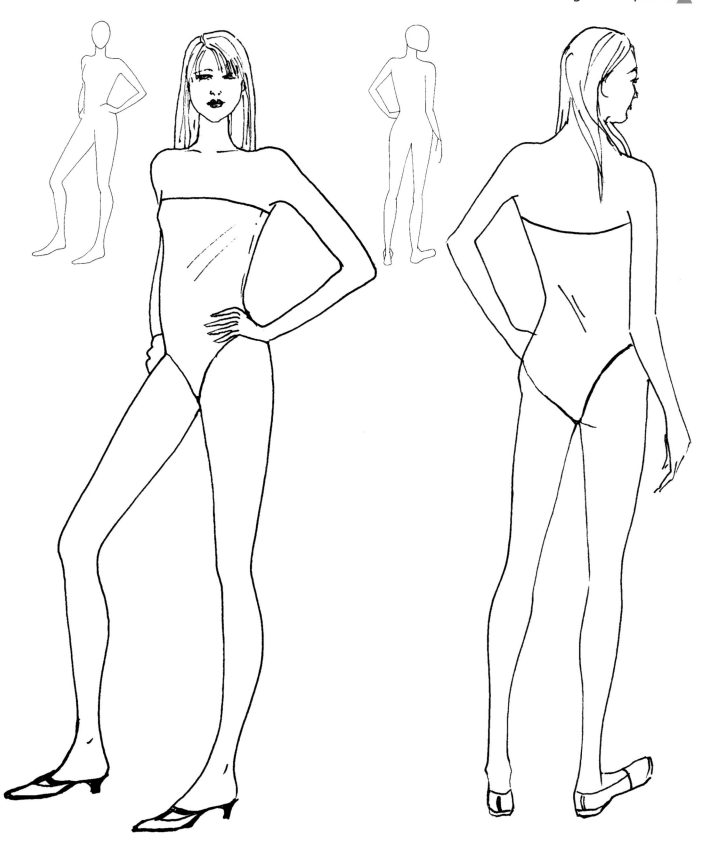

Figure 7.5: Template 6 (fashion matrix)
Fleshed out, side turned pose with hip thrust forward accentuating the model's supple body, the arm furthest away is foreshortened, body weight on load bearing foot in the foreground, interesting side pose

Figure 7.6: Template 7 (fashion matrix)
Fleshed out, back turned figure with head in profile, an interesting asymmetrical back view

Figure 7.7 to 7.9:
3 additional poses,
rough sketches
(finished figures next
page)

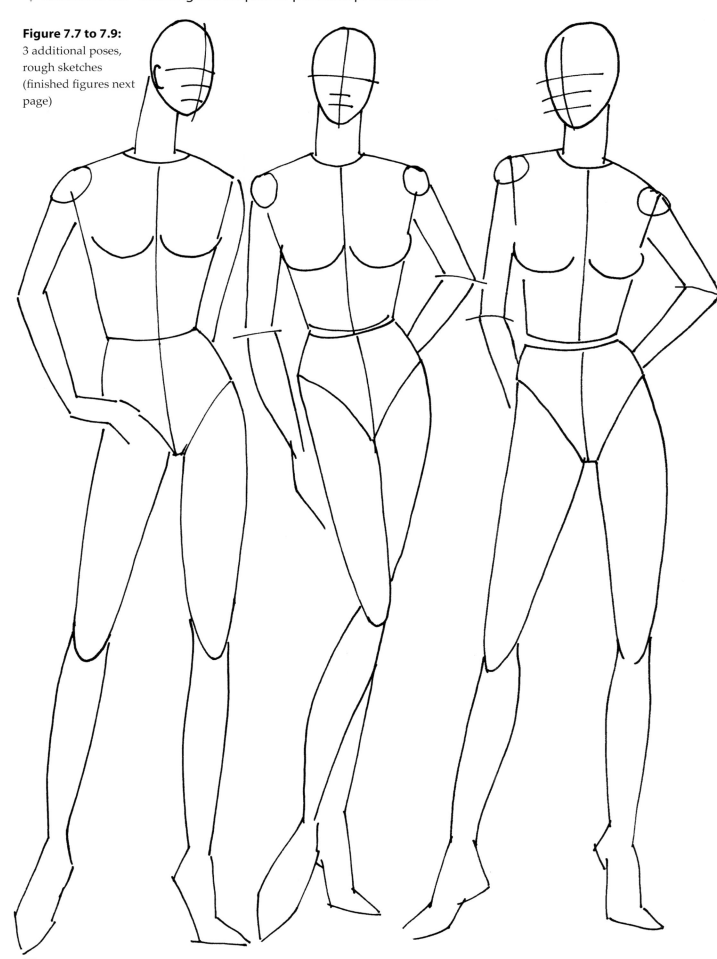

Figure 7.10 to 7.12:
Drawings by Lynnette Cook
3 poses, finished figures
(roughs previous page)

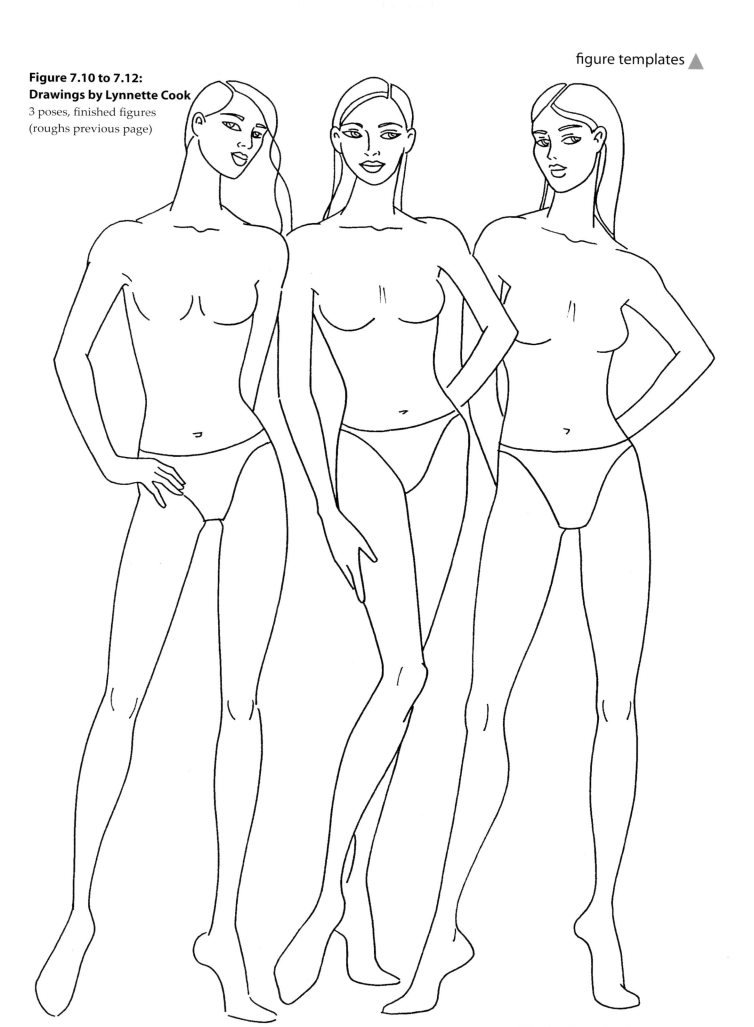

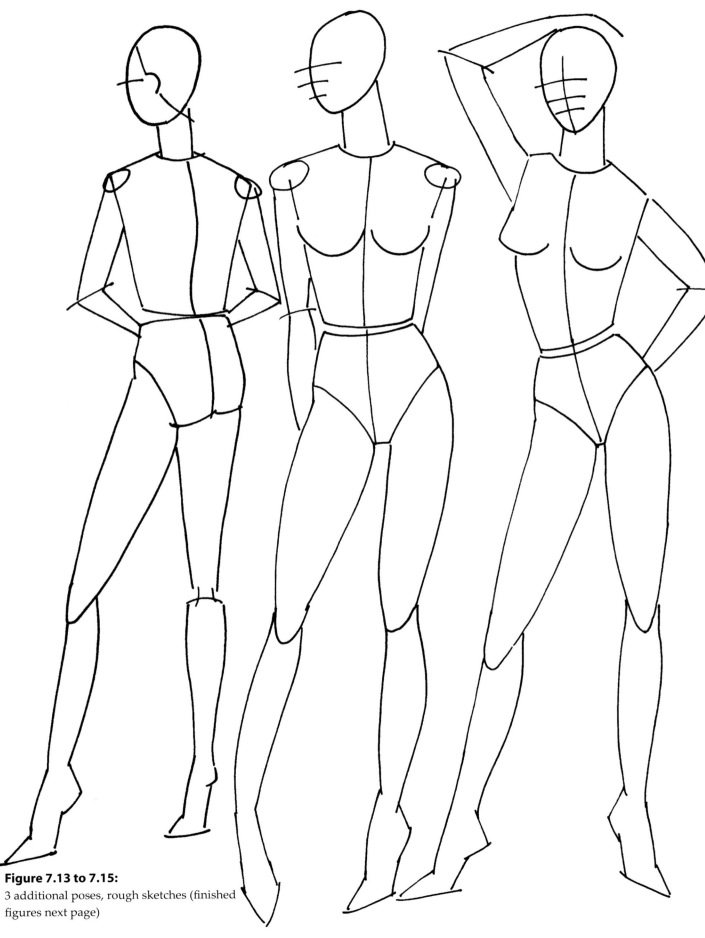

Figure 7.13 to 7.15:
3 additional poses, rough sketches (finished
figures next page)

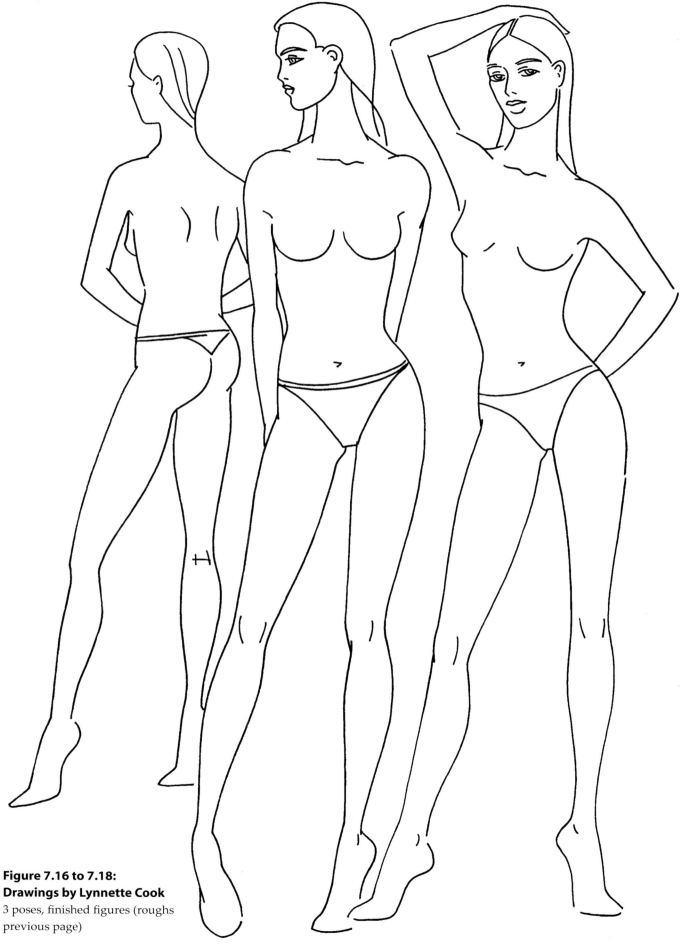

Figure 7.16 to 7.18:
Drawings by Lynnette Cook
3 poses, finished figures (roughs
previous page)

8

drawing from life

Drawing from life is the best way to appreciate the **body in action** and will give your fashion figures the **spirit of life.** Drawing from life introduces the three dimensional body and helps you develop a **personal drawing style,** be it a realistic or cartoon approach. Once you understand the proportions of the human figure, you will find that you can even draw a **fourteen head** fashion figure convincingly. Drawing from life is an essential part of learning to draw fashion figures as you gain a better understanding of the shape, form and movement of the body, in comparison to drawing from a 2D, flat photograph. Drawing the clothed, live model will help you appreciate how garments lie and drape around the body.

Just a few one hour drawing from life sessions will make all the difference to applying your figure drawing skills. Soon you will be sketching the figure quickly and skillfully, even capturing a model strutting down the catwalk or an inspirational outfit being worn in the street. Drawing from life should be fun and creative, so get out those messy charcoal sticks and pastels, grab huge pieces of paper and start drawing **BIG** and **BOLD**.

Illustration by Karen Scheetz

art box

- A2 (18 x 24 inch) inexpensive paper - lots of waste: semi-transparent paper, brown wrapping paper, newsprint, wallpaper etc. Use quality paper for sketches you wish to present in your portfolio.
- Charcoal sticks or pencils.
- Any of the following: Coloured pastels stick or pencil form, wax crayons, markers (thick nib), thick brushes if working with inks etc.
- Fixative Spray - use for good work; hair spray - rough work; use with charcoal and pastels.
- Easel or a raised drawing board.
- Putty eraser - to lighten media and for particular effects.

1 ▼

the studio

The venue you use for your drawing from life sessions:

- Must have adequate lighting to clearly see your model and to observe how light falls on the body creating highlights and shadows.
- Must allow you enough space to work on large sheets of paper.
- May become very messy when using dusty charcoals and pastels; you may need to cover the floor with paper; it is also advisable to wear old gear.

Preferably work at an easel or use a large drawing board - to produce your best work you need a comfortable drawing position. You also need to be able to stand back from your work periodically and check your drawing for its overall impression.

The media listed in this art box has been selected to encourage a bold approach to drawing, this means looking at the figure as a whole leaving out intricate details. For drawings, which are not to be used for presentation, you can use a cheap hair spray to temporarily fix the media (charcoals/pastels) - this is not recommended for finished artwork as it is not a permanent fix and may discolour the paper.

Figure 8.1:

Drawing from life class at AUT: students work at raised drawing boards while the model holds a pose for a few minutes

Figure 8.2:

Drawing from life at Central St Martins: student works at an easel, note how he exaggerates the figure drawing

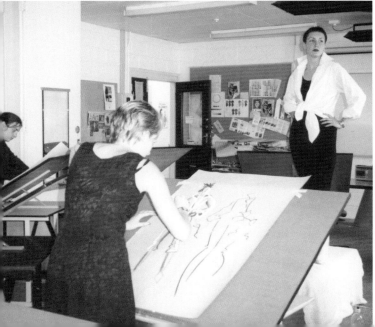

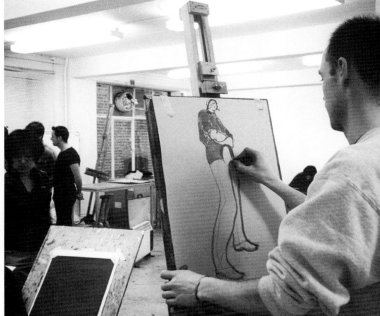

2 ▼
the model

Female and male fashion figures are generally drawn as young and slender, this is in line with how the fashion industry typically promotes clothing. If your models do not fit this '*perfect*' description it is not a problem as it is good experience and practise to draw people of all age groups and with different figure shapes. Later, you can alter your sketches to make them more like a fashion figure.

Drawing people in movement is also good practise. When fashion reporters and illustrators are capturing the latest fashion trends at fashion shows they only have a few seconds to sketch the models strutting down the catwalk.

Initially, in your drawing from life sessions, the model should either be wearing fitted garments so that you can concentrate on the shape and stance of the body or posing nude. As you become more proficient at drawing the figure in different poses, you can progress to drawing the model wearing various styles of clothing - this will help you to understand how a garment fits on and around the body, how it hangs, drapes and creases. Costume designers would especially benefit if the model is dressed in a uniform, period costume or as a specific character.

3 ▼ ▶
the poses

In your 'fashion' **drawing from life** classes, I suggest you start with the standard poses such as those outlined in the figure matrix (page 13), then develop the poses by drawing variations. Action poses can come later as you become more proficient at drawing the body. The emphasis should be on capturing the pose and body shape, not necessarily drawing intricate details (in contrast, in a traditional **life drawing art class** the nude model holds a pose for 30 minutes to an hour and the artist is expected to draw more explicit sketches). Here are some suggestions for the drawing exercises:

- Warm up exercise - start by drawing a sequence of quick poses where the model holds the pose for only 30 seconds to a minute, allowing just enough time for you to capture the overall figure pose. This is a great exercise for releasing inhibitions as there is no time to get bogged down with details.
- Move on to two minute poses; this will give you enough time to flesh out the body.
- Progress to longer poses of five to 20 minutes giving you time to sketch in more detail - look at shading the figure, the shadows, the highlights, and begin to define or soften lines.

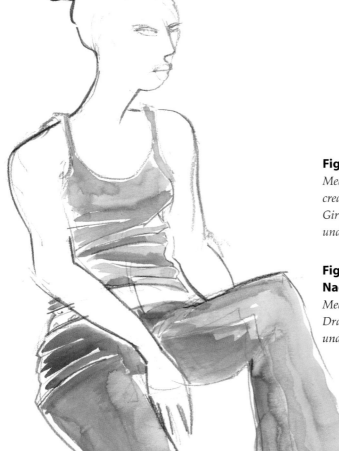

Figure 8.3 (left): Life drawing by Maggie Doyle
Media - pastel (water-soluble); water and a brush have been used to create a water colour effect
Girl sitting - capturing people in various poses greatly adds to your understanding of the human form and actions

Figure 8.4 and 8.5 (facing page) : Life drawings by Naomi Austin
Media: sketch using pencil, ink, fineliners etc.
Draw models in various poses and styles of clothing to help you understand how a garment fits, hangs, drapes and creases

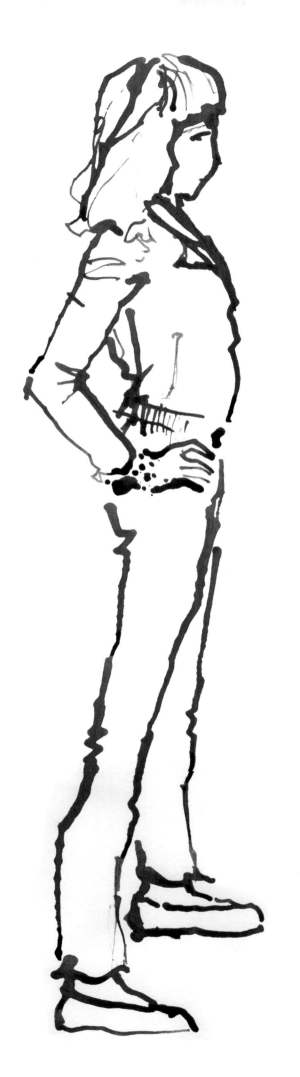
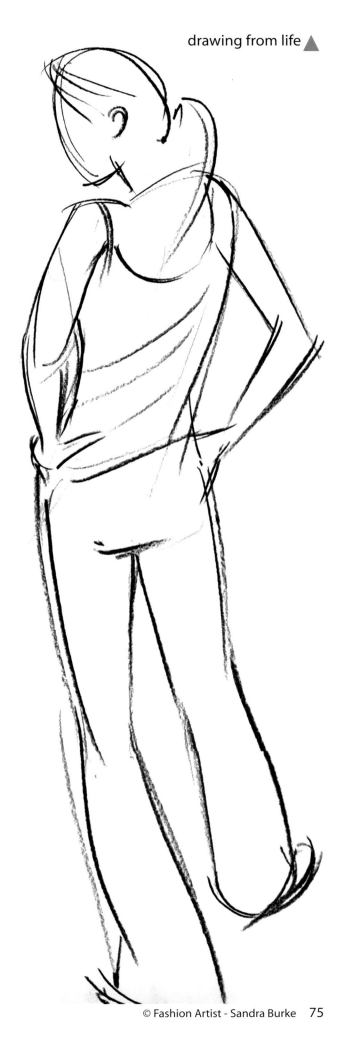

4 ▼ ▶
drawing techniques and method

The oval and triangle technique is an excellent way to get you started when drawing from life. As you sketch the ovals for the legs you can elongate the model's legs as in chapter 4, *Oval and Triangle Technique*, Fig. 4.13 to 4.22. The idea is to capture the pose quickly and simply and then develop the drawing in more detail as time allows. Do not worry about making mistakes, just relax, you should be having fun while loosening up your drawing style and understanding more about the body.

Begin drawing your model by:
 a. Analysing the pose from head to foot.
 b. Then take a large piece of paper and a charcoal or a dark pastel stick.

Techniques (Using the same oval and triangle drawing techniques as Chapter 4, Fig 4.13 to 4.22):
 c. At the top of the page mark in the head with an oval.
 d. Note the load bearing foot and faintly mark in the vertical balance line from the pit of the neck.
 e. Draw the neck, triangles, ovals and diamonds to capture the overall body pose.
 f. Draw the angles of the shoulders, waist and hips.
 g. Draw the centre front line.

Flesh out the figure:
 a. Observe the model and using the oval and triangle shapes as your guidelines sketch the body shape starting from the head down (chapter 5, *Fleshing Out*).
 b. You do not need to use the overlay technique here, drawing over the top of the guidelines is fine as these are rough drawing exercises.
 c. Lines can be smudged with your fingers if too dominant or distracting to your eye.

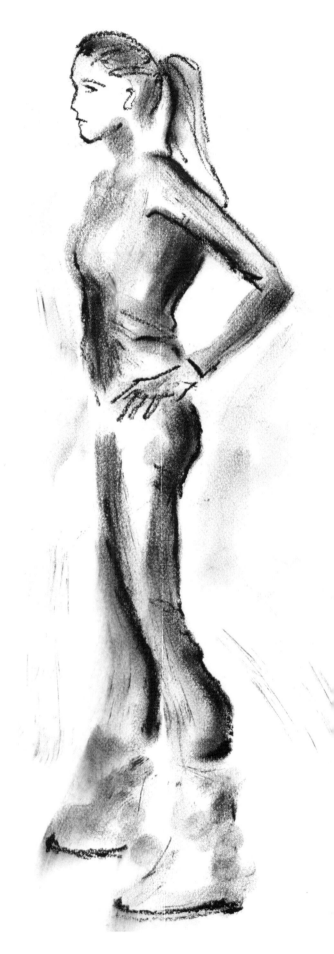

Figure 8.6 : Life drawing by Naomi Austin
Media: charcoal is used to create a softer looking drawing; note the use of strong, dark and soft smudged lines creating shadows and highlights

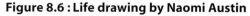

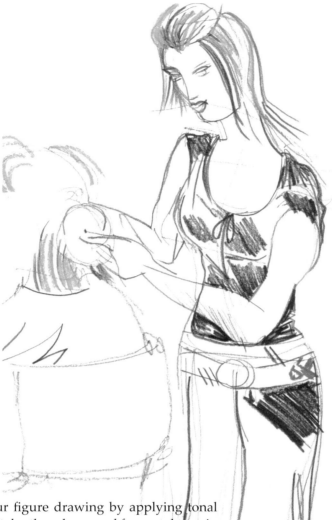
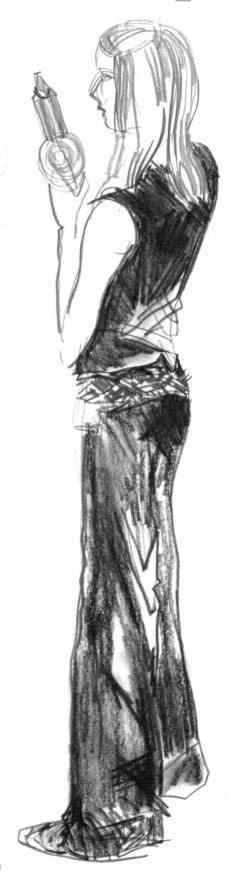

Shade: Shade your figure drawing by applying tonal definition to give it depth, volume and form and to gain a 3D effect (Fig 8.6 to 8.9):

a. Look at the figure you are sketching and identify the three main tones - dark, medium and light - these give the 3D effect; dark tones appear further away than light tones; dark tones appear on inward curves, higher areas are lighter.

b. Start drawing the darkest tones first.

c. Now draw in the mid-tones by lightly using your charcoal or a lighter pastel.

d. Next take a white pastel and sketch the lighter areas.

e. Go back over the figure, retouching if necessary; be careful not to overwork the shading; remember less is best.

f. Add only the minimum amount of detail to the face - rather lightly shade and give only an impression of the features, see Fig 8.6 to 8.9.

Figure 8.7: Hairdressers in action by Maggie Doyle

Media: coloured pencils

Quick sketches of people in everyday life will greatly enhance your understanding of the body and improve your fashion drawing skills

5 ▼▶
creative exercises

Try these exercises to further develop your drawing skills, enhance your creativity and innovative thinking:

- **Semi-blind sketching:** Study the figure for half a minute, keep your eyes focused on the model, begin drawing from the head down and only look at the drawing paper to relocate a point, e.g. from an outline to the centre front – do not hurry the drawing.
- **Opposite hand:** Draw with the opposite hand to what you would normally use.
- **Boot polish:** Cover finger with dark boot/ shoe polish and create bold figures in movement.
- **Continuous line:** Draw figures using one continuous line, never breaking until the figure is complete (just like peeling an apple in one go!).
- **Flat charcoal:** Take the flat side of a charcoal stick and draw the complete figure.
- **Vary the scale:** Draw figures large scale to thumbnail size on one page.
- **Paper and media:** Work on different coloured papers, use various colours for outlines, experiment with all media and combinations.

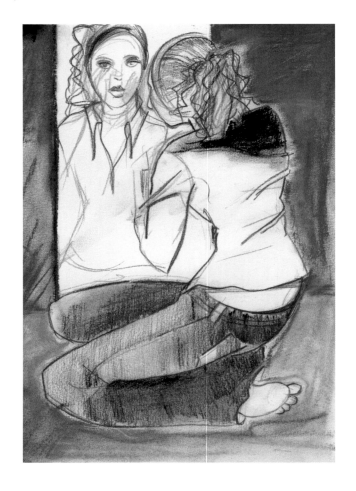

Figure 8.8 (top right): Drawing by Maggie Doyle
Girl at mirror; media: pastel pencil

Figure 8.9 (right): Drawings by Ann-Marie Kirkbride
Girl seated from sketchbook; media: marker and wax crayon
Girl standing; media: felt pen, emulsion and acrylic

Taking just a few minutes a day to capture everyday actions like these will greatly improve your fashion drawing skills
And experimenting with different media and techniques will add to your creativity

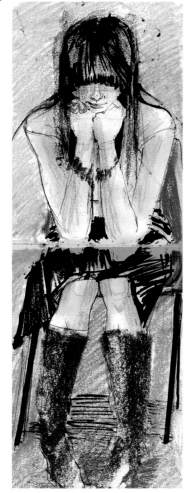

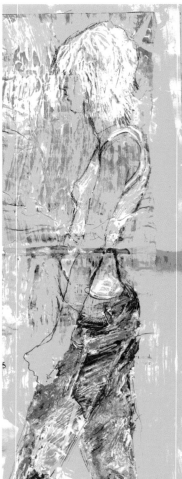

6 ▼ ►

life drawings as fashion templates

Select your best drawings to use as fashion figure templates. Overlay the drawings with semi-transparent paper and trace over the life drawing figure using a pencil or fine liner, correcting and enhancing lines as you proceed from head to toe. Drawings that are too large a scale to use as templates can be scaled down using a commercial large format photocopier, scanner or doing so manually.

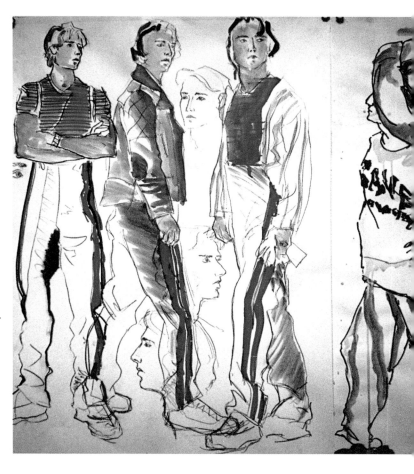

Figure 8.10 (right): Courtesy of MMU (Manchester Metropolitan University)
In this layout the artist has sketched various poses of the male model on one sheet, creating an interesting study of poses and faces

Figure 8.11 (below): Male models by Jasper Toron Nielsen
In this layout of the male figure the artist shows he has a great understanding of the human form and has created an interesting study with a strong theme

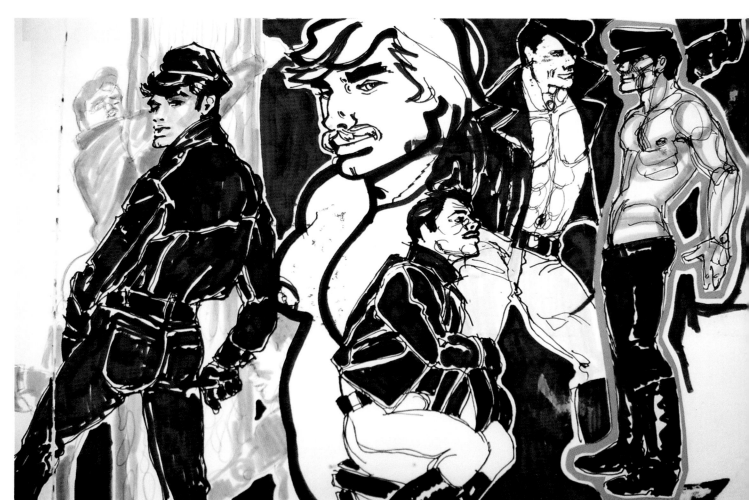

7 ▼▶

artists gallery

Take a look at the following gallery of stylised fashion artworks from illustrators and designers around the world. Note the various styles of illustration and how the artists' portray the body. Their understanding of the body is such that they are able to exaggerate certain parts of the figure or pose and make the artwork both dynamic and convincing.

Figure 8.12: Illustration by Karen Scheetz

Figure 8.13: Illustration by Rosalyn Kennedy

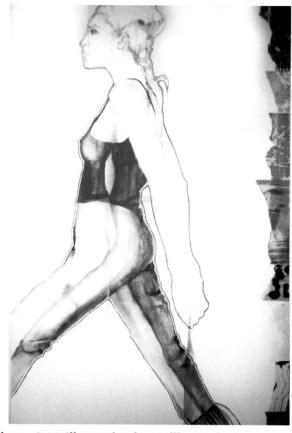

Figure 8.14: Illustration by Melika Madani

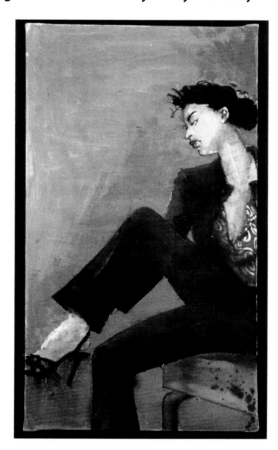

Figure 8.15: Illustration by Jacqueline Bisset

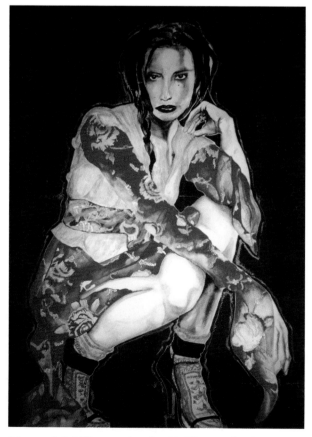

Figure 8.16: Illustration by Melika Madani

Figure 8.17: Illustration by Lynnette Cook

Figure 8.18: Illustration by Mark Risdon

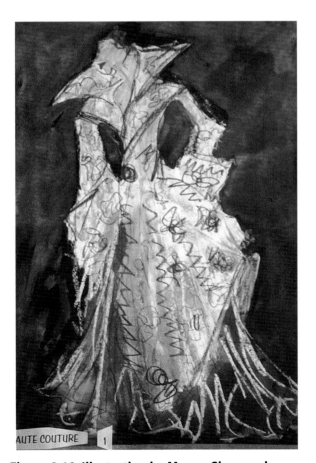

Figure 8.19: Illustration by Megan Simmonds

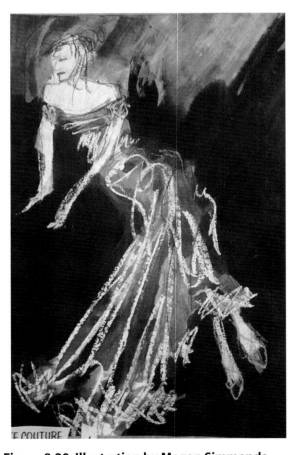

Figure 8.20: Illustration by Megan Simmonds

Figure 8.21: Illustration by Kashmir Kaur

Figure 8.22: Illustration by Veronica Frankovich

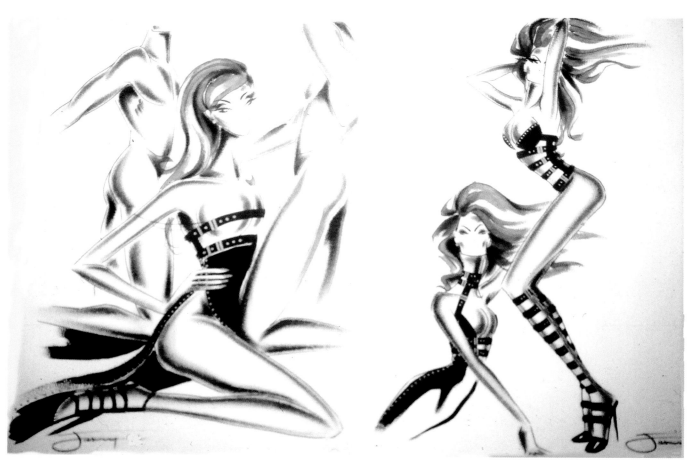

Figure 8.23: Illustration Jason Ng

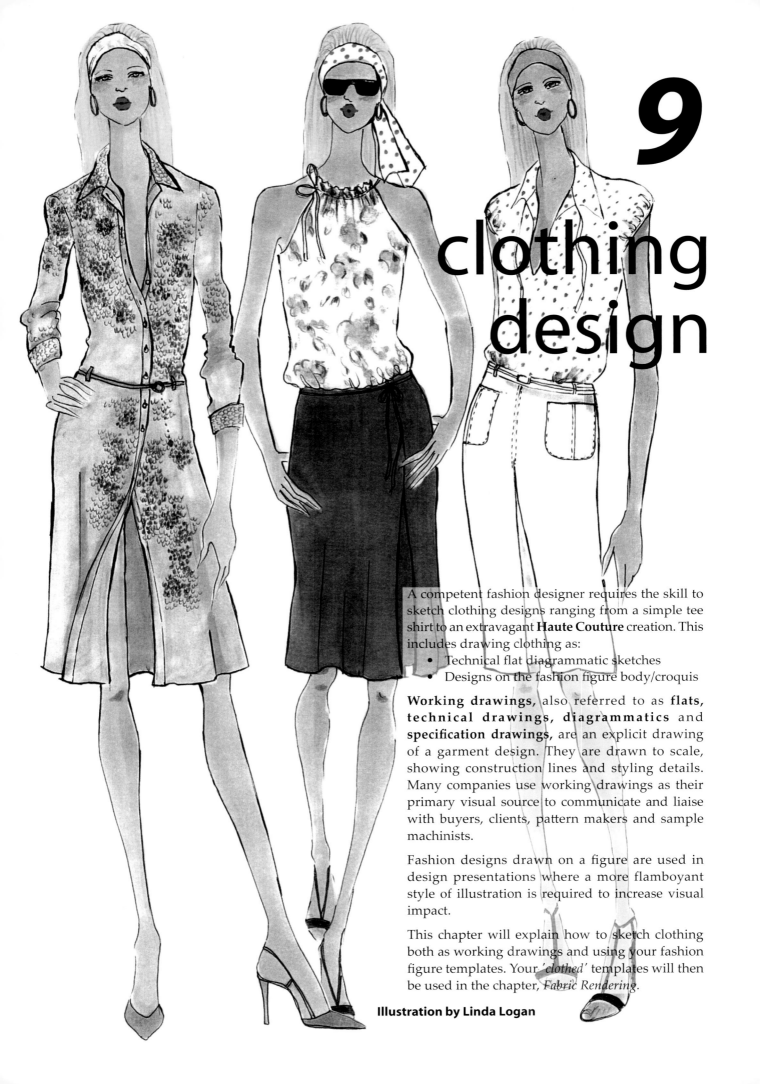

9
clothing
design

A competent fashion designer requires the skill to sketch clothing designs ranging from a simple tee shirt to an extravagant **Haute Couture** creation. This includes drawing clothing as:

- Technical flat diagrammatic sketches
- Designs on the fashion figure body/croquis

Working drawings, also referred to as **flats, technical drawings, diagrammatics** and **specification drawings,** are an explicit drawing of a garment design. They are drawn to scale, showing construction lines and styling details. Many companies use working drawings as their primary visual source to communicate and liaise with buyers, clients, pattern makers and sample machinists.

Fashion designs drawn on a figure are used in design presentations where a more flamboyant style of illustration is required to increase visual impact.

This chapter will explain how to sketch clothing both as working drawings and using your fashion figure templates. Your *'clothed'* templates will then be used in the chapter, *Fabric Rendering*.

Illustration by Linda Logan

1 ▼

clothing figure template

The **industry standard body** for flats/working drawings is front or back facing with normal body proportions **(seven to eight heads)**. Your fleshed out Template 1, from the *Fleshing Out* chapter, is ideal for front and back views, but you need to **redraw** it with the normal length legs as per the human form (Fig. 9.1). Note that the head and feet of the back view are reshaped as per example. Name this new figure, **Template 1 Basic.**

Draw the style lines on your clothing template as per Fig. 9.2. These style lines correspond to the dress form and are the fit and construction lines from which clothing patterns and garments are made. They will help you draw the correct fit, proportions and details for clothing designs.

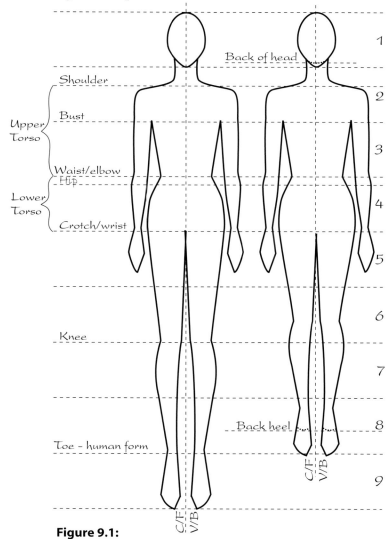

Figure 9.1:

*Redraw **Template 1** with normal leg proportions for the front and back view clothing template; **Template 1 Basic** - note the head and feet of the back view are reshaped*

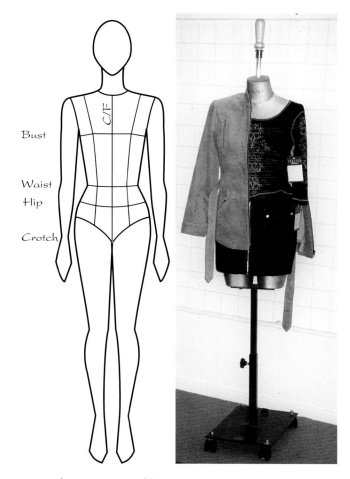

Figure 9.2 a and b:

*a. Template **1 Basic** with style lines*

b. The dress form (mannequin)

2 ▽ ▶

flats/working drawings

The following three pages of flats/working drawings demonstrate several garment bodies used in clothing design. Design changes can be made to them by altering the styling details, shape and fit lines. More examples can be found in my book *Fashion Computing - Design Techniques and CAD* and my forthcoming book *Fashion Designer - Design Techniques to Catwalk and Street*.

- Flats may be drawn freehand or computer generated using a drawing package, such as Illustrator, CorelDRAW or Freehand.
- These flats are the starting point for specification (technical) drawings for production purposes (*see books as above*).
- When drawing a garment start with the silhouette, followed by the details.

- To achieve the correct proportions start drawing from the top down.
- When drawing manually, a ruler and french curves will help you draw more accurately.
- As in the previous drawing exercises, overlay with semi transparent paper and redraw until you are happy with your sketch.

Practise drawing the following basic silhouettes and details. Use **Template 1 Basic** as your guide for achieving the correct clothing proportions. Once you have completed these working drawings, practise drawing variations using your resource files for reference.

dresses

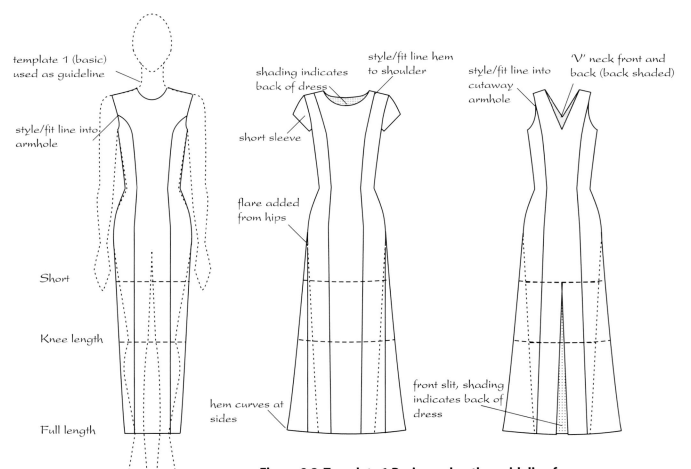

template 1 (basic) used as guideline

style/fit line into armhole

Short

Knee length

Full length

shading indicates back of dress

short sleeve

flare added from hips

hem curves at sides

style/fit line hem to shoulder

style/fit line into cutaway armhole

'V' neck front and back (back shaded)

front slit, shading indicates back of dress

Figure 9.3: Template 1 Basic used as the guideline for proportions

Dress silhouettes - basic fitted dress, in three dress lengths - short, knee and full length, showing style and fit variations

skirts and tops

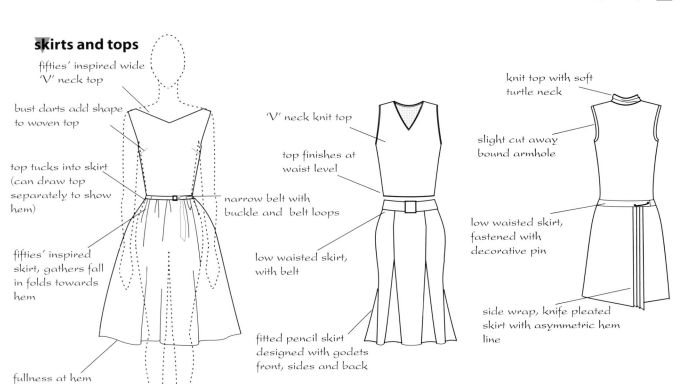

fifties' inspired wide 'V' neck top

bust darts add shape to woven top

top tucks into skirt (can draw top separately to show hem)

fifties' inspired skirt, gathers fall in folds towards hem

fullness at hem

'V' neck knit top

top finishes at waist level

narrow belt with buckle and belt loops

low waisted skirt, with belt

fitted pencil skirt designed with godets front, sides and back

knit top with soft turtle neck

slight cut away bound armhole

low waisted skirt, fastened with decorative pin

side wrap, knife pleated skirt with asymmetric hem line

Figure 9.4: Template 1 Basic used as the guideline for proportions
Skirt silhouettes with woven and knit tops showing style and fit variations

pants and shirts

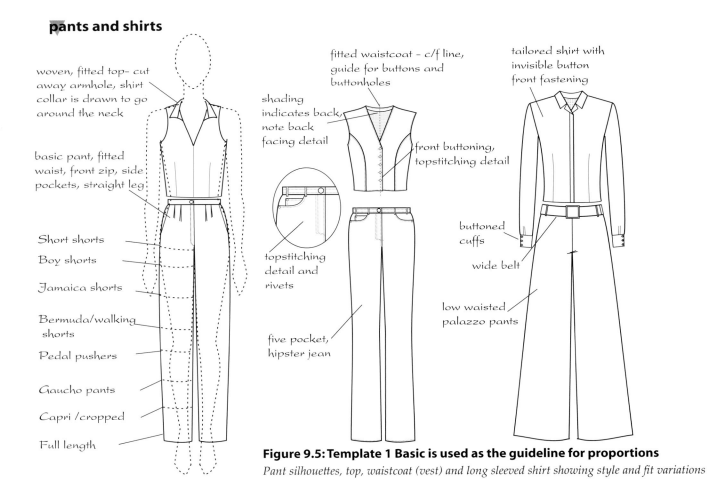

woven, fitted top- cut away armhole, shirt collar is drawn to go around the neck

basic pant, fitted waist, front zip, side pockets, straight leg

Short shorts

Boy shorts

Jamaica shorts

Bermuda/walking shorts

Pedal pushers

Gaucho pants

Capri /cropped

Full length

shading indicates back, note back facing detail

topstitching detail and rivets

five pocket, hipster jean

fitted waistcoat - c/f line, guide for buttons and buttonholes

front buttoning, topstitching detail

tailored shirt with invisible button front fastening

buttoned cuffs

wide belt

low waisted palazzo pants

Figure 9.5: Template 1 Basic is used as the guideline for proportions
Pant silhouettes, top, waistcoat (vest) and long sleeved shirt showing style and fit variations

jackets

The centre front line plays a very important part in drawing single-breasted and double-breasted jackets correctly, especially when drawing; the angle of the collar 'roll' line, the positions of the button and buttonholes, and the amount of wrap over allowed.

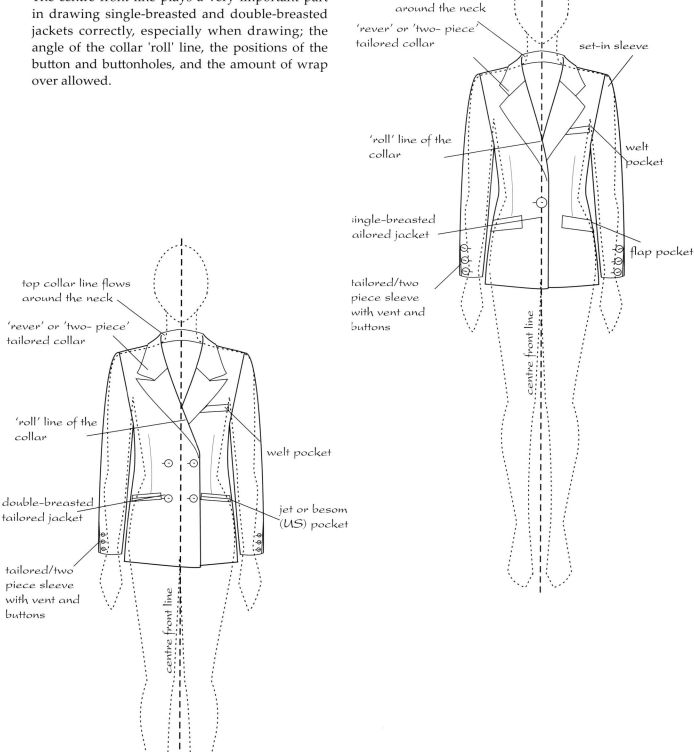

top collar line flows around the neck

'rever' or 'two- piece' tailored collar

set-in sleeve

'roll' line of the collar

welt pocket

single-breasted tailored jacket

tailored/two piece sleeve with vent and buttons

flap pocket

centre front line

top collar line flows around the neck

'rever' or 'two- piece' tailored collar

'roll' line of the collar

welt pocket

double-breasted tailored jacket

jet or besom (US) pocket

tailored/two piece sleeve with vent and buttons

centre front line

Figure 9.6: (left) and 9.7 (above): Template 1 Basic is used as the guideline for proportions

Tailored jacket silhouettes - single and double breasted showing style variations

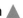

3 ▼▶

flats/working drawings gallery

Take a look at the following gallery of flats/working drawings from a number of designers (Fig. 9.8 to 9.31). Note the various styles of illustration and methods of presenting them. Depending on your design brief, this will determine to some extent the required style of drawing, the technical accuracy, and if back views are necessary.

Figure 9.8 to 9.27: Flats (working drawings) by Lynnette Cook

Hand drawn flats, drawn to scale, suitable for presentation and specification drawings for production purposes

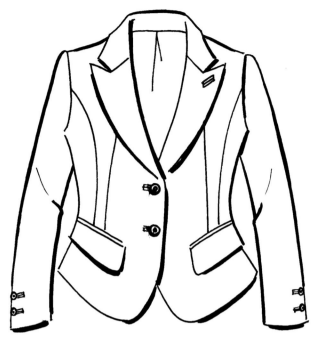

Figure 9.8: Single Breasted Jacket by Lynnette Cook
Single breasted fitted jacket with notched (tailored) collar (lapels) and flap pockets

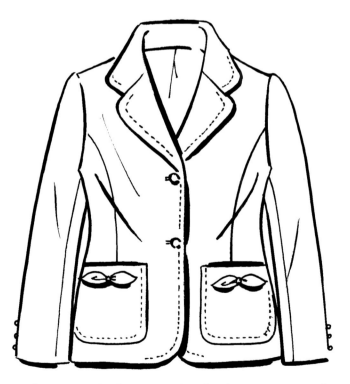

Figure 9.9: Single Breasted Jacket by Lynnette Cook
Single breasted fitted jacket with notched/rever (tailored) collar (lapels) and patch pockets with tie detail

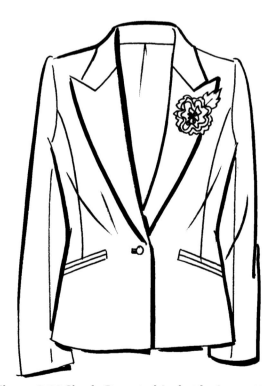

Figure 9.10 Single Breasted Jacket by Lynnette Cook
Single breasted fitted jacket with notched (tailored) collar (lapels), jet pockets and flower brooch

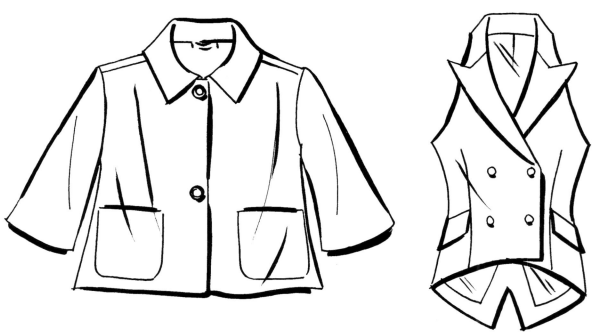

Figure 9.11: Jacket by Lynnette Cook
Short, flared jacket with large button detail and patch pockets

Figure 9.12: Waistcoat (vest) by Lynnette Cook
Fitted, double-breasted waistcoat with rever (tailored) collar, cut away armhole and flap mock pockets

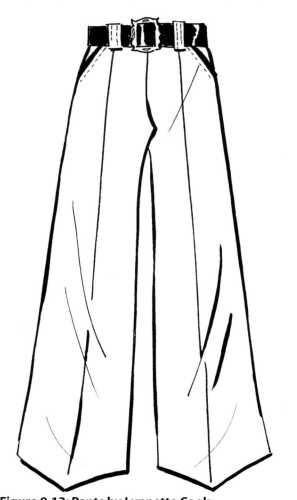

Figure 9.13: Pants by Lynnette Cook
Wide legged, waisted pants/trousers with leather belt, decorative buckle and wide belt loops

Figure 9.14: Pants by Lynnette Cook
High waisted pant/trousers with grown on waistband, stitched front seam detail, tie belt

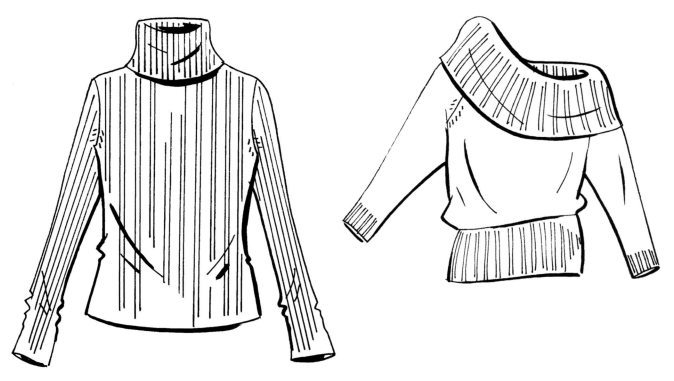

Figure 9.15: Sweater/jersey by Lynnette Cook
Rib knit roll/turtle/polo neck fitted sweater/jumper

Figure 9.16: Sweater/top by Lynnette Cook
Plain knit sweater/jumper with huge rib collar and deep rib waist/hipband and raglan armhole

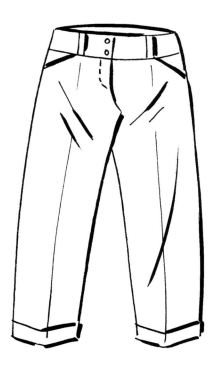

Figure 9.17 : Cropped pants by Lynnette Cook
Cropped waisted pants with side pockets, and wide belt loops

Figure 9.18: City shorts by Lynnette Cook
City, low waisted shorts with turn-ups, and front slant pockets

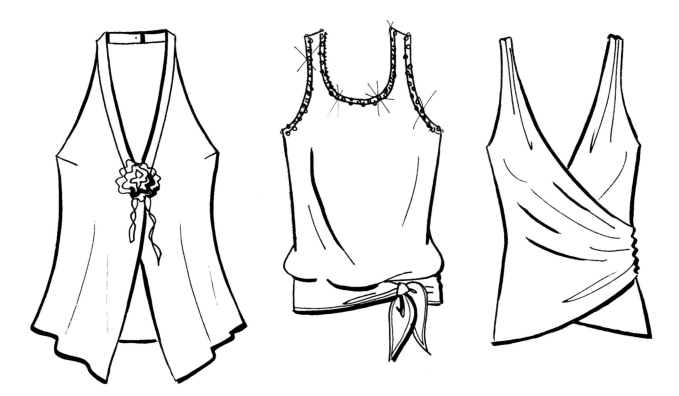

Figure 9.19 to 9.21 (left to right): Tops by Lynnette Cook
Halter neck top with centre front brooch fastening
Round neck, sleeveless top with sequin/palettes trim and tie hip band
Wrap top

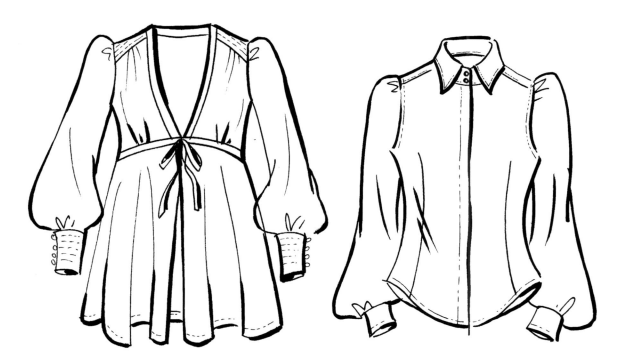

Figure 9.22: Blouse by Lynnette Cook
Empire line blouse with tie front fastening, shoulder yokes and deep cuffs with multi-stitched decorative topstitching

Figure 9.23: Blouse by Lynnette Cook
Fitted blouse with invisible front buttoning, wide puff sleeve and deep cuffs

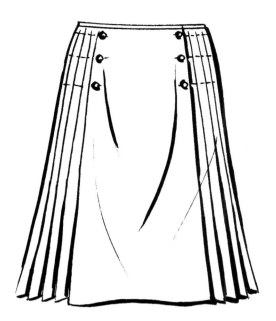

Figure 9.24: Skirt by Lynnette Cook
Knife pleated, knee-length kilt skirt with double button fastening

Figure 9.25: Skirt by Lynnette Cook
Mini ruffled rumba/salsa style skirt with rib waist/hip band

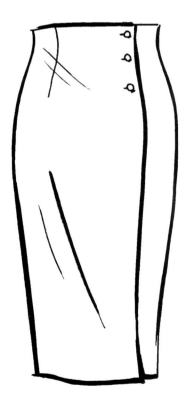

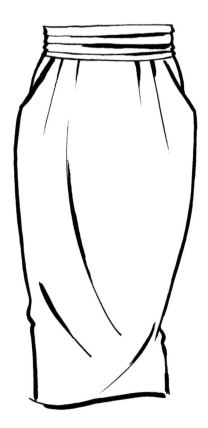

Figure 9.26: Skirt by Lynnette Cook
High waisted, below-the-knee skirt with grown-on waistband, and side front button fastening

Figure 9.27: Skirt by Lynnette Cook
'Harem' style skirt with softly tucked waistband and front slant/slash pockets

Figure 9.28: Presentation courtesy of Beales

Presentation of flats showing a casualwear collection
Fabric: denim and lycra jersey
Note the layout and the overlaid garments

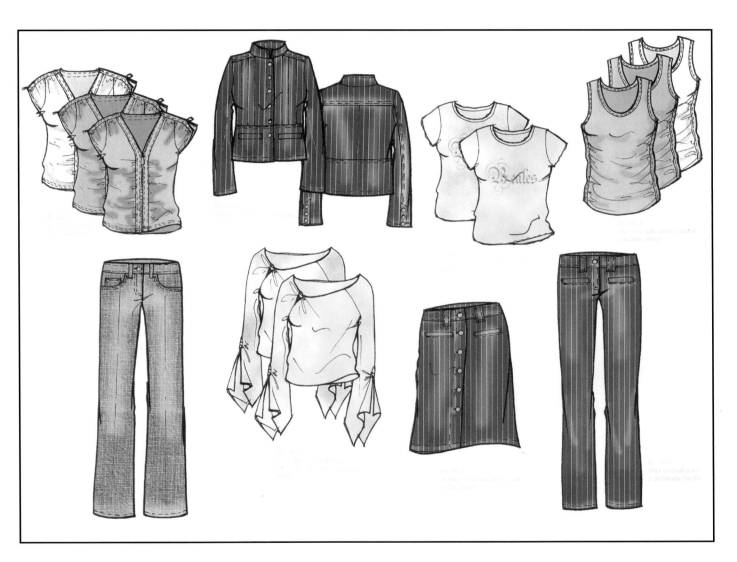

Figure 9.29: Presentation courtesy of Beales

Presentation of flats showing a casualwear collection
Fabric: denim and lycra jersey
Note the layout and the overlaid garments

Figure 9.30: Presentation by Chelsea West

Presentations of flats showing a casualwear collection
Fabric: denim and cotton lycra
Note the layout and the overlaid garments

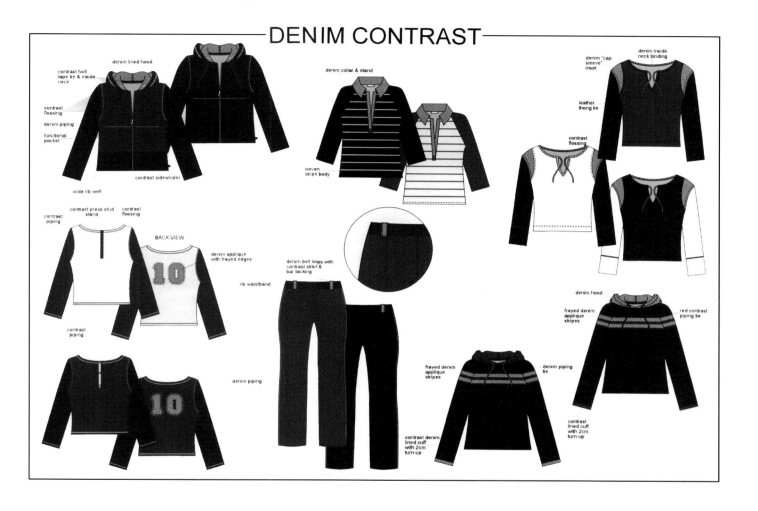

Figure 9.31: Presentation by Chelsea West

Presentations of flats showing a casualwear collection
Fabric: denim and cotton lycra
Note the layout and the overlaid garments

4 ▼▶

clothed fashion figure (figure matrix)

This section explains how to draw clothing onto our fashion figure templates 2 to 7.

When designing clothing it is can be a chicken and egg situation - which comes first, the fabric and trimmings, or garment design? In this case, as we have been developing our templates progressively through the chapters, the clothing will come first. When designing garments for a particular project you may find it is the **fabric**, a **theme** or **mood** that inspires you. From this initial concept, the clothing designs are developed as a series of rough sketches before producing a final design.

Another point to consider is that the pose should be appropriate for the style of garment so that it shows the design to its best advantage. This is usually a front view, but a back or side view may also be required.

Think of the body like a coat hanger, providing the shape on which a garment will hang and drape around it. The designs should not appear flat, like that of paper clothing on a paper doll. If the fabric in the design is soft, for example, silk, chiffon or muslin, it will drape softly and fall around the body in a fluid way. If the fabric is firm, such as a heavy cotton, denim or satin, it will hold its shape and, depending on the styling, may stand out from the body.

drawing the clothed fashion figure

- Using your figure templates from the *figure templates* chapter, copy the clothing as per Fig. 9.32 to 9.37 (templates 2 to 7). I have sketched a variety of garments to demonstrate examples of clothing design details but, if you wish, adapt these to include your own design ideas.
- Redraw using the overlay technique until you are happy with your fashion figure and styling.
- Once satisfied, using a fine liner, trace over your clothed fashion templates onto cartridge paper or your preferred art paper. Note: semi-transparent paper is best used for tracing, rough sketches and design development (see Chapter 2, *Art Kit*).
- If the paper you have chosen to use does not allow you to see the image by using the overlay technique you will have to do a graphite tracing or use a lightbox (see Chapter 2, *Art Kit*).

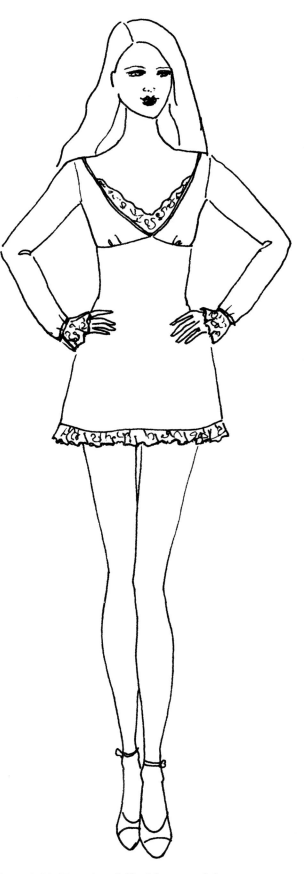

Figure 9.32: Template 2 (fashion matrix)
Mini dress fitted bra fitted line, lace edged neckline, ruffle lace cuffs and hemlines

Figure 9.33: Template 3 (fashion matrix)
High-neck Victorian styled blouse under double-breasted waistcoat/vest, worn with slim fit (cigar) pants

Figure 9.34: Template 4 (fashion matrix)
Empire style 'V' neck top with belt under bust, worn with micro mini skirt

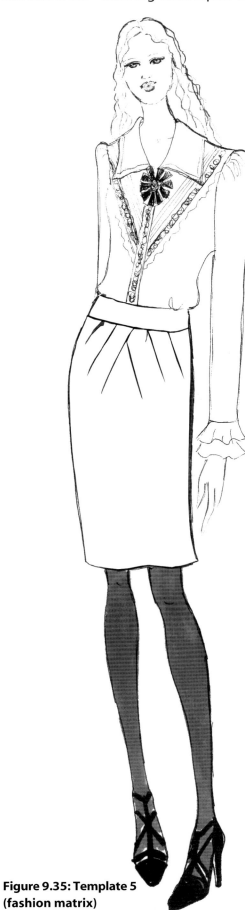

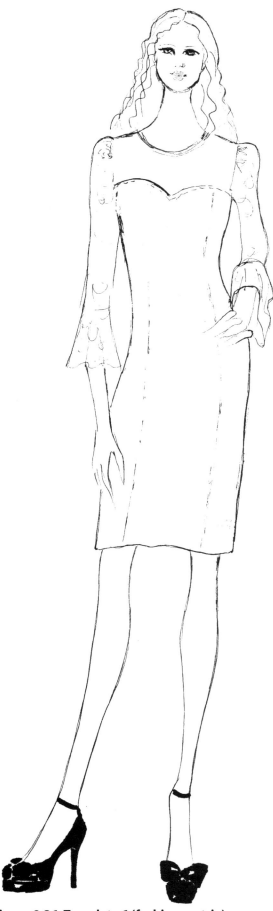

Figure 9.35: Template 5 (fashion matrix)

Shirt with pin tucked yoke and lace trim, double, bias cut cuffs; knee-length skirt with deep pleat front detailing

Figure 9.36: Template 6 (fashion matrix)

Fitted, knee length dress with lace front and back yoke and puffed sleeves

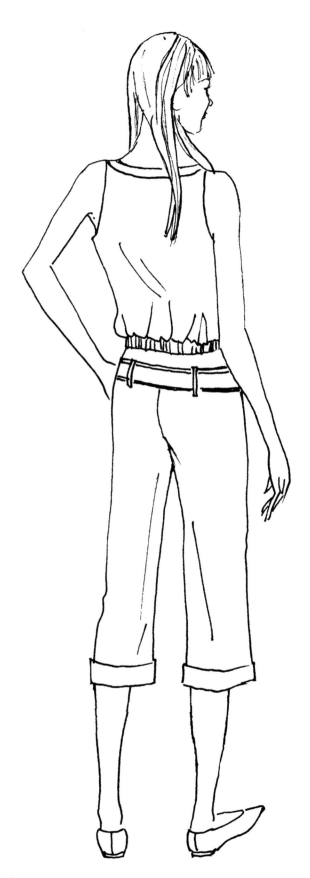

Figure 9.37: Template 7 (fashion matrix)
*Cut away armhole top with elasticated hem band, belted city
shorts and turn-up cuffs*

5 ▼▶

fashion gallery

Take a look at the following gallery of clothed fashion figures from a number of designers around the world (Fig 9.38 to 9.49). Note the various styles of illustration, the use of line, its thickness and the drawing techniques to sketch clothing - gathers, seams, pocket, collar details etc. Depending on your design brief or project, this will determine to some extent your style of work.

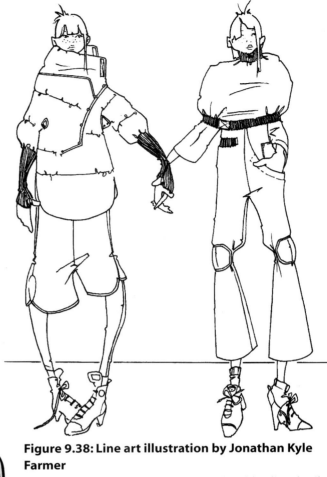

Figure 9.38: Line art illustration by Jonathan Kyle Farmer
Outfits feature padded sections, gathered and binding details and rib trims.

Figure 9.39: Illustrations by Lynnette Cook
Two casualwear sporty designs

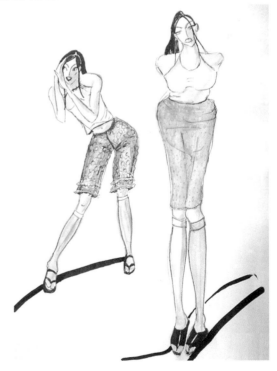

Figure 9.40: Illustration by Kristin Goodacre
Walking shorts and cotton lycra halter tops (vests)

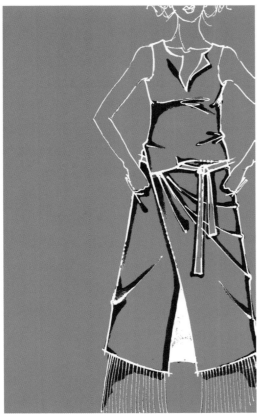

Figure 9.41: Illustration by Bindi Learmont
Top with wrap skirt with tie belt and fringed, beaded hem detail

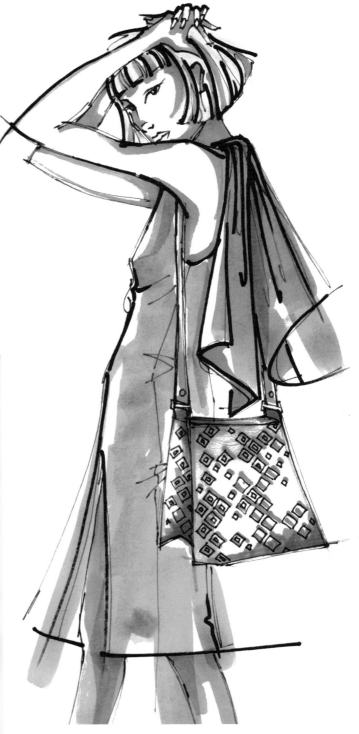

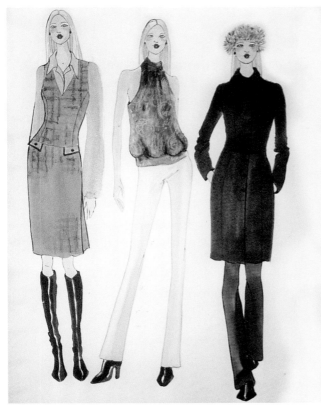

Figure 9.42: Fashion Presentation by Linda Logan
Winter mini collection of six pieces
Fabrics: wool lycra, cashmere and silk blouse weight

Figure 9.43: Illustration by Bindi Learmont
Silk chiffon and silk A-line dress; branded fabric bag

Figure 9.44: Line art illustration by Linda Jones
Model struts across the page

Figure 9.45: Illustration by Ellen Brookes
Coloured pencil illustration: sheer top worn over

concluding comments

- Drawing clothing as flat, working drawings is just as important as drawing clothing on the fashion figure - in fact some fashion companies only work with these type of drawings.
- Perfect your drawings of back views as well as front as they are often required in presentations and are always needed for production specification work.

In the next chapter we will look at fabric rendering (illustrating or representing) fabrics onto your clothed templates 2 to 7. This will give your templates a more 'finished' look and then you will be ready for the *Presentation* chapter.

Figure 9.46: Illustration by Lynnette Cook
Casualwear styling, soft rounded shoulders and funnel collar detail

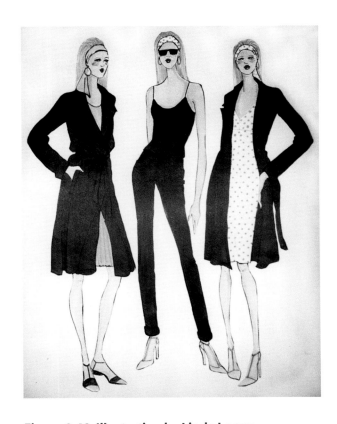

Figure 9.47: Line art illustration by Linda Jones
Halter neck, evening dress with high front slit, front and back view

Figure 9.48: Illustration by Linda Logan
Spring mini collection of six pieces
Fabrics: chameuse, silk bottom and silk blouse weight

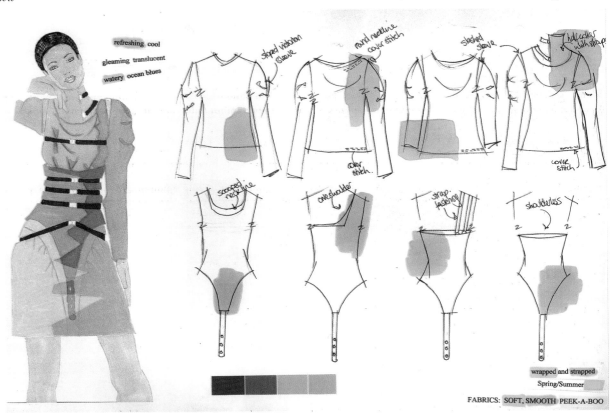

Figure 9.49: Illustration by Kashmir Kaur
Presentation of casualwear collection showing figure and flats

10
fabric rendering

Fashion is all about style and innovation, the cut of a design, the fashion colours and, of course, a vital ingredient, the fabric and trimmings. Illustrating fabrics brings another important dimension to fashion drawings making the designs *come alive.*

To achieve a professional standard of fabric illustration it is necessary to observe the way fabrics hang and drape on and around the body. A fine silk jacket for example, drapes from the shoulder whereas a leather jacket hangs more solidly; a full length gathered satin skirt will stand slightly proud of the body whereas one in voile follows the body shape. It is also important to understand what fabric qualities are suitable for particular styles of clothing. At the clothing design stage the appropriate fabric is chosen to complement the style of a garment and create the desired *look.*

Fashion designers are generally required to illustrate fabric using the simplest and quickest methods to give an overall impression of fabric type, texture, print and colour. Our fashion figures so far have been based on simplifying line and shape, and drawing fabric is no exception. In this chapter simple rendering techniques will be demonstrated both in flat swatch form and on the body, including the clothed fashion templates. Your 'rendered' templates will then be used in the next chapter, *Design Presentation.*

Illustration by Karen Scheetz

art box

- Your clothed fashion templates, 2 to 7, and art box from previous chapter
- Colouring media (your preference): Coloured markers (flesh and hair colour useful), pastels (suggest water soluble and fixative if not using water), coloured pencils (suggest water soluble), gouache, acrylics, inks, etc. and brushes
- Silver/white roller ball (use over dark colours for outline and shine effect)
- Scissors and pinking shears
- Adhesive and double-sided tape
- Putty rubber (good for pastels)
- Selection of fabric swatches - described below
- Sketchbook/folder/plastic sleeves for fabric swatches
- Portfolio/folder

1 ▼

fabrics swatches

Fabric swatches are an important component of your design data. Collect small samples of fabric to use as references for your fashion drawings and as sources of inspiration for future designs. Fabric stores, and some fabric wholesalers, will often cut small swatches from their rolls of material. An ideal size for swatches is approximately 5 x 5 cm (2 x 2 inches). Take note of the feel and handle of the fabrics on the piece, as this will help you understand their drape when you start to render them. Other sources for fabric swatches are dress makers, clothing factories and charity shops.

Consider these fabric types:
- Soft and sensual fabrics: sheer, silk, silky handle, laces, net and mesh
- Wools, tweeds, worsteds and denims
- Surface interest patterns and weaves
- Shiny and matt fabrics: satin, leather and suede effects

- Prints: stripes, plaids, checks, florals, animal prints and various other print designs
- Novelty fabrics: velvet, sequins, beading and embroidery
- Knits and stretch: cable stitch to jersey

Keep fabric swatches grouped in a **sketch book** or alongside appropriate design ideas (photo below), or:
- file in a fabric resource folder
- in small plastic bags, per fabric group
- in a 'slide holder' plastic sleeve
- attach to a card and place in a plastic sleeve (photo below)

Note relevant details such as fabric quality and fibre content, price and width, name of supplier. This information will be especially important later if you wish to purchase some of the fabric.

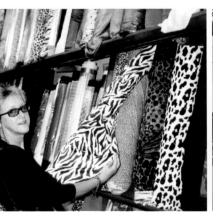

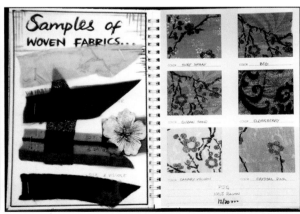

Figure 10.1: *Selecting fabrics at a New York wholesaler*
Figure 10.2: *Typical scene in New York's garment district as wholesalers deliver fabric*

Figure 10.3: *Fabric swatches and their details, courtesy of Ricki Wolman of Citron; and Priyha Vasan*

2 ▼

media and techniques

As you experiment with your art media you will find you are able to illustrate any number of fabric qualities, weaves, prints and textures skilfully and creatively.

On a separate piece of the same quality art paper you will use for your rendered figures, check:

- The media are compatible with each other, for example, paint will not adhere to wax.
- The reaction of the media on the paper, for example, too much water on cartridge paper may cause it to wrinkle (the solution is to use watercolour paper).

Marker pens and fine liners are an effective and quick method to illustrate fabric, hence many fashion companies use this medium. Markers give a slightly flat finish, but the illustration can be enhanced using mixed media; **coloured pencils, pastels, paints** etc.

- Some brands of markers bleed more than others on certain paper (using marker paper prevents bleeding) - work according to the desired amount of bleed required.
- Work in the same direction for a block of colour, keep the line wet or it will streak.
- Use several coats of colour or slightly darker tones to indicate density, shade, folds and gathers in a garment.
- A clear blender blends, lightens and softens edges.
- Make use of line thickness (markers often have different sized nibs in one pen).

Pastel pencils and sticks (water soluble):
- Vary the pressure on the pastel to make light or dark lines of different thickness.
- Build up tone by adding layers of colour.
- Smudge with fingers or use a pastel stump to soften the pastel.
- Add highlights and shine using a white or light pastel.
- Use fixative to stop the soft dusty media from spreading.

Coloured pencils (water soluble):
- Use dry or wet - apply colour pencil onto the art paper and work into it with a slightly wet brush.
- Build up layers to intensify colour.

Acrylic:
- Use a little water for an opaque finish, or with more water as a water colour effect.
- Quality acrylics can be air brushed.

Gouache:
- Similar to watercolour but is mixed with white pigment and extender to make it opaque.
- Use a little water for an opaque finish, or with more water as a water colour effect.
- Dries to a slightly different colour, so test before applying to the artwork.

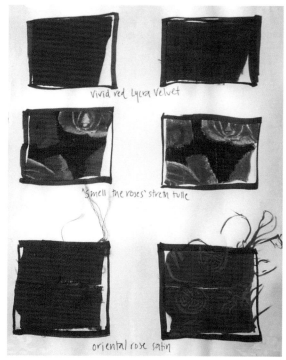

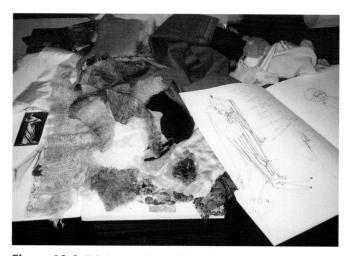

Figure 10.4: *Fabric swatches and sketchbook courtesy Edinburgh College of Art*

Figure 10.5: *Fabric Rendering (fabric swatch left, rendering right) by Kristen Goodacre*
Media - mixed media of watercolour, coloured pencil, wax crayon, pastels and fine liners

Watercolour:
- **Wet on dry -** each layer is allowed to dry before another is added.
- **Wet on wet -** colours applied over each other while still wet.
- **Build up** to a denser colour, the darkest applied last.

Art media tips:
- Dark tones appear further away than light tones e.g. white will stand out, use it to create shine.
- Rather than always using white paper, experiment with coloured and black paper for different effects.

Figure 10.6: Illustration by Joseph Kim
Media - fine liner and brush felt markers; note the use of light and shade to create a 3d impression of the fabric/garment

3 ▼
fabric rendering/illustration

In this next section, illustrate the fabric examples both as fabric swatches and by rendering your clothed fashion templates, Fig. 10.7 to 10.12.

The fabrics I have selected for the clothed figures range from all-over lace, a pinstripe medium weight wool, soft cotton shirting weight, medium weight washed denim, crepe with a self pattern rose, and suede. By using suitable fabrics for the clothing styles, I have paired up the templates, making three groups.

Interpret your drawings in your own style and use my renderings as examples.

Begin by rendering small swatches of the fabrics to:
- Test out the media.
- Capture the overall design of the fabric.
- Reduce the scale of pattern. (Tip: observe the fabric from a distance - it will appear less detailed and easier to interpret.)

Once satisfied with the fabric representation, copy onto the clothed fashion templates. (As you render the clothing, you will find you naturally scale the fabric design to suit the scale of illustration.)

Figures 10.7 to 10.12, Templates 2 to 7: I have used marker pens and fine liners for all fabrics, but use another media if you want to achieve a different effect. Select your own colours rather than copying in black and white as presented here.

Sequence for rendering the templates:
- Add flesh colour to your figures; if you wish, work back into the flesh to indicate darker areas of shade which helps give a 3D effect.
- When applying colour to the clothing, work over the whole drawing each time finishing with the finer details.
- You may leave some areas free of colour or pattern by gradually fading to nothing.
- Prints may be drawn unbroken, from top to bottom, or broken up at folds and crease lines e.g. where the arm bends, folds in fabrics.
- Add colour to the hair, lips and shoes.
- Finally, overdraw and thicken lines, if you wish, to enhance and define the overall look.

Note: The templates have been grouped to complement each other for design, fabrication and layout: Template 2 and 3, Template 5 and 6, Template 4 and 7.

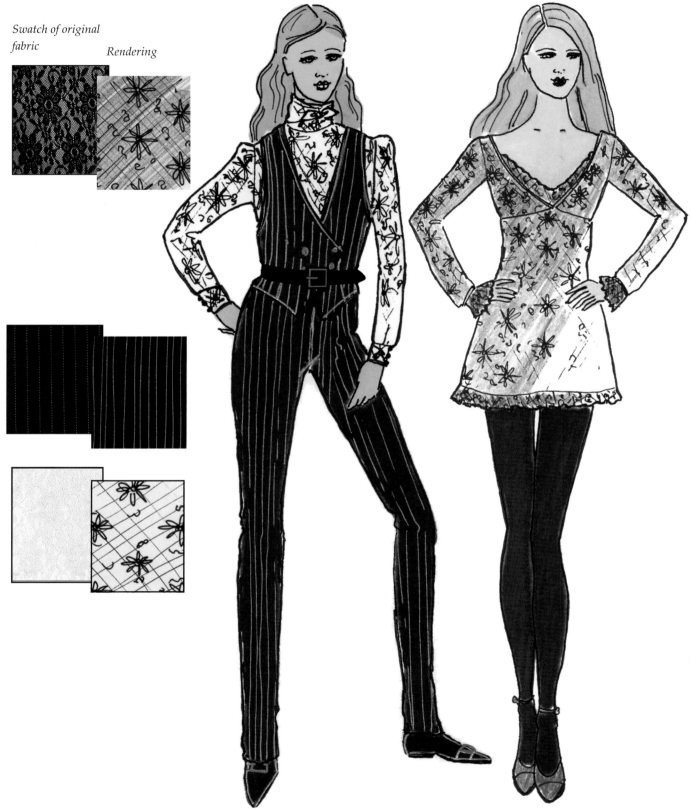

Swatch of original fabric *Rendering*

Figure 10.7: Template 3 (fashion matrix)
White cotton lace shirt: Fine liner used to draw lace pattern
Black pinstripe wool waistcoat (vest) and pants: Rendering sequence - black marker for the background, silver rollerball for the stripe and to highlight seam details, buttons etc.

Figure 10.8: Template 2 (fashion matrix)
Black lace mini dress: Rendering sequence - all-over lace and edge lace (neckline, cuffs and hem ruffle), sketch the predominant floral pattern of the lace with fine liner, then sketch criss cross lines to achieve the lacey/mesh background, a graphite pencil is used to create a shade of dark gray to indicate the black lace (a gray marker may also be used)

Swatch of original fabric

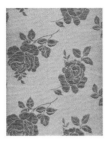

Swatch for dress

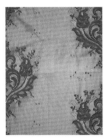

Swatch for dress sleeves and yoke

Figure 10.9 Template 5 (fashion matrix)

White voile shirt: *No media necessary as the white paper is adequate*

Black crepe skirt: *Render using a charcoal and a black marker*

Figure 10:10 Template 6 (fashion matrix)

Dress (body) in rose pattern crepe; sleeves and yoke in rose pattern lace: *Rendering sequence - use colour pencils for the main colour of the dress and a lighter shade for lace yoke and sleeves; for the rose pattern use a fine marker in deeper shades*

Note: *These illustrations have been sketched using a lighter line and so create a softer look*

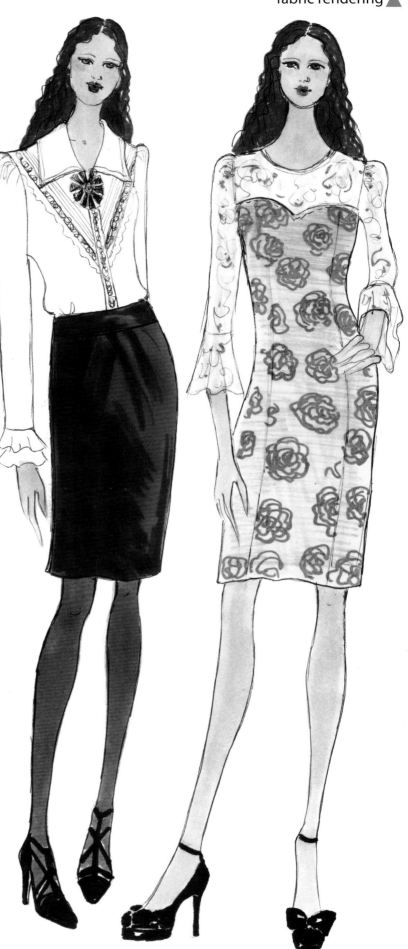

Swatch of original fabric *Rendering*

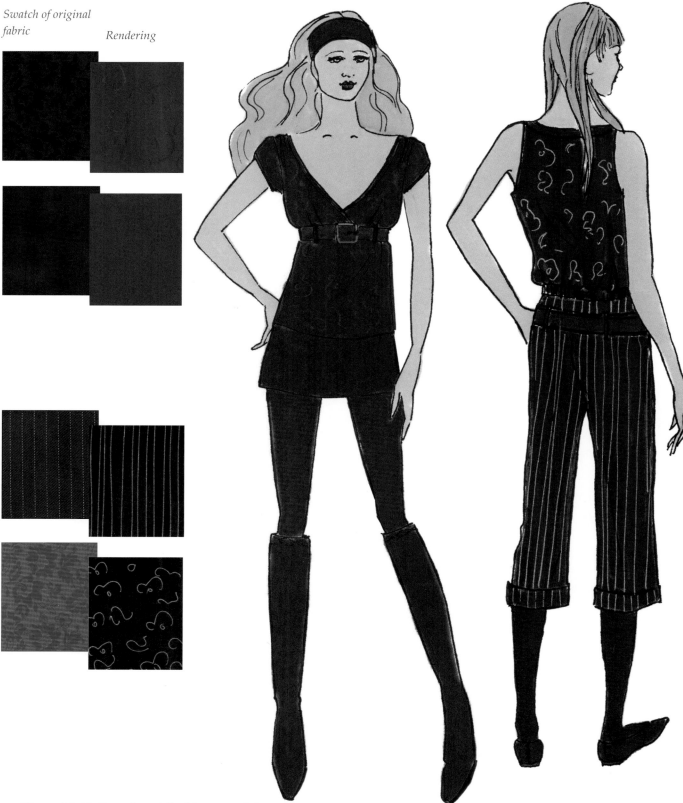

Figure 10.11: Template 4 (fashion matrix)
Rose crepe top: Rendering sequence - select appropriate colour for top, use a graphite pencil to draw the self rose pattern
Suede mini skirt: Select appropriate colour for skirt

Figure 10.12: Template 7 (fashion matrix)
Rose crepe top: Rendering sequence - select appropriate colour for top, use a graphite pencil to draw the self rose pattern
Black pinstripe wool pants: Rendering sequence - black marker for the background, silver rollerball for the stripe and to highlight seam details, etc.

4 ▼

designers/illustrators gallery

The following artworks show fabric and clothing techniques by various designers and illustrators. Note:

- The fabrics used for the clothing.
- The media and techniques used to render the fabric.
- The poses used, how the figures are balanced, the angles of the shoulders and hips.

- The style of drawing, the method of drawing hands, faces, shoes and the overall look of the illustration.
- Some of the artworks have been presented on a board with figure, flats and fabrics. This will be covered in the next chapter on *Design Presentation*.

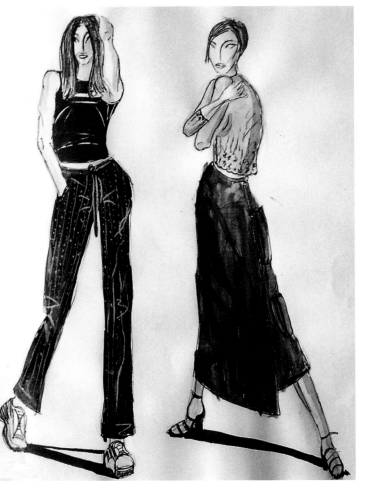

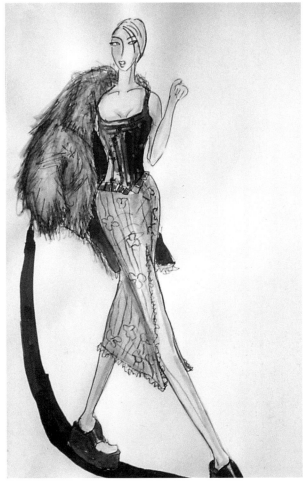

Figure 10.13a and b: Illustrations by Kristin Goodacre
Fabrics: Crinkled georgette, printed tulle, printed satin, dobby effect tweed, printed georgette and ultra long fur fabric

Media: *Mixed media of watercolour, coloured pencil, wax crayon, pastels and fine liners*
Note: *Use of shading to indicate movement and 3D shadow effect anchoring the figures to the page*

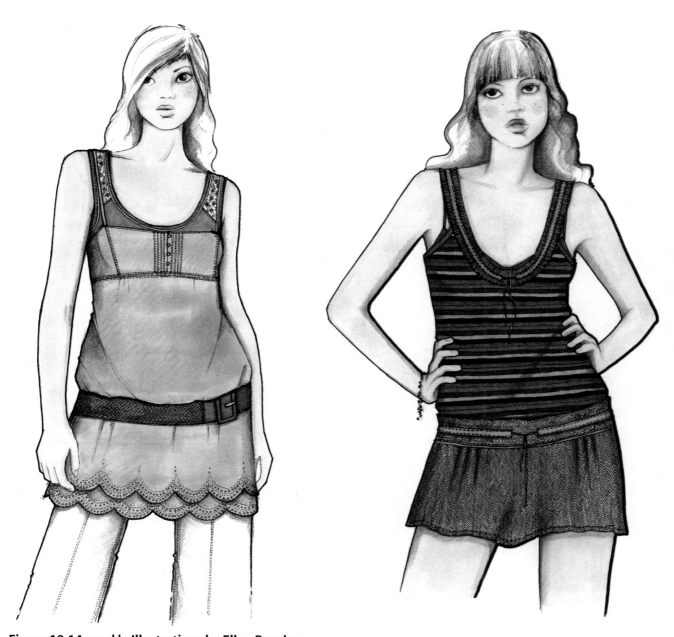

Figure 10.14a and b: Illustrations by Ellen Brookes

Fabrics include: Top - chameuse with eyelet embroidered edging, lace and leather,
Tank top - striped machine knit, skirt - herringbone wool
Media: mixed media coloured pencil, graphite pencil, fine liners, markers

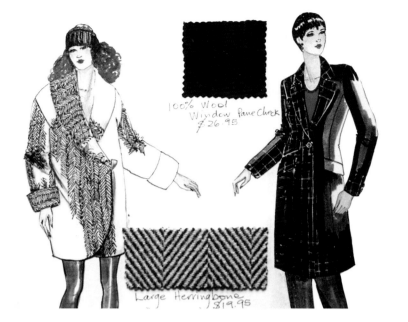

100% Wool
Window Pane Check
$26.95

Large Herringbone
$19.95

Figure 10.15 a, b and c: Illustrations by Linda Logan

Fabrics include:

a. Coats (top left) - *herringbone wool and window pane check wool (open check with plain centres)*

a. Shirts and tops (middle left) - *striped chameuse, silk floral print and plaid wool check*

c. Sleepwear/baby dolls (below left) - *silk chiffon with finely corded lace trim, and swiss cotton voile with cotton broderie anglaise trim*

Media: *Markers, coloured pencil and fine liners*

Note: *Areas where fabric fades off to nothing and the transparent effect on the 'baby dolls' by using marker and coloured pencil*

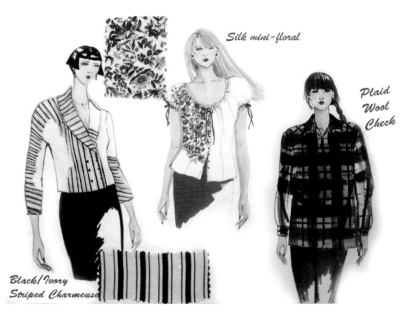

Silk mini-floral

Plaid
Wool
Check

Black/Ivory
Striped Charmeuse

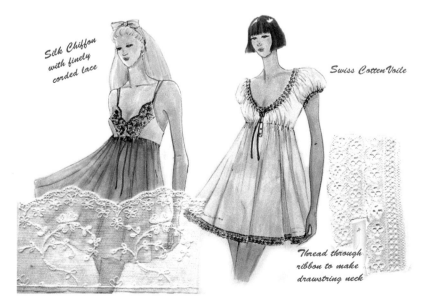

Silk Chiffon
with finely
corded lace

Swiss Cotton Voile

Thread through
ribbon to make
drawstring neck

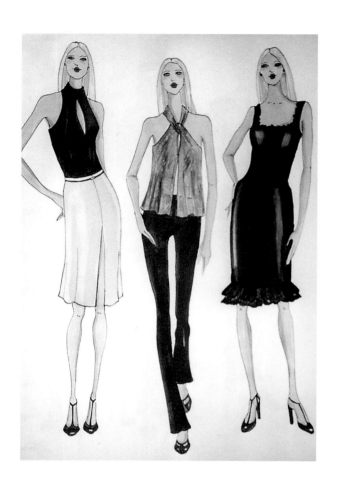

Figure 10.16a, b and c: Illustrations by Linda Logan

Fabrics include:

a. 'Cocktail Silkies' (top right) - halter neck satin tops, silk georgette skirt, silk/lycra pant, silk dress with ruffled hem

b. 'Classic Winter' (below left) - tailored tweed coat; 'Burberry' check cashmere bomber jacket; cashmere flared pants; wrap silk shirt

c. 'Classic Winter' (below right) - tailored wool coat over 'Burberry' check fine wool skirt; silk jersey knit top, lycra wool pants; 'Burberry' check double-breasted coat over silk wool skirt

Media: Markers, coloured pencil, fine liners and gold roller ball for jewellery

Note: The use of the media to display texture, print and shading; and the elegant figures and poses which perfectly display the sophisticated styling

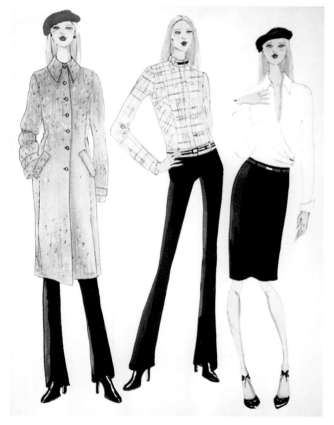

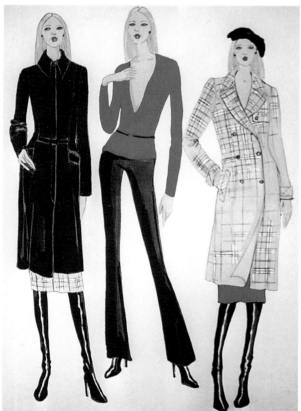

Figure 10.17 (right): Courtesy of the Fashion Department, the Hong Kong Institute

Fabrics include: Mink fur jacket in light and dark colourways, chameuse pencil skirt

Media: Coloured pencils used both wet and dry

Note: The wash and sweeping strokes of the brush which have been used to create depth and softness of the fur and chameuse on the paper

Figure 10.18a and b: Courtesy of the Fashion Department, the Hong Kong Institute

Fabrics include: a. (below left) - dress in silk chiffon with silk lined bodice

b. (below right) - blouse in silk chiffon; sarong in silk georgette

Media: Markers and fine liners

Note: The body is drawn using a fainter line giving a transparent effect; the shaded techniques; the ruched trim detail on the garments and the corresponding swatch as an example

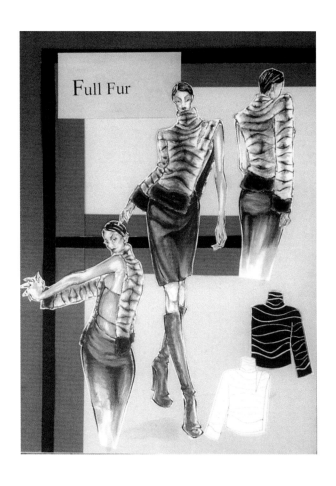

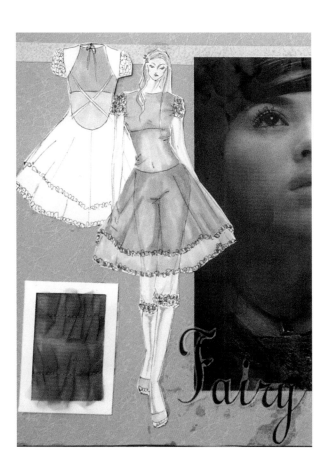

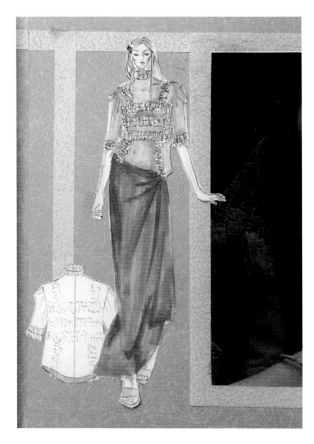

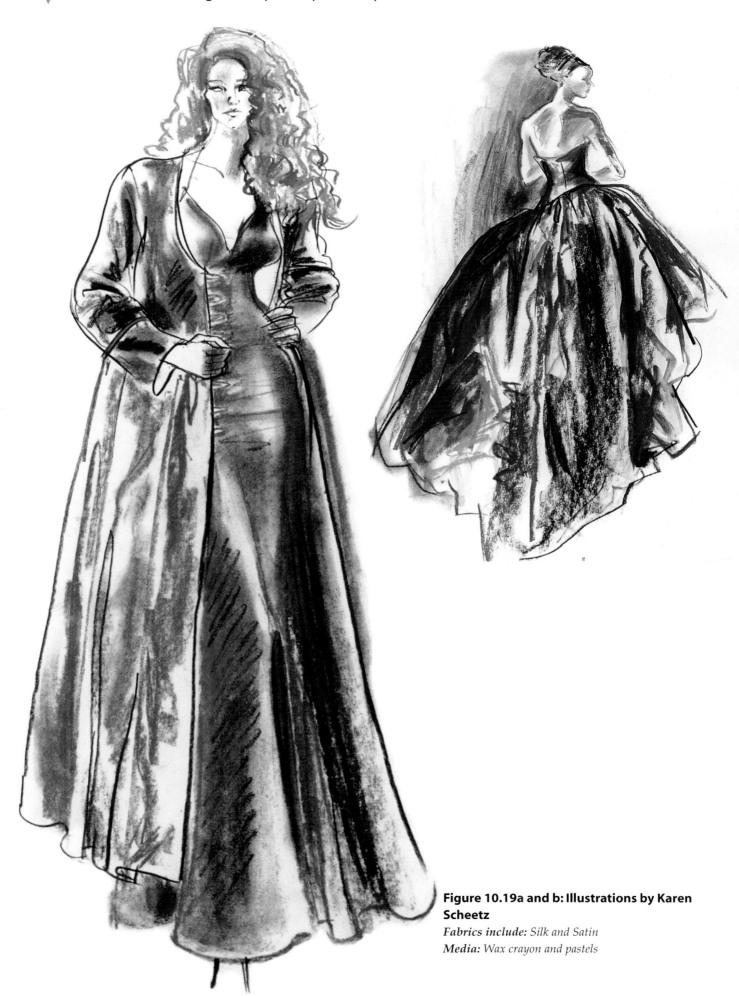

**Figure 10.19a and b: Illustrations by Karen
Scheetz**
Fabrics include: Silk and Satin
Media: Wax crayon and pastels

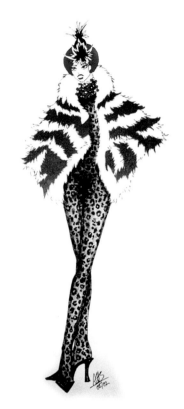

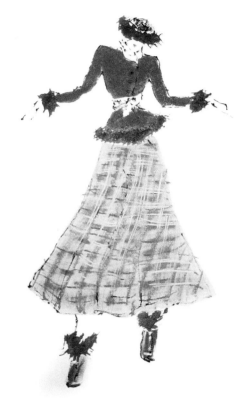

Figure 10.20: Illustration by Aase Storeheier
Fabrics include: Fur fabric jacket and animal print lycra catsuit
Media: Gouache, markers and fine liners

Figure 10.21: Illustration by Linda Jones
Fabrics include: Fur fabric and wool jacket; wool tweed skirt
Media: Pastel and brush felt markers

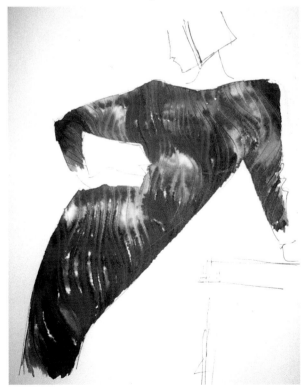

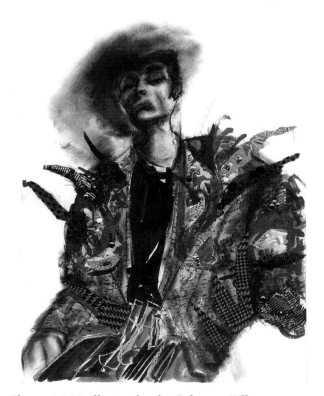

Figure 10.22: Illustration by Linda Jones
Fabrics include: Silk dress with dramatic watercolour print
Media: Brush felt markers, water and fine liner

Figure 10.23: Illustration by Salmone Wilson
Fabrics include: tweeds, dramatic prints, sequins
Media: Pastels and charcoal

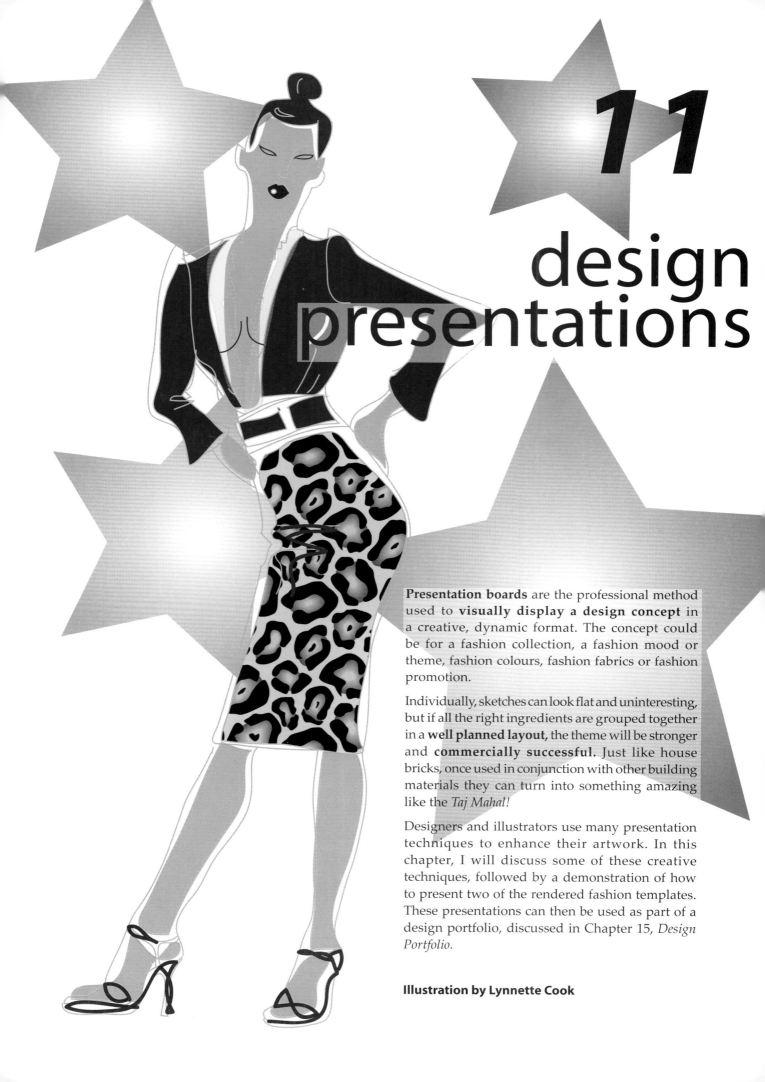

11

design presentations

Presentation boards are the professional method used to **visually display a design concept** in a creative, dynamic format. The concept could be for a fashion collection, a fashion mood or theme, fashion colours, fashion fabrics or fashion promotion.

Individually, sketches can look flat and uninteresting, but if all the right ingredients are grouped together in a **well planned layout,** the theme will be stronger and **commercially successful.** Just like house bricks, once used in conjunction with other building materials they can turn into something amazing like the *Taj Mahal!*

Designers and illustrators use many presentation techniques to enhance their artwork. In this chapter, I will discuss some of these creative techniques, followed by a demonstration of how to present two of the rendered fashion templates. These presentations can then be used as part of a design portfolio, discussed in Chapter 15, *Design Portfolio.*

Illustration by Lynnette Cook

art box

- Your rendered fashion templates 2 to 7, and art box from clothing chapter, plus working drawings
- Selection of fabric swatches - described below
- A3 (14x17 inch) or A2 (18x24 inch) light weight coloured card (suggest slightly heavier than your art paper to use as a background for your presentation layout)
- Knife/scalpel for cutting card
 Optional Extras:
- Collage items: string, tin foil, clear wrap, decorative giftwrap, glitter, feathers, beads etc.
- Lettering - computer generated or transfer lettering
- Velcro dots

1 ▼

planning a presentation

It is important to think through your presentation to ensure it is successful and dynamic. Initially consider the purpose and objective of the presentation. It may be for a fashion prediction board or forecasting board displaying directional looks and trends. It could also be for a fashion design board, a promotional drawing, an advertisement for a magazine, newspaper or television. Depending on the design brief, the target market, and the purpose of the presentation, a typical design presentation may include some or all of the following ingredients:

- The designs illustrated on the fashion figure and/or as detailed working drawings.
- Fabric swatches (all the fabrics used in the designs).
- Colour story (palette) - all the colours used for the design and colour choices if required.
- Trims used.
- Photographic images.

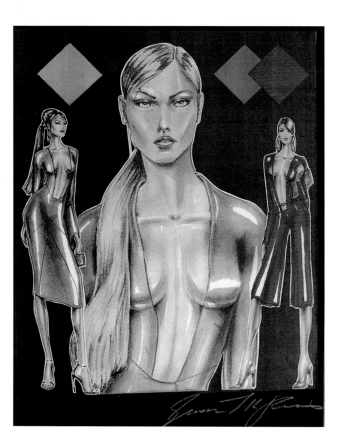

Figure 11.1: Presentation by Jevon Ruis
Fashion Design Presentation displaying perfectly the design of the garments, fabric and colourways. A half figure dominates the presentation, and the two smaller figures add balance

2 ▼▶

presentation techniques

- **Theme:** The presentation should have a strong theme to capture the mood, and a short title of typically three words. The theme may be determined by the fabrics, *Neutral Organzas;* the season, *Winter Wovens;* or the gimmick of the merchandise, *Pop Culture* (Fig. 11.2.), *Emperor's New Clothes, Gothic Rock, Metamorphosis.* If possible avoid using year identification as this dates the work immediately.

- **Pose:** Choose the appropriate pose for the particular look you wish to portray e.g. a sophisticated pose for a classic mood, or a fun pose for a funky look (Fig. 11.3. and 11.4).

- **Crop figures:** Will the figures all be full length? One enlarged, cropped figure in the foreground with a group of smaller full length figures in the background can work well. Only crop, if the lower part of the figure does not have important design detail (Fig. 11.2).

Figure 11.2 : Presentation by Ellen Brookes

Cropped figure - note the print on the top is carried through to become the image for the background, hence a strong 'Pop Culture' theme is produced

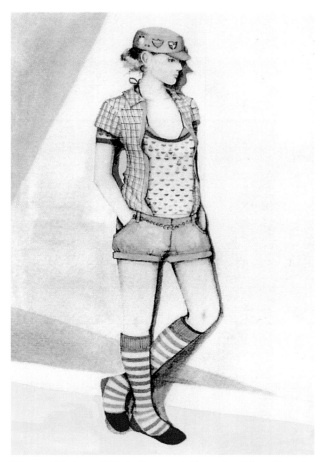

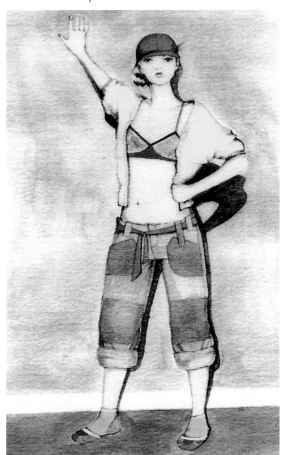

Figure 11.3 and 11.4 : Presentations by Ellen Brookes

These casual poses enhance the casual wear designs creating a soft relaxed mood

Figure 11.5: Presentation by Ellen Brookes

*Two figures are used in this presentation. The relaxed poses enhance
the softness and comfort of the casual wear designs*

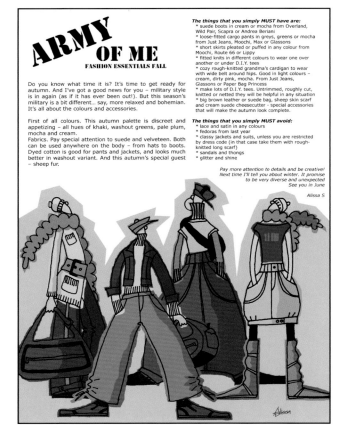

ARMY
OF ME
FASHION ESSENTIALS FALL.

Do you know what time it is? It's time to get ready for autumn. And I've got a good news for you – military style is in again (as if it has ever been out!). But this season's military is a bit different... say, more relaxed and bohemian. It's all about the colours and accessories.

First of all colours. This autumn palette is discreet and appetizing – all hues of khaki, washout greens, pale plum, mocha and cream.
Fabrics. Pay special attention to suede and velveteen. Both can be used anywhere on the body – from hats to boots. Dyed cotton is good for pants and jackets, and looks much better in washout variant. And this autumn's special guest – sheep fur.

The things that you simply MUST have are:
* suede boots in cream or mocha from Overland, Wild Pair, Scarpa or Andrea Beriani
* loose-fitted cargo pants in greys, greens or mocha from Just Jeans, Moochi, Max or Glassons
* short skirts pleated or puffed in any colour from Moochi, Route 66 or Lippy
* fitted knits in different colours to wear one over another or under D.I.Y. tees
* cozy rough-knitted grandma's cardigan to wear with wide belt around hips. Good in light colours – cream, dirty pink, mocha. From Just Jeans, Glassons or Paper Bag Princess
* make lots of D.I.Y. tees. Untrimmed, roughly cut, knitted or netted they will be helpful in any situation
* big brown leather or suede bag, sheep skin scarf and cream suede cheesecutter - special accessories that will make the autumn look complete.

The things that you simply MUST avoid:
* lace and satin in any colours
* fedoras from last year
* classy jackets and suits, unless you are restricted by dress code (in that case take them with rough-knitted long scarf)
* sandals and thongs
* glitter and shine

Pay more attention to details and be creative! Next time I'll tell you about winter. It promise to be very diverse and unexpected
See you in June

Alissa S

- **Number of figures:** The presentation may require a number of figures to illustrate the designs (Fig. 11.1, 11.5 - 11.8, 11.12 and 11.16). The figures do not all have to be the same size - varying the scale can create greater visual impact. For example, one large scale figure in the foreground can be dynamic (Fig. 11.1 and 11.16).
- **Anchor the sketch:** To prevent a figure looking like it is floating on a page, a shadow effect can be used to anchor the figure to the paper (Fig. 11.5 and 11.6).
- **Text:** The style of text should match the mood of the presentation. For example, if the theme is **powerful,** the text should follow suit (Fig. 11.6). Handwriting is acceptable if it is legible

Figure 11.6 (left): By Alissa Stytsenko-Berdnik
Four figures present this concise small collection
The figures are anchored to the presentation by the shadow that surrounds them - edited in Photoshop
The text describes the collection and design theme

Figure 11.7 (below left): Courtesy of IVE, Hong Kong
Collage handbag design presentation has clean, sharp lines reflecting the feel of leather and the styling

Figure 11.8 (below): Courtesy of IVE, Hong Kong
A small amount of basic text is all that is needed for this 'Fur Competition' presentation - note background computer generated imagery picks up the fabric design

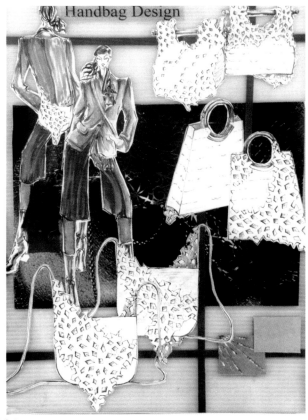

Handbag Design

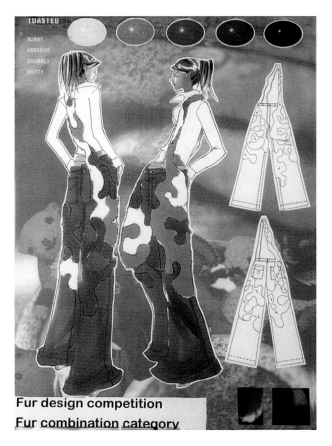

Fur design competition
Fur combination category

and suits the presentation. A more professional approach may be to use computerised or transfer lettering.

- **Descriptions:** The clothing designs, fabrics and colours may need brief descriptions (Fig. 11.6).
- **Collage:** Collage gives a 3D dynamic impact to your presentation - use anything from photographs, computer generated images, magazine clippings, coloured tissue paper, clear film, foil, feathers, string, sand etc., to capture the spirit and theme, and to enhance your presentation (Fig.11.9 - 11.11).
- **Fabric:** Prepare swatches to suit the presentation format by using any of these techniques:

Figure 11.9 (right): Presentation by Alexis Mason
Magazine clippings and fabric have been used to create this Burberry Theme

Figure 11.10 (below): By Alissa Stytsenko-Berdnik
The line drawing was scanned and edited in Photoshop to create this presentation

Figure 11.11 (below right): Courtesy of MMU
Various fabrics have been used to create these handbag designs

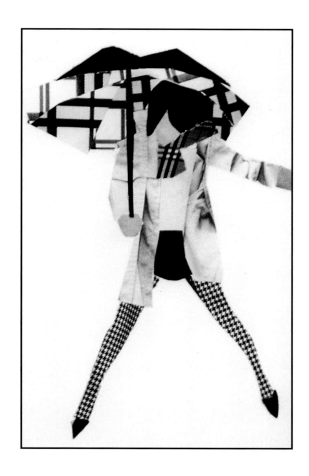

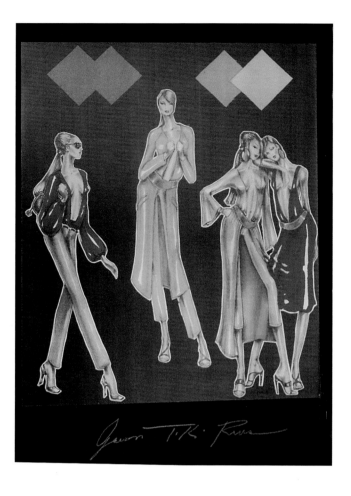

- Trim the fabric swatches using double-sided tape to prevent edges fraying and adhere to the paper (Fig. 11.1, 11.5, 11.11 and 11.15).
- Cut with pinking shears - this cuts a zigzag edge and stops the edges fraying.
- Scrunch in little bundles using double-sided tape.

If you are presenting a **casual knitwear** board for example, using a handmade paper for the background, with a torn paper effect, can give the rustic look you may require (Fig. 11.14). In contrast, if the theme is **clean**, cut out leather handbags, then sharp, graphic shapes and images would be more suitable (Fig. 11.7).

Figure 11.12 (left): Presentation by Jevon Ruis
The beautiful sexy appeal of the poses in this group of figures enhances the sexuality of the designs; note the technique used to add shine and slinkiness to the garments

Figure 11.13 (below left): By Alex Ravenhall
The newspaper background emphasises this strong and funky pose and design

Figure 11.14 (below): By Megan Simmonds
The cut out figure and magazine image, both with white borders, complement the soft collage effects; knitted samples and rolls of wool indicate the fabric and colour story

© Fashion Artist - Sandra Burke

- **Border:** Just as a picture is enhanced in a frame, so a design presentation can be enhanced when surrounded by a border (Fig. 11.1 and 11.12).
- **Flat mount**: Use light weight, complementary coloured card or board (light weight card is ideal for portfolios as it is more portable when it comes to weight). Boards are used more for display purposes where weight is not an issue.
- **Portrait and landscape layout:** For portfolio presentation, portrait is the preferred layout as it relates directly to the standing figure. Some poses call for a landscape layout, for example, it is often used for men's and children's presentations, and when there are more than two images, but there are no strict rules (Fig. 11.16).

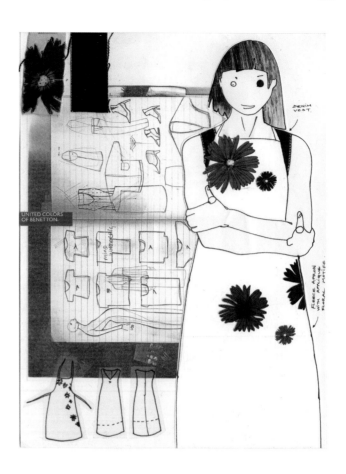

Figure 11.15: (right) By Jonathan Kyle Farmer
This design presentation is both hand drawn and computer generated
Note the cropped figure in the foreground, flats of the design, fabric swatches, and pencil sketches which create an interesting background

Figure 11.16 (below): By Jonathan Kyle Farmer
Design Presentation for Michael Kors
Figures of varying sizes display the collection perfectly; the business theme is enhance by a line drawing of the city

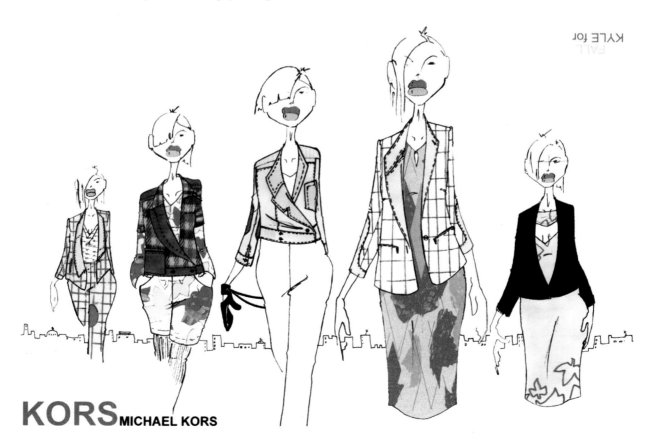

KORS MICHAEL KORS

3.1 ▼▶
presenting the fashion figures

*Template 5 and 6
(figure matrix)*

*Template 4 and 7
(figure matrix)*

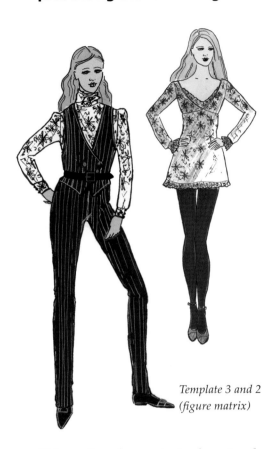

*Template 3 and 2
(figure matrix)*

This section demonstrates how to plan and make a design presentation using two of the rendered fashion figure templates from the figure matrix.

Planning: The six rendered fashion illustrations above, display the clothes perfectly and three very strong looks and themes are coming through: The *Pinstripe and lace fabric Dandy* (templates 2 and 3); the *Denim and cotton ruffles Dandy/Rock* (templates 5 and 6); and the *60s rose crepe and pinstripe fabric* (templates 4 and 7).

For this fashion design presentation example, we will take templates 2 and 3. They have a strong theme of Dandyism, the 80s Romantics revival and Paris - the title for the presentation will be *Paris Romantics.*

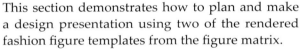

Drawing exercise: Follow the presentation method, sections 3.2 to 3.5, and then make presentations of all three themes yourself. Use the following techniques and ideas, including those from the presentations by other artists as discussed in the previous section. By presenting all three themes you will have some good pieces of finished work to display in your design portfolio.

3.2 ▼
resizing the figures

The size of a figure for a presentation is usually decided before redrawing and rendering by reading through the design brief and planning accordingly. Obviously this is not possible with the progressive method of learning in this book.

As I now plan the layout of my presentation, I first consider the **size** of my fashion figures and how they will look on my A3 sheet. I feel fashion template 3 should stand in the foreground and template 2 reduced in size in the background - so template 2 will need to be redrawn smaller.

• **Photocopier:** A photocopier makes resizing figures immediate by mechanically enlarging or reducing the image. Once the figure is copied to the correct scale, redraw onto the art paper for colouring and finishing. Note: Photocopy ink is not colour fast so it is necessary to redraw - coloured photocopies could be used for presentations but they look flat. The professional standard is to redraw on art paper using the preferred media.

• **Computer generated:** If you use a computer for drawing your figures, or scanning in your images (I use Photoshop), you can resize your figures to whatever scale you wish and print out the image (Fig. 11.17). If your printer only takes A4 size paper, you could split the A3 image and print out two pages then redraw onto your art paper.

• **Resize manually:** If none of the above are available you will have to resize manually, copying your figure to the desired scale. For future figure drawing you could build up a series of different sized templates, these can be useful until you are more experienced in drawing.

3.3 ▼

cut and paste preparation

There are three ways to complete a presentation: **Cut and paste** (the most common technique); **single paper rendering** (everything drawn on one sheet of paper), and **computer generated.**

The 'cut and paste' technique means that all the finished pieces of artwork, fabrics, trims, colours and visuals, are cut to shape and then pasted onto the presentation sheet. The advantage of this method is that it allows you the opportunity to redraw if something goes wrong, and more options and flexibility to rearrange until you are happy with the final layout. Once satisfied with the layout, everything can be pasted down.

The cut and paste technique is the method used for this presentation as it is the most flexible and popular.

Collate: Collate the visuals and text for the design presentation and prepare them for pasting. This includes all rendered fashion figures and working drawings, fabric swatches, colour story, any collage items, graphics and text to enhance the presentation.

Figures and working drawings: The finished figures and working drawings are cut neatly leaving a space of a millimetre or two around the image (Fig. 11.18).

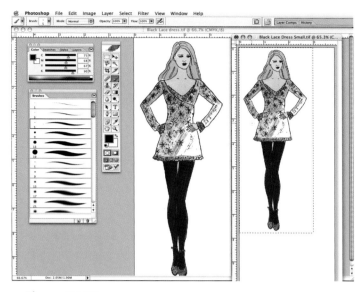

Figure 11.17:
Fashion template 2 is resized using Photoshop (this can also be done using a photocopier)

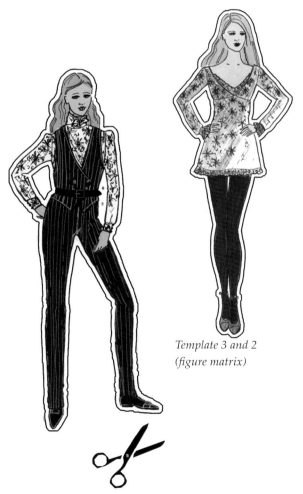

*Template 3 and 2
(figure matrix)*

Flats of Paris Romantics collection

Figures 11.18:
Fashion template 2 has been redrawn smaller onto cartridge paper, and the fabric rendered. The excess paper is cut away from both figures and flats/working drawings leaving just a millimeter or two of white paper surrounding the images in preparation for pasting

Collage: This digital photograph of the Eiffel Tower, Paris, I will use to complement the design concept. The photograph was taken at the largest setting, night shot, transferred to the computer and saved as a Tiff (see my book, *Fashion Computing - Design Techniques and CAD* for more information) (Fig. 11.19).

Fabric: The fabrics are neatly trimmed (these could be pinked). Double-sided tape is used on the under side edges to prevent fraying and in preparation for positioning later (Fig. 11.20).

Theme title and text: These have been computer generated using Photoshop. *'Paris Romantics'* and the pinstripe and lace indicate both a hard and soft look, hence the font is a *'Serif font'* and 'bolded' (Fig. 11.21).

Background: A wide range of coloured and textured papers and cards are available. I am using the print of the Eiffel Tower as the background, mounted onto plain white lightweight card (Fig. 11.22 and 11.23a).

Tip: To help you decide on a background paper you could take your rendered art work and fabric swatches to the art shop, and compare the effects the various coloured and textured backgrounds have on your work. For example; a bright background can make the work look vibrant, a pale colour can give a softer mood. Black is often an easy and effective choice. Obviously the theme and mood determines the decision.

Figure 11.19: Photo courtesy of Bob Burns and Judi Nester
The Eiffel Tower at night, edited in Photoshop then printed

Figure 11.20:
Fabric swatches prepared

Parisian Romantics

Figure 11.21:
Theme computer generated and printed

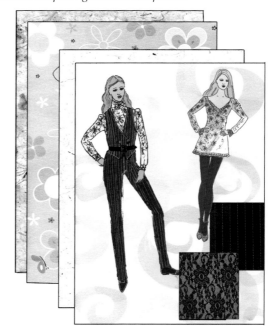

Figure 11.22:
The figures and fabrics are laid on various background papers to help decide which works the best for the presentation

3.4 ▼

design layout

When the visuals are laid on the presentation paper consider the following:

- Will the completed presentation fit into your portfolio?
- Play around with the layout (Fig. 11.23a compare to 11.24a). A good layout is creative and carefully planned, concentrating on what is the most important aspect of the artwork; secondary information and the mounting must never dominate.
- Everything that is absolutely vital to the presentation to get the message across is laid down first, then the extras. Never force something to work simply because you like the picture, and be careful not to overcrowd the presentation - less is best. For this presentation, a second board to display the working drawings and the fabric colours is the best solution (Fig. 11.23a and b).

- The most important images are the rendered figure drawings - they must not get lost amongst other information on the page. Everything should be arranged to look balanced and not cluttered. Rather than evenly spacing everything, items can be grouped and overlaid to create interesting use of space, and positioned off centre.
- Care should be taken when putting dark colours on dark grounds or white on white (Fig. 11.23a and b) - the images will lose definition unless they are have a contrasting border or a shadow effect is used (Fig. 11.24a and b).
- A particular style detail may need to be highlighted, for example a pocket detail. By drawing it in a larger format more focus will be put upon that design detail (Fig. 9.30 and 9.31, *Clothing Design* chapter).
- The top margin of a border can look more stylish if it is slightly smaller than the bottom (Fig 11.24a).

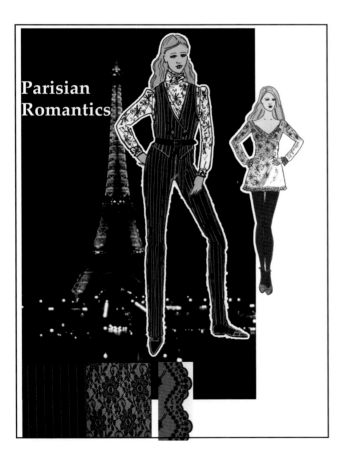

Figure 11.23a and b:

The components are laid on the background sheets and rearranged before deciding on the final layout

3.5 ▼ ▶

paste technique

Pasting the images to the presentation sheet must be done carefully. Follow this procedure:

- Remove each item, one at a time from your final layout, making a light pencil mark indicating the corners where each image is to be positioned once pasted.
- Apply the adhesive - to avoid wrinkles and expel air bubbles, spread from the centre out using your hand or a ruler to make sure the item has adhered.
- Double-sided tape is the best for sticking fabrics to the presentation as glues may bleed through the fabric. Velcro dots to position fabric can also be used.

Pasting the presentation sheet to the backing sheet:

- Apply the adhesive to the back of the presentation sheet and carefully (with help is easier) fit the two end corners of the presentation to the background before laying the whole sheet down. Press down from middle out to expel air bubbles and make absolutely sure it has adhered.

Tips:

- If you have a guillotine or paper trimmer available use this to precision cut your presentation paper and card.
- Alternatively, use a knife (Stanley/X-Acto etc.) and cut on top of thick cardboard or on a cutting mat. This way the knife slices easily through the paper and does not blunt the blade. Use a sharp 2H pencil for drawing cutting lines and a metal ruler as your guiding edge - the knife cannot cut into it. Initially cut a fine line, then the second cut will slice like a knife through butter, and not tear the paper/card.

With the presentation of template 2 and 3 complete, continue to make design presentations using the remaining rendered fashion figures (templates 5 and 6, 4 and 7). These presentations can then be displayed in your design portfolio.

Figure 11.24a and b:

Completed presentations - Fashion illustrations and extra flats from the collection

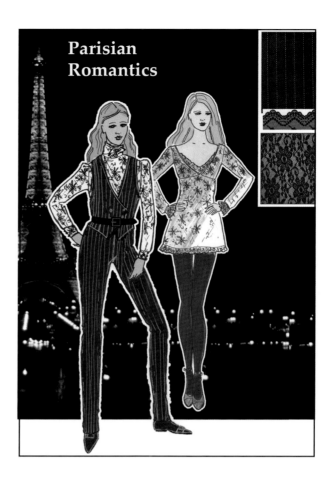

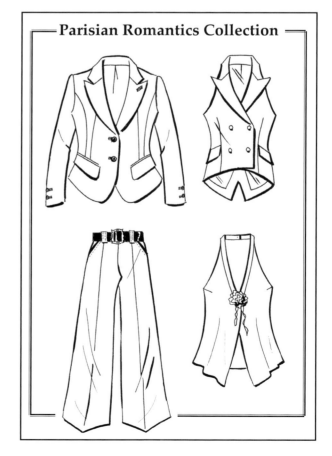

3.6 ▶
computer generated presentations

Depending on the design brief, you may consider doing part or all of your presentation using computer graphics. For example:

- Illustrator, CorelDRAW, and Freehand can be used to draw working drawings and design the fonts.
- Scan in background images to be edited in Photoshop etc.
- Print out all necessary visuals and text, cut and paste together with any manually rendered fashion figures/designs and fabric swatches (Fig. 11.25).

Once you are skilled in using the computer packages such as Freehand, Illustrator, Coreldraw and Photoshop, and depending on what software is accessible to you e.g. CAD systems, you may consider computer generating all your fashion figures and the layout as one presentation sheet. The printing of this type of presentation would need a large format printer and may need to be done at a service bureau.

For more information see my book, *Fashion Computing - Design Techniques and CAD*.

In the next chapters we move on to drawing men, children and costume designs, before discussing how to display presentations and artwork in a design portfolio.

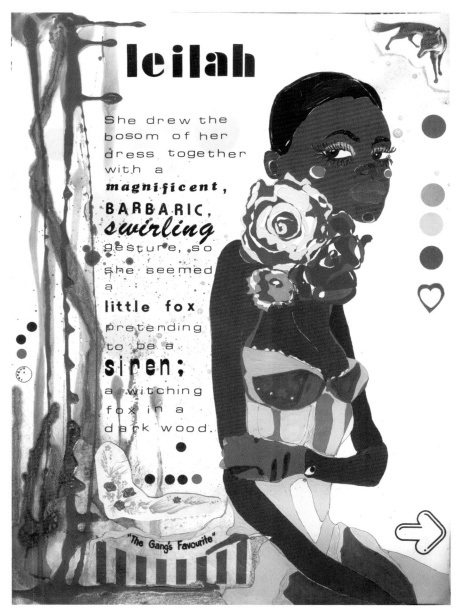

Figure 11.25: Presentation by Sarah Beetson
Hand drawn and computer generated illustration

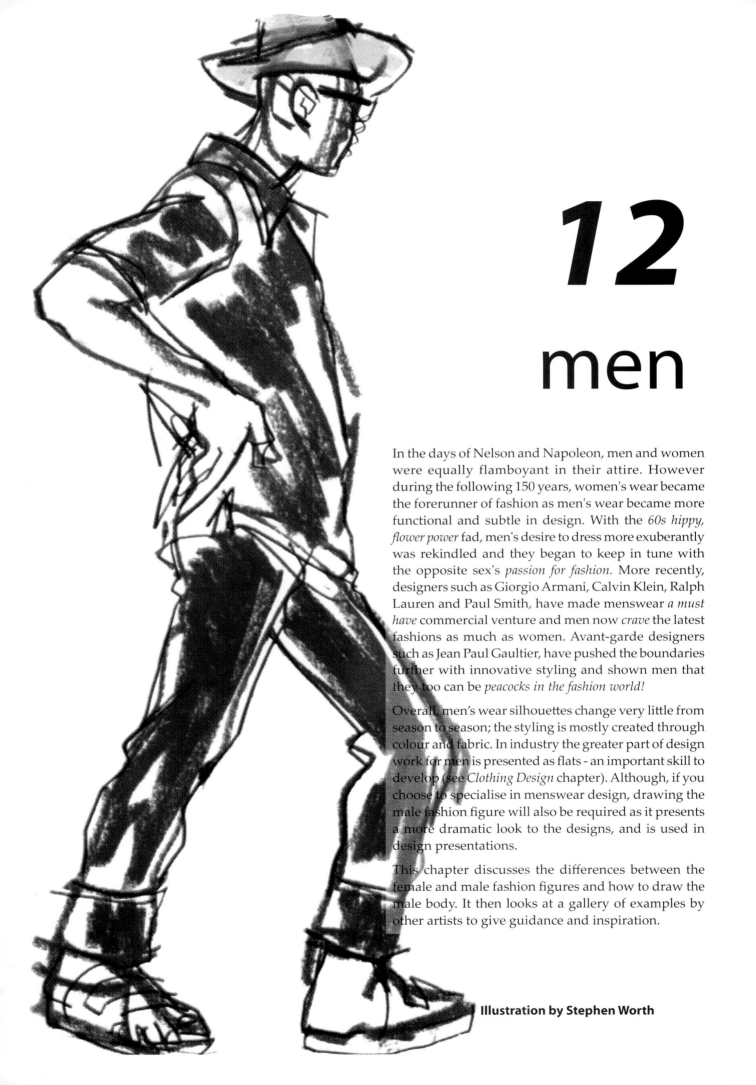

12

men

In the days of Nelson and Napoleon, men and women were equally flamboyant in their attire. However during the following 150 years, women's wear became the forerunner of fashion as men's wear became more functional and subtle in design. With the *60s hippy, flower power* fad, men's desire to dress more exuberantly was rekindled and they began to keep in tune with the opposite sex's *passion for fashion*. More recently, designers such as Giorgio Armani, Calvin Klein, Ralph Lauren and Paul Smith, have made menswear *a must have* commercial venture and men now *crave* the latest fashions as much as women. Avant-garde designers such as Jean Paul Gaultier, have pushed the boundaries further with innovative styling and shown men that they too can be *peacocks in the fashion world!*

Overall, men's wear silhouettes change very little from season to season; the styling is mostly created through colour and fabric. In industry the greater part of design work for men is presented as flats - an important skill to develop (see *Clothing Design* chapter). Although, if you choose to specialise in menswear design, drawing the male fashion figure will also be required as it presents a more dramatic look to the designs, and is used in design presentations.

This chapter discusses the differences between the female and male fashion figures and how to draw the male body. It then looks at a gallery of examples by other artists to give guidance and inspiration.

Illustration by Stephen Worth

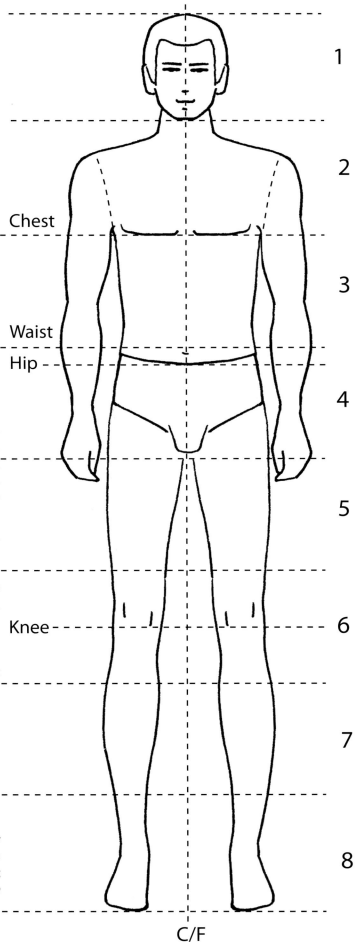

1

art box

- Oval and triangle template 1
- Black fine liners
- A3 (14x17 inch) semi-transparent paper
- Portfolio/Folder
- Sketchbook and/or folder and plastic sleeves for fabric swatches
- Men's fashion magazines

1 ▶

male proportions and body shape

You can use the same oval and triangle technique to develop poses for male figures as described in the *Oval and Triangle Technique* chapter. An eight heads male figure has been developed here. When you flesh out the male figure remember that it is drawn bulkier in size and shape compared to the female fashion figure.

Compared to the female figure, the male figure's body shape has;
- a stronger and bulkier build overall
- less shape in the upper and lower torso, the waist is thicker so there is less definition between the waist and the hips
- larger, developed body muscles
- broader, squarer shoulders
- a deeper chest line (not the high, small bust as the female figure)
- thicker and stronger looking arms and legs
- squarer face and thicker neck.

Figure 12.1: Template 1 (male)
An eight heads male fashion figure has been drawn here. Use the same oval and triangle technique to create your poses as in the Oval and Triangle Technique *chapter. When 'fleshing out' remember the male is much bulkier overall compared to the female fashion figure*

Chest

Waist

Hip

Knee

C/F

1 2 3 4 5 6 7 8

2 ▼▼▶

the male face

The male face can be divided using the same guidelines as the female face, but the features are drawn bolder with:

- a squarer, larger and more defined forehead and jaw
- narrower eyes with less eyelid - women enlarge their eyes with make up
- thicker, heavier, and lower eyebrows
- a more dominant nose - draw stronger lines
- narrower lips with less emphasis on the shape
- more defined ears
- stronger, higher hairline
- character lines for more rugged, mature look - every line can add ten years.

Compared to the female, male hands are (see illustrations on the following pages):

- squarer and broader
- fingers are blunter
- more boxy looking overall.

Compared to the female, male feet and shoes are (see illustrations on the following pages):

- broader and wider
- shorter looking
- thicker ankle
- heavier sole.

Figure 12.2a,b,c and d (top): Illustrations by Tang
The facial characteristics of a male are much squarer, larger and more defined than a female face

Figure 12.3 (right): Illustration by Naomi Austin
Computer generated male torso; note the use of light and shade to create the muscles of the body

3▼ ▶

male poses

When drawing a male fashion figure beside a female fashion figure, fashion illustration dictates the male will be drawn slightly taller, so the figure is scaled up accordingly (Fig. 12.4).

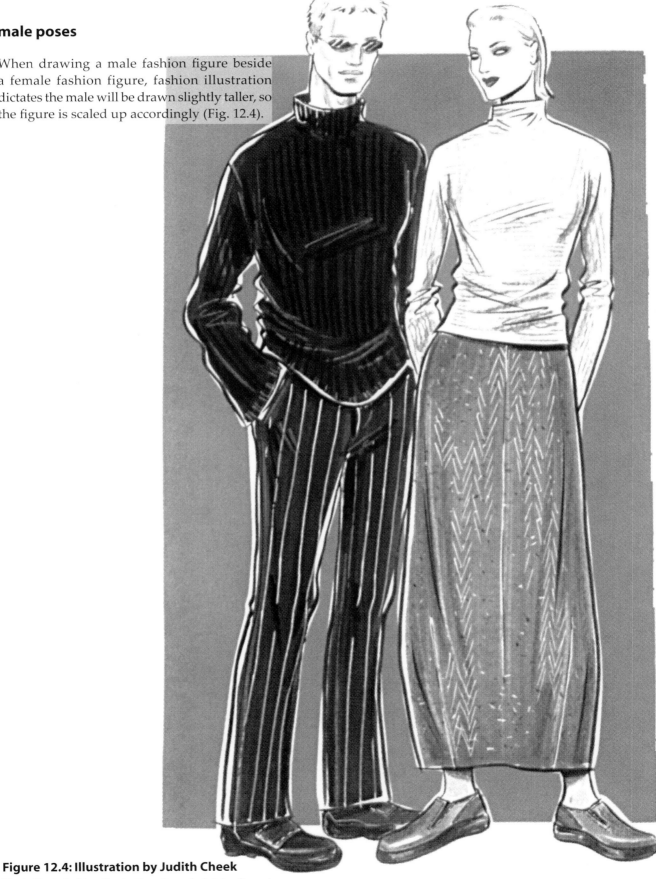

Figure 12.4: Illustration by Judith Cheek
Typically, in fashion illustration, the male fashion figure is drawn slightly taller than the female fashion figure

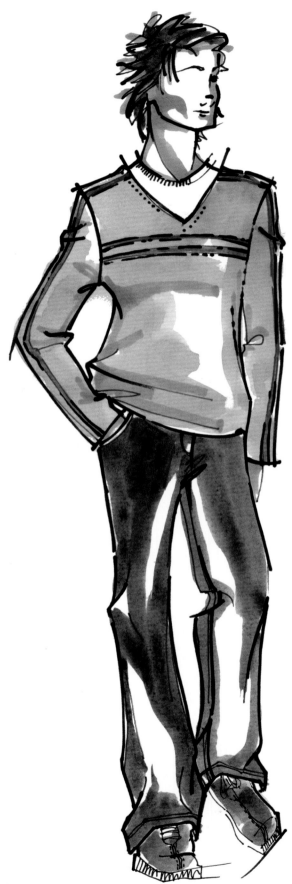

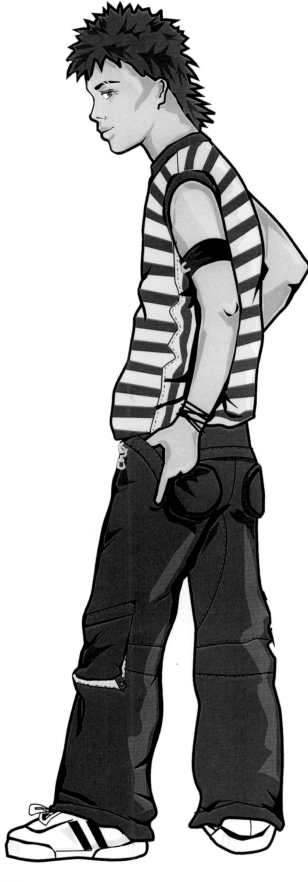

Figure 12.5:
Bindi Learmont - *Knit 'V' neck sweater over*

Figure 12.6:
Naomi Austin - *Striped tee, and cargo pants*

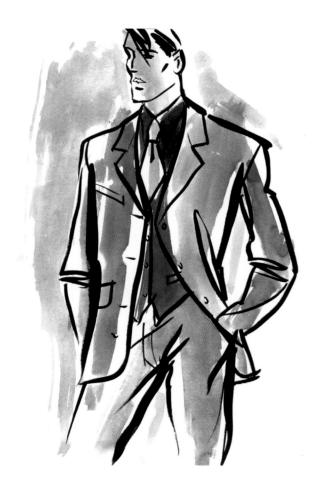

Compared to female poses, males:
- stand more squarely and consequently the angles of the shoulders and hips are less exaggerated
- place weight solidly on heels, with no pointing of the foot
- roll their shoulders when walking - women move their hips more
- swing their arms freely when moving - women's arms swing gracefully
- place their elbows away from the body with hands curving towards thighs - women's elbows are often placed against their body
- hold their wrists and hands in a less graceful way than women
- stand with their knees and feet pointing outwards - women's knees and feet often points inwards.

4

male clothing

With a larger male body frame, men's clothing is drawn accordingly. The main differences are that garments close **left over right** and, for a classic tailored trouser, waists finish slightly below the navel.

Men's clothing categories may be divided as;
- boys
- young men's
- contemporary sportswear/separates
- active wear
- knits/tops (cut and sew)
- sweaters
- woven shirts
- bottoms
- outer wear
- traditional/traditional classics
- black tie.

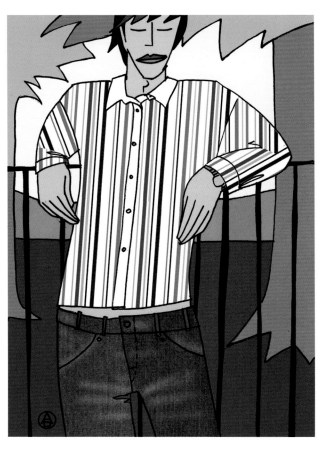

Figure 12.7 (top right): Illustration by Neil Greer
Classic tailored three-piece suit and tie

Figure 12.8 (right): By Alissa Stytsenko-Berdnik
Scanned line drawing, edited in Photoshop (adding colour and creating the complete presentation)

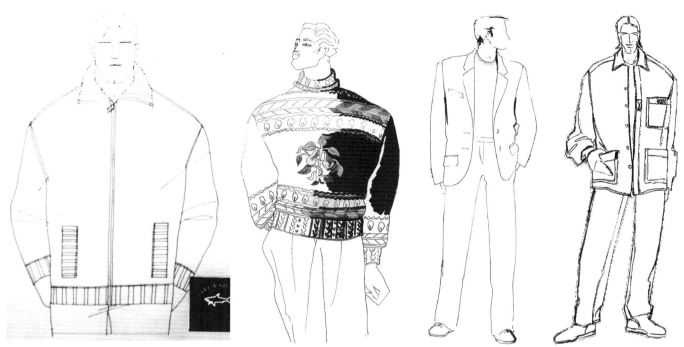

5 ▼▶

men's fashion gallery

Take a look at the following gallery of male fashion illustrations and presentations from a number of designers around the world. Note the various styles of illustration, the way the male figures are drawn and the methods of presentation. Depending on the design brief/project, this determines to some extent the approach and style of work.

Figure 12.9 to 12.12 (above left to right):
Paul Rider - *Sportswear styling - casual jacket, rib detail*
Mandy Smith - *Cable and patterned hand knit wool sweater*
Linda Jones - *Tailored suit worn with crew neck tee shirt*
Courtesy of Lectra Systèmes - *Casual jacket and pants*

Figure 12.13 and 12.14 (below left to right):
Courtesy of Southampton Solent University
Sportswear designs - bomber jacket, 'tee' and casual pants
Illustration by Naomi Austin
Sportswear designs - long sleeved sweater and cargo pants

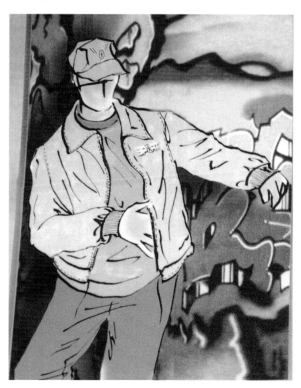

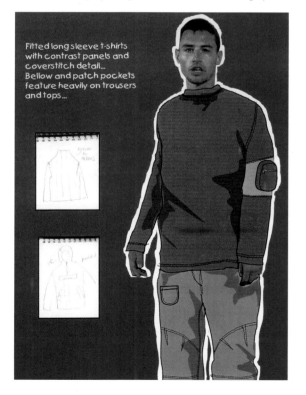

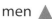

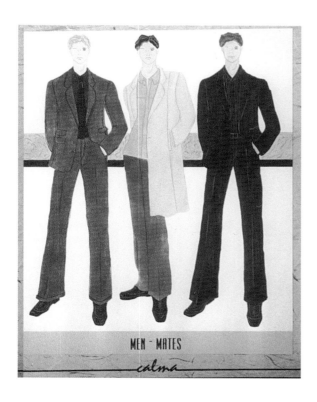

Figure 12.15 (above): Courtesy of IAD Toronto
Classic tailoring for men

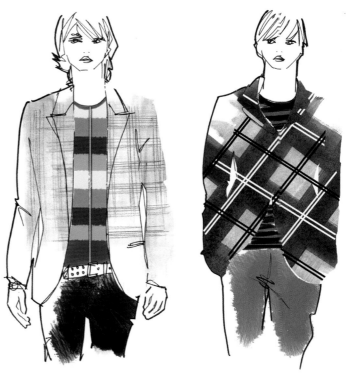

Figure 12.16 to 12.17 (above left to right):
Stuart McKenzie - *Classic check wool jacket over striped silk knit long sleeved tee, and cotton drill pants*
Stuart McKenzie - *Classic diagonal check wool/silk jacket over striped viscose knit long sleeved tee, and cotton drill pants*

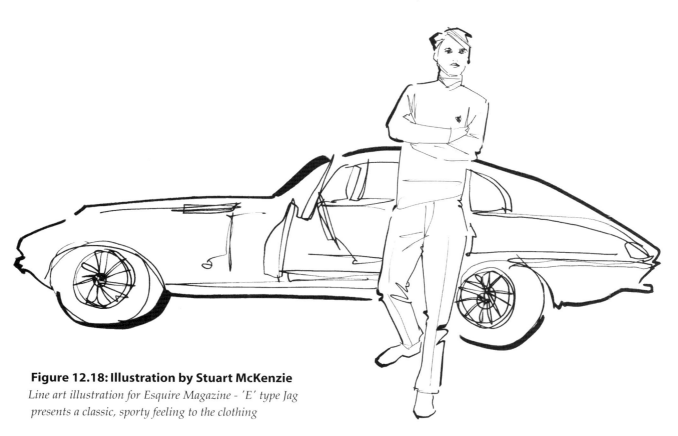

Figure 12.18: Illustration by Stuart McKenzie
Line art illustration for Esquire Magazine - 'E' type Jag presents a classic, sporty feeling to the clothing

13
children

Drawing children and designing children's clothes presents an interesting but fun challenge. Children's body shapes and poses are quite different to the adult fashion figure. They have less shapely bodies, the poses are less sophisticated and more playful, and the illustrations often have cartoon like qualities. As a child grows so the body proportions change dramatically. There are **vast differences in height** and body proportions from a **newly born child** to a **young adult.** Overall, the younger the child, the cuter and more rounded the figure, with a proportionally larger head.

Illustration by Sandra Burke

art box

- Black fine liners
- A3 (14x17 inch) semi-transparent paper
- Portfolio/Folder
- Sketchbook and/or folder and plastic sleeves for fabric swatches
- Children's fashion magazines

1 ▼

childrens poses

To be a children's wear designer you must be aware of the various age groups, from new borns to teens, as well as the special requirements both in design and drawing the body proportions and figures. In this chapter we will take a brief look at these differences.

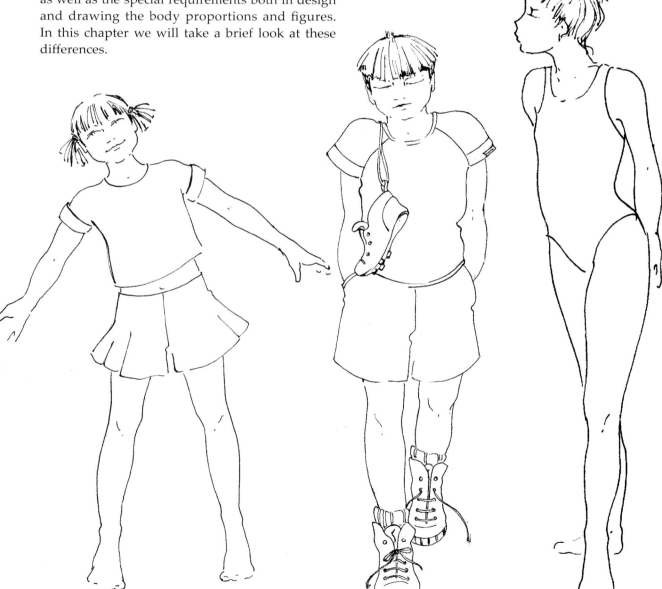

Figure 13.1 to 13.3: Illustrations by Linda Jones

Children 7 to 10 - poses are becoming less cute and taking on more young adult-like gestures

2▼ ▶

children's body proportions and shape

As with the adult fashion figure, children's fashion drawings are also measured in head depths but the number of heads varies depending on the age of the child (Fig. 13.4).

Figure 13.4: Childrens Figure Template
Shows the variation in the number of heads that divide into the body from an infant to an adolescent

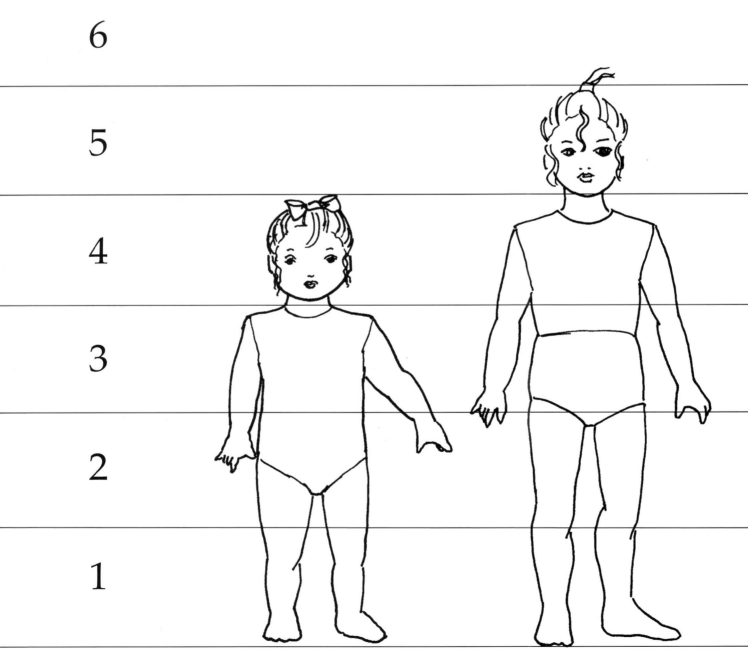

8

7

6

5

4

3

2

1

Infant/two to three years, measure 4 heads

Small child/four to five years, measure 5 heads

© Fashion Artist - Sandra Burke

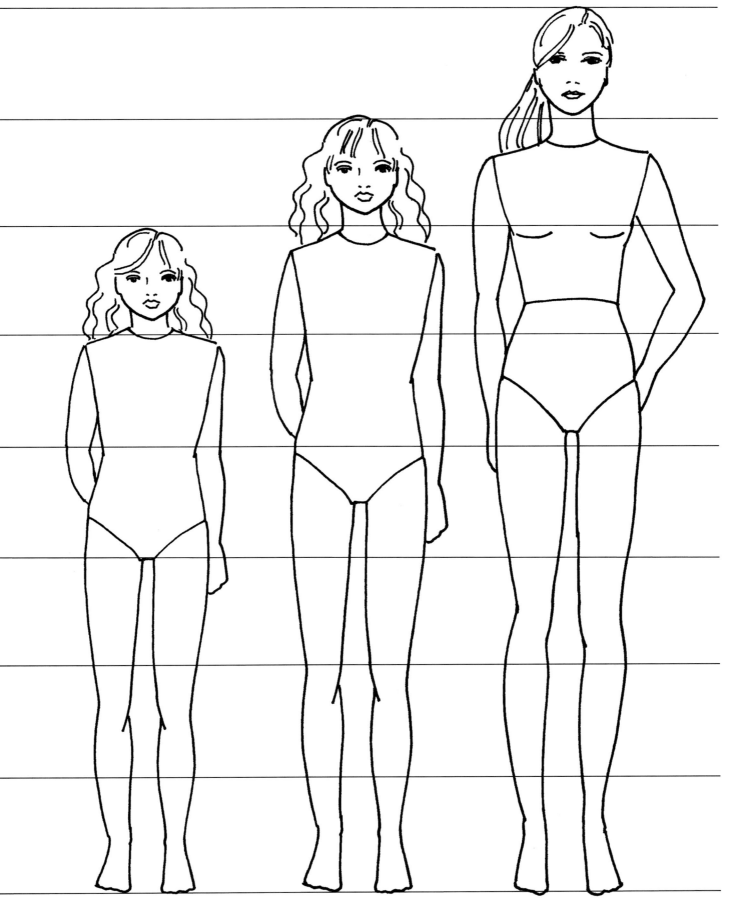

Child, six to eight years,
measure 6 heads

Child, nine to eleven years,
measure 7 heads

Young teen/adolescent,
measure eight heads

Figure 13.5 to 13.6: Birth to One Year

Photo - courtesy of Munko Clothing (children from birth to one year old are presented either lying or sitting propped up)
Flats by Pumpkin Patch (romper, jacket and booties)

3 ▼ ▶

children's fashion gallery

In this section we take a look at a gallery of photographs and illustrations of children from birth to ten years of age. From the photographs we can see how a child actually develops in body shape and appearance, and from the illustrations we can see how the different age groups are drawn. It is particularly interesting to note the different poses a child takes on and how this helps us to determine their age.

Babies from birth to one year old: The head is approximately 1/4 of the total height. Their body, torso, head, arms and legs all have a rounded look. They have big rounded eyes, and exaggerated dimples on their cheeks, knuckles and knees. At this age they are sketched either lying down or sitting propped up (Fig. 13.5 to 13.7).

Toddlers from one to two years old: The head is still large in comparison to their body and measures four heads high. Everything about them is still chubby and cute looking with no defined body shape. They have protruding stomachs and may still be in nappies (diapers) which makes them even more rounded. There is little distinction between boys and girls.

The face is still round with big cheeks and no jaw definition, and the neck is short. The eyes are rounded with just a little definition for the eyebrows. Noses are small. The hair is beginning to have a little style.

Toddlers are in the early stages of learning to walk and can sit without support, consequently the poses are generally drawn with the child sitting.

Figure 13.7 to 13.9: Toddlers

Photo - courtesy of Munko Clothing; Illustration by Sandra Burke; Flats by Pumpkin Patch (top and pants)
(Toddlers, one to two years old, are generally presented sitting)

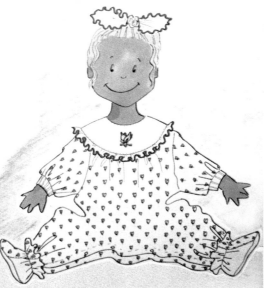

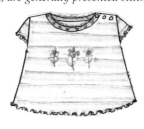

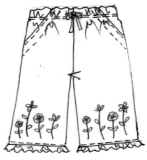

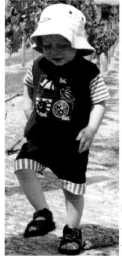
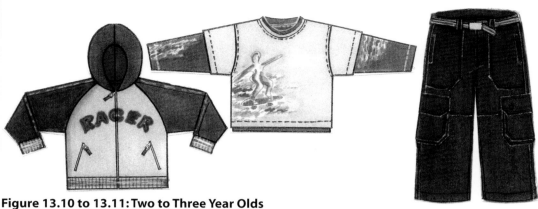

Figure 13.10 to 13.11: Two to Three Year Olds
Photo - James Grant, by Sandra Burke
Flats by Pumpkin Patch (hoodie, long sleeved tee, cargo pants)
Children from two to three years old are walking, they are active but awkward
in their movements, almost 'colt' like

Children from two to three years old: They are four to four and half heads in height. Most of the change in height is in the legs - the legs are now drawn straight as they are strong enough to support the body when standing. The arms and legs have more shape but are still podgy. They still have the characteristic slightly protruding belly.

Their faces are more defined and their neck is longer; their mouth is larger and they now have teeth. The hairstyle is more defined, but girls and boys still look similar in body shape.

At two years old children are walking. They are awkward in their movements, almost 'colt' like even up to three years old.

Children at three years old: They are drawn standing in cute poses, sometimes carrying something. They still have the feeling of 'colt' like awkwardness, but are becoming very active in their movements.

Their clothing is becoming more interesting and fashionable. Children even begin to tell their parents what they want to wear as they become more aware of other children's dress.

Figure 13.12 to 13.13:
Photo - courtesy of Munko Clothing; Flats by Pumpkin Patch
Children at three years are drawn standing in cute poses, often holding something
(bucket, toy, flower); there is still a feeling of 'colt' like awkwardness about them

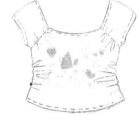
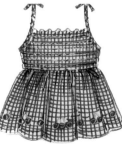

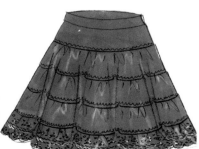
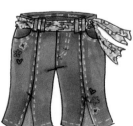

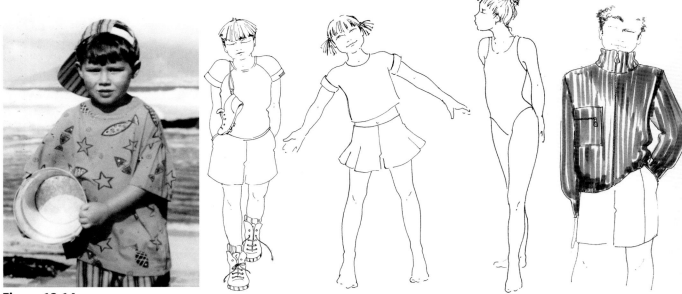

Figure 13.14:

Photo - courtesy of Munko Clothing; Children four to six years - boys and girls start to look different in body and features

Figure 13.15 to 13.18: Children 7 -10

Artwork by Linda Jones
Children 7 to 10 - poses are taking on more young adult-like gestures

Children four to six years: The children are now approximately five heads high and most of the growth is in the legs. There are some changes in the body shape now. The torso loses baby fat and the stomach protrudes less, but there is no defined waistline.

The face is slightly narrower, the eyes less round becoming more almond shaped, and the eyebrows are darker. The nose is more defined with a roundness at its tip. The mouth is larger as the teeth have now developed fully. The hair is more styled.

Boys and girls start to look different in body and features, and because of this their clothing becomes a mix of both innocence and fashion.

The poses are more active and animated, but still have a slight awkward appearance.

Children 7 to 10: The children are now approximately seven heads high. Muscle gradually replaces baby fat but still the waist is not really defined. The arms, legs and torso are becoming slimmer with knees and elbows more apparent.

Baby fat is also disappearing from the face although there is still a roundness in the cheeks. The eyes are more shapely, the nose is still small but becoming stronger with a wider bridge. The mouth is developing in shape.

Poses are now becoming less cute and taking on more young adult-like gestures.

Figure 13.19 and 13.20: Children 7 - 10

Illustration by Jonathan Kyle Farmer
Flats by Pumpkin Patch

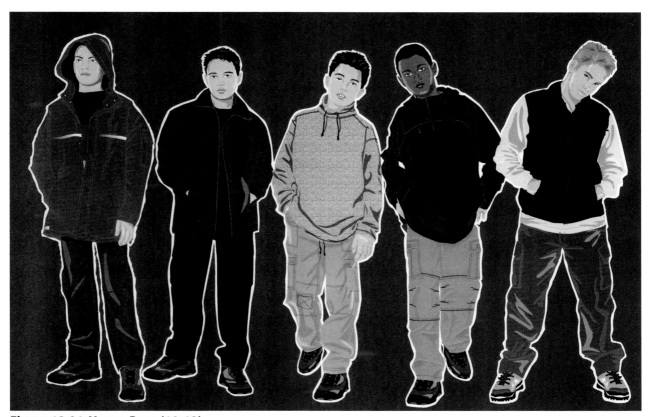

Figure 13.21: Young Boys (10-13)
Presentation by Naomi Austin; note the poses suit the age of the young boys and the style of clothing

children's wear illustration and design

The following are points to consider when illustrating and designing children's wear:

- Sketches require more of a stylised approach to that of the adult, to identify age and gender differences.
- Characterisation is popular - freckles, large heads and feet, knock-knees, and captivating charm and innocence.
- The hairstyles, props, poses will all help to define the age of the child.
- Often baby girls wear pink and baby boys wear blue; this can carry over until they are two years old.
- Children's designs are generally fun loving; often cute and whimsical; using bright colours and fun prints.
- Styles may be theme driven e.g. western, comic characters, sailor looks etc.
- Traditional fabrics are often used - cute and sweet for younger children.
- Colour and print is important; black is used mainly for an older age group.

- Portfolio and presentation formats will vary - there is not so much a fashion approach rather tradition and character play the biggest part in presentation.
- Page orientation, as in men's wear design, is often presented in a landscape layout which is more appropriate for small items and individual pieces of clothing.
- Research for design and inspiration: Children's literature, film and books - Cinderella, Snow White; museums, zoos, alphabet, numbers etc.
- Characters such as Mickey Mouse, Little Mermaid, Pocahontas, Pokemons, Thomas the Tank Engine, are very popular - you will need a special license to buy the rights and to sell the garments commercially.
- When sketching children from life you must do very quick sketches, as you are unlikely to get a child to stay still for long. You may find it is much easier to take photographs and sketch from the developed image!

14
costume design

Costume drawing and design for stage, screen and television, is a performing branch of fashion design within the creative industry. In education you can choose to specialise in costume, but there are many costume designers who began their studies in fashion, learning drawing techniques, pattern making and garment construction before going on to become a costume designer or both. For example **Paul Poiret** (1879 - 1944) designer, and **Erté** (1892 - 1990) illustrator/designer and, more recently, designers such as **John Galliano** (1960 -), and **Jean Paul Gaultier** (1952 -), have all combined their design talents between fashion and costume. Fashion designer **Elsa Schiaparelli** (1890 - 1973) created the most exciting theatrical and stunning fashions in the thirties; for her it was almost an art form.

This chapter looks at the skills required of a costume designer together with artwork by costume designers from around the world.

Illustration by Amber O'Keeffe

1 ▼

costume designers

Although costume designers and fashion designers use the same drawing techniques, there are certain challenges that further test a costume designer's skills:

- The costume designer may be required to research their designs so that they are convincingly authentic in every detail relating to a particular period, and to satisfy the production's standards, for example, accuracy is often critical for historical and period pieces. From the Stone Age bear skins of the cave man, to the highly constructed and constricting crinolines and corsets of the 1800s, up to the present day *'anything goes'* creations, the costume designer needs to be aware of them all.

- When illustrating various characters in a production it is usually acceptable to use a degree of artistic licence. However, the costume designer may also be required to embellish the illustration with a more convincing likeness, caricature or cartoon approach.

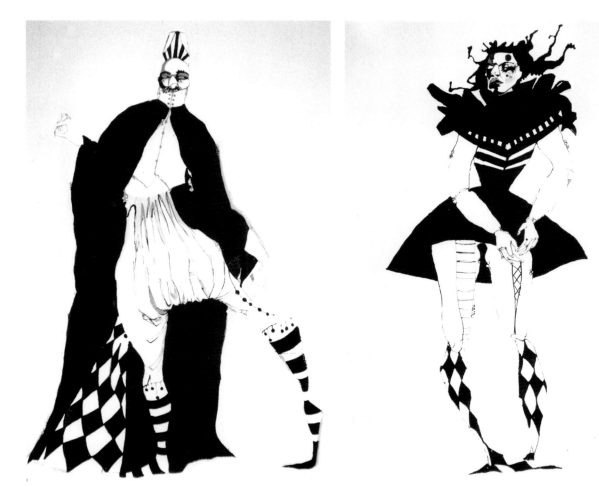

Figure 14.1 and 14.2: Illustrations by Amber O'Keeffe
*These **Harlequin characters** in costume depict perfectly the animated quirkiness of typical harlequin characters - they also have a slightly quirky fashion feel to them*

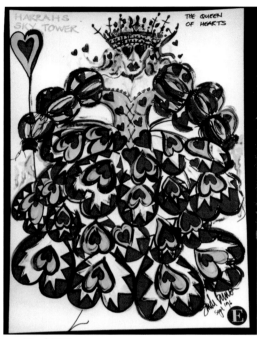

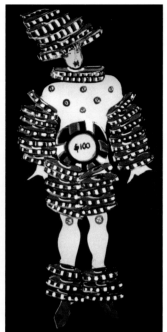

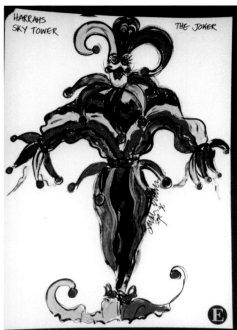

2 ▲▼

costume design gallery

This gallery of costume designs displays a mixture of caricature, cartoon as well as realistic figures. The various designs cover both screen and stage and are often drawn very boldly, giving them a larger than life attitude.

Unlike fashion figures, costume characters are not usually drawn with elongated legs, but may have other body parts exaggerated, e.g. a nose, fingers, feet, giving them humour and intrigue. On stage characters compete with the scenery and lighting around them, and are generally viewed from a distance, hence, the **bolder the better.**

Designs for the actors of television productions may need to be down played so that they do not dominate the rest of the set. Filming tends to zoom in on the head and mid shots, making the design of the upper half of the body more important.

Figure 14.3 to 14.7 (all this page): By Sarah Burren
Queen of Hearts, Joker and Card designs for the opening of a casino are bold and over the top
Media: Acrylics and collage

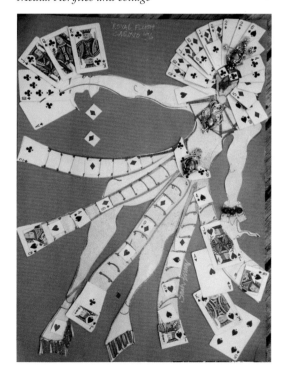

Figure 14.8 to 14.9 (above left to right):
Diaghilev Presentation by Jenny Huang
Sergei Diaghilev (1872-1929) ballet impresario, was the inspiration behind this oriental looking costume design for stage; the pose depicts the actress performing a dance sequence
Masked Carnival by Gislene Amageshi-Brown
Masked figure in costume

Figure 14.11:
Wizard Presentation by Sharon Jennings
Devious half man, half beast wizard - even his pose makes us think he is about to cast some strange spell on us!

Figure 14.10 (above right):
Zena Presentation by Kelly Hepple
*A futuristic, powerful Zena **Super Woman** - the figures are drawn with fashion proportions to typify the sexual tones and beauty of the characters; the cartoon background and cut out figures suitably depict the strong, action mood of the presentation*

Figure 14.12:
Shivers Presentation by Mira Jukic
The Boy Who Left Home To Find Out About The Shivers
(book) - the shivers (ghost-like creatures) prance across the page in mystical fashion; the background give an air of mystery to enhance the mood of the presentation

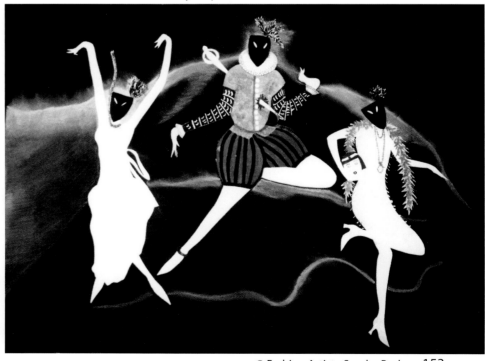

3 ▼▶

illustration styles

The costume design brief will indicate the style and flamboyance of the illustration. For example, a rough sketch portraying the mood of the costume and character, or a very detailed look with a particular actor or persona in mind may be required. The illustration may need to be very realistic and graphic. For example if the costume is for a very large, elderly man, then the illustration should show the costume on a very large, elderly man.

You may also need your skills in sketching working drawings to be able to liaise with pattern makers and seamstresses concerning the making and construction methods of the garment.

Figure 14.13 to 14.15 (this page): By Val Fisher

Banquo, Macbeth - the strength of this character is enhanced by his wild hair, dominant pose and warrior accessories

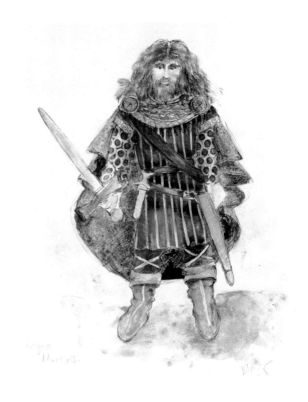

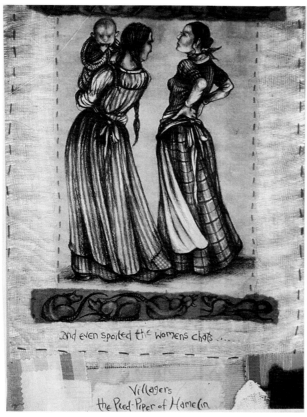

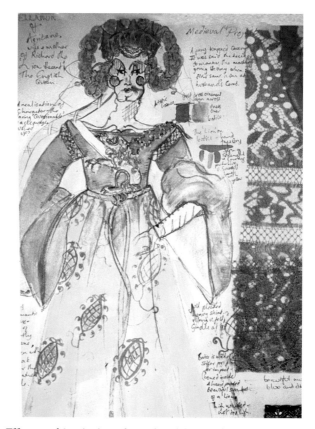

*The **Pied Piper of Hamlin** artwork depicts the medieval period in history when London was infested by rats - the clothing relates to that era; the hessian stitched border effect and sketch of rats help set the mood of the presentation*

Ellanor of Aquitaine - the medieval design of this garment has been researched from costume history books and interpreted to suit the production; descriptions of the play and costume have been noted on the presentation; fabric swatches are attached

4 ▼ ▶
research

Many hours of research and sketching goes into costume design to make the costumes appear authentic and accurate to the period. Ideas can be sourced from:

- History of costume - books (see *Further Reading*), art galleries, museums - designers and illustrators such as Toulouse Lautrec (1864 - 1901), Eric (1891 - 1958), Coco Chanel (1883 - 1971), etc.
- Contemporary styling and current trends - fashion magazines, fashion shops, television and film, street wear and real-life examples.
- Futuristic styling - look to the avant-garde styles of designers like Jean Paul Gaultier, and Alexander McQueen who have designed for both fashion and costume.

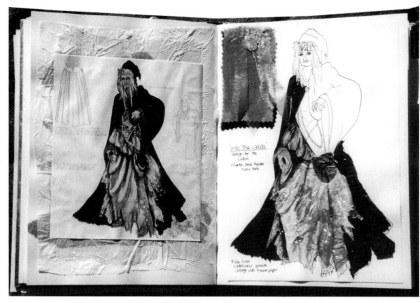

Figure 14.16: Sketch book by Val Fisher,
Sketch book showing design development sketches and fabric for one of the witches in Macbeth

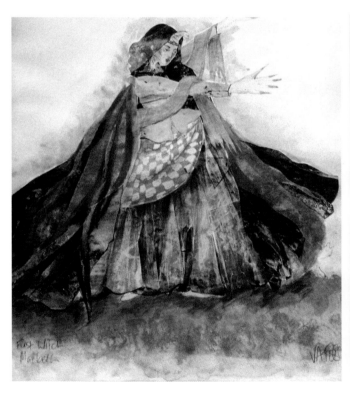

Figure 14.17: Presentation by Val Fisher,
First witch, Macbeth - Mixed media and collage create this dramatic witch, with spell binding, exaggerated hands to match

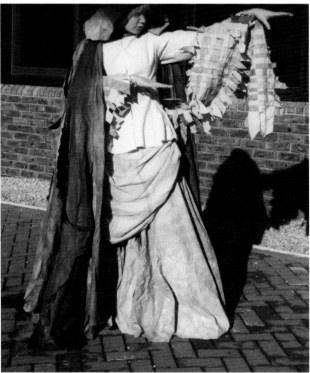

Figure 14.18: Presentations by Val Fisher,
First witch, Macbeth - Costume made by costume students at Bournemouth Arts Institute

15

design portfolio

Illustration by Hamza Arcan

Your fashion design portfolio is not just a collection of your work and an example of your talent, it is also your **principle marketing tool.** In an interview situation, a creative and well planned portfolio provides visual evidence of your capabilities - it expresses your unique qualities; your range of demonstratable skills and your expertise; your design sense, drawing, illustration and presentation skills, as well as your technical skills (pattern making, sewing etc.). Your portfolio should be constantly updated, throughout your studies and career. It is your passport to success and career development.

Design Portfolio discusses what type of portfolio to buy, ideas on presentation and layout, what to include in the portfolio and, just as importantly, what to leave out.

1 ▼

what is a design portfolio?

A quality portfolio shows you are serious about your work. It is your:

- Professional way to collate and present visual evidence of your talent and skills - artwork, designs, illustrations, press cuttings, fashion photographs etc.
- Method of enhancing the overall look and appeal of design work, while keeping it in order, clean and tidy in plastic sleeves.
- Tool to obtaining a job or entrance to a course or a degree as it shows demonstrable skills.
- Portable and demonstrable method to present visual information - especially beneficial in an interview situation, presenting work to clients.

2 ▼

choosing a portfolio

When purchasing a portfolio consider:

- The ideal portable size - A3 (11x14 or 14x17 inch); A2 (18x24 inch) is more suitable if you want to work on a larger format, but obviously not as portable.
- Portfolio types vary but the **most popular** is a flat case with a handle and unzips to open like a book, displaying single or double page spreads (design work) in plastic sleeves.
- Alternatives - display portfolios with plastic sleeves which are folded back for a freestanding tabletop presentation; a **box** or **pocket** type where work is protected, but this is not a straightforward way of displaying the work or keeping it organised.
- Good quality portfolios are made of tough plastic material or leather; they should last a life time
- Colour - black portfolios look smarter and do not scuff easily.

Figure 15.1: *A3 (14x17 inch) portfolio with zipper*

Figure 15.2: *Display portfolio for a table top presentation; illustration by Linda Jones*

3 ▼

portfolio contents and layout

The layout, order and sequence of work in a portfolio is just as important as its contents. Consider the following:

- **Size** - the size of your design presentations will depend on the requirements of the design brief and/or size of your portfolio, A3 (14x17 inch), A2 (18x24 inch) - if you need to present larger work you could take photographs and present these.
- **Introductory page** - start with something about yourself, unique to you, a logo or graphic, not a highly fashionable garment design that can date quickly; attach a business card or address card to it so that you have something to leave with your interviewers so that they remember you; also, if your work is named it can always be returned to you if lost.
- **Display** your best work and build up to a grand finale (wedding, evening wear).
- **Variety** - display your creative talents, design skills and flexibility by presenting a range of artwork to prevent it from being repetitive.

- **Selective** - present your best work and remove any weak links.
- **Creative** and graphically well presented, not necessarily wild on every page, but show design sense.
- **Organise** your portfolio either by design or season (latest first) - you could index your content.
- **Informative** - your portfolio should tell a story about yourself and your abilities, keep it direct - strong themes.
- **Clean and neat** - remove grubby marks, cut work to neatly fit, be sure plastic sleeves are the right way up.
- **Double page spreads** - allow pages to work together to create more visual impact.
- **Orientation** - chose a specific layout, portrait or landscape, maintain flow and be consistent so the portfolio does not have to be turned continuously for viewing - if you change the page orientation the facing pages (double page spread) should be the same orientation if possible.
- **Group pages** - for order and flow, group pages which relate to the same theme.
- **Portable** - keep it light and easy to carry, do not use heavy card for mounting.

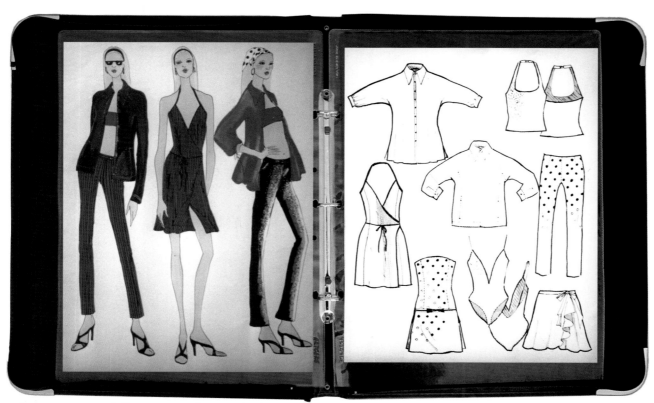

Figure 15.3: Portfolio Presentation by Linda Logan
Double page spread, showing illustrations and flats

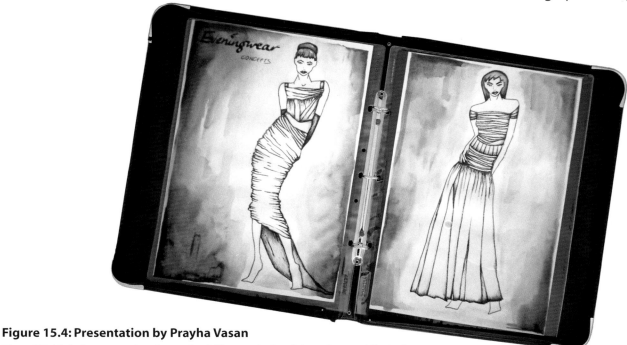

Figure 15.4: Presentation by Prayha Vasan

Oscar Night designs - evening dresses in chiffon, ruched and draped around the body

- **Update and rearrange** - always keep your work up to date; plastic sleeves allow you to present work as single or double page spreads and to rearrange the order, and replace work as necessary.
- **Stand alone** - your portfolio must be self explanatory in its use of text and presentation techniques; this is especially important as your portfolio may, at some time, be viewed without your presence.
- **Colour Xeroxing -** this may be necessary, especially if you need to send your portfolio to several venues at the same time (e.g. for an entrance portfolio on to a course, or to show your design skills); if possible always show original artwork.

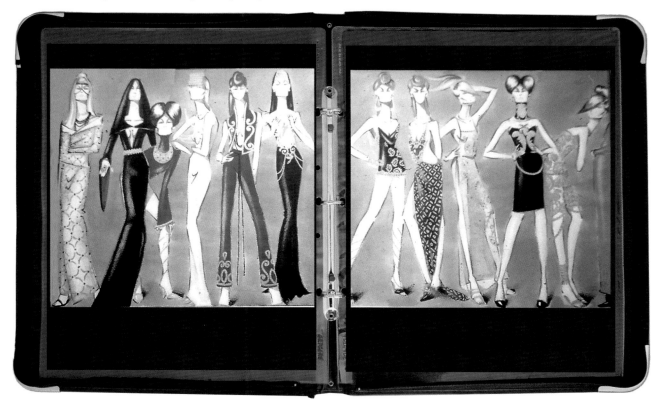

Figure 15.5: Portfolio presentation by Jason Ng

A impressive double page spread of 'Versace' inspired collection in portrait view

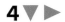
4 ▼ ▶

target your portfolio

"The mark of a professional portfolio is its focus. Targeted to a special customer and market, its design sense should be consistent from start to finish." Linda Tain *(Portfolio Presentation for Fashion Designers).*

Think professionally and target your portfolio. The layout of your portfolio and the design work you put into it will depend on what company or educational course you are applying to, or to whom you are marketing your talents. Decide what you want your portfolio to do for you, display and direct your portfolio to that end.

You may need a portfolio for:

- An entry to a course, school, college, university - entry-level portfolios should consist of a variety of formats to demonstrate design and rendering skills. Unless specified, you will need a range of work to show your capabilities in some or all of the following; your techniques and use of media, fashion awareness, design development, fashion poses, fashion flats, colour and fabric sense, design work, photographs of clothing you have made, competition work, costume designs if applicable, etc.
- Applying for a position in the fashion industry - this may be your first job or a development in your career. For your first job, present a selection of your design capabilities from fashion design work to presentation, colour and fabric sense. When moving on in your career you need to show your current work and the best of what you can do. In both cases you may need to target your work to a particular company - when a company reviews a portfolio they expect to see the same type of clothing that they manufacture.
- Acquiring freelance work - you may need to target your portfolio specifically for the client or show your talent and skill in all areas of design.
- Marketing or presenting your latest clothing range.
- A competition - the design brief will describe what is required.

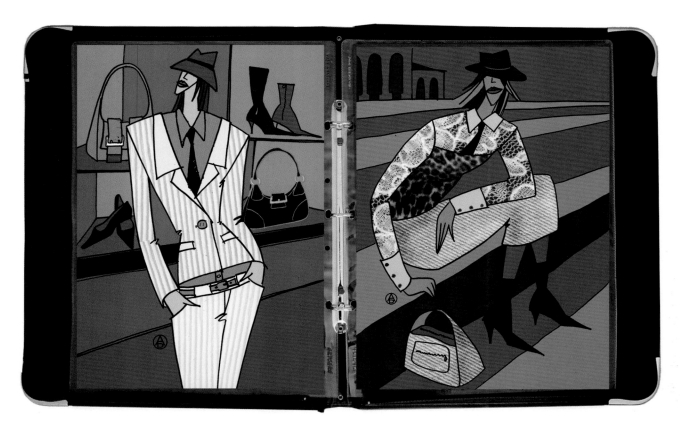

Figure 15.6: Presentation by Alissa Stytsenko-Berdnik
'High Fashion Shopping' theme, double page spread displaying fashion illustrations and accessories

Media: ink on paper, scanned illustrations and fabrics, edited in Illustrator and Photoshop

Figure 15.7: Portfolio Presentation by Alissa Stytsenko-Berdnik
Double page spread displaying fashion designs for Spring/Summer
Media: ink on paper, scanned illustration, edited in Photoshop

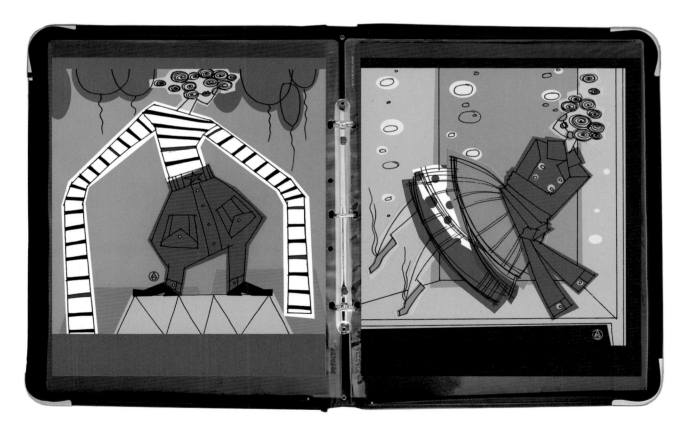

Figure 15.8: Portfolio Presentation by Alissa Stytsenko-Berdnik
*'Circus' theme, double page spread displaying fashion designs for fun casual
wear*
Media: ink on paper, scanned illustration, edited in Photoshop

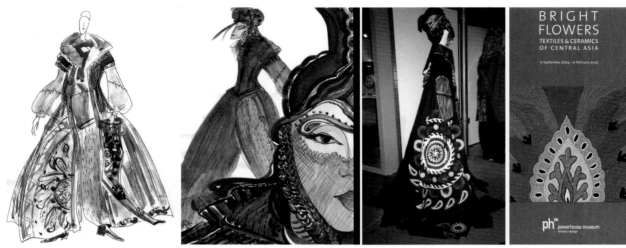

Figure 15.9: Presentations by Paul Rider, Lucy Jones and Vera Chursina
Portfolio of design work for 'Bright Flowers' exhibition displaying textiles and ceramics of Central Asia (Power House Museum, Sydney); concept sketch, finished artwork, photo of garment and brochure for exhibition

5 ▼▲▶
layout format

As you take on more design projects and build up your design work, consider this layout format:
- Introduction page.
- Theme one - consisting of:
- Mood/Theme/Concept Page.
- Fabric and colour page to follow.
- Rendered fashion designs on the fashion figure.
- Flats of the designs (unless already included on your design page).
- Approximately four more themes should follow, ending with a stunning piece of artwork as your *grand finale*.

Begin adding work to your design portfolio and plan its layout. So far, with the artwork you have completed in *Fashion Artist*, you have only your drawing exercises (figures, rendered fabrics), fashion design presentations and life drawing exercises. But you may have some other work or photographs you wish to include. Collate your best work and following the presentation techniques in the *Design Presentation* chapter, prepare all your visuals for your portfolio. Later, as you work through various design briefs, you will have more artwork to present and display your skills more comprehensively.

Note: *It is important to start and end your portfolio with eye-catching work so that people **remember** you.*

6 ▼
design journal/croquis sketch book

A fashion design journal/croquis sketch book, that documents your thinking process and demonstrates your creativity and basic drawing skills, makes an excellent addition placed in your portfolio.

7 ▼
back-up

Always keep a back-up of the work in your portfolio, particularly your best pieces. This is a useful and professional approach:
- You may need to send your portfolio to several places at the same time (check if slides, photographs or a CD of your work is acceptable).
- In case of loss or damage.

Make a backup copy by:
- Printing colour copies.
- Photographs or slides (transparencies/slides give the best colour, sharpest detail and make for an excellent presentation).
- Scan your work and save on file.
- Have your own website and post your portfolio on the net (this way a company or educational establishment can see what you do - clarify this is an acceptable method for the recipient).

Figure 15.10: Presentations by Sarah Beetson
Fashion design presentation for Satta James displaying not only the black cotton drill jacket front and back view, but also a mood and theme for the collection and label

Figure 15.11: Presentations by Sarah Beetson
'Rock and Roll Band' fashion presentation displaying an extremely powerful, strong theme with not only the garments but the mood and experience for the whole collection and fashion label

glossary

If you want to enter the world of fashion illustration and design, then you must speak the language of fashion. This glossary introduces many of the terms commonly used by fashion designers and illustrators.

A1 paper size: (594x841 mm), 24x32 inch
A2 paper size: (420x594 mm), 18x24 inch
14x17 inch
A3 paper size: (297x420 mm), 11x14 inch
A4 paper size: (210x297 mm), 8x10 inch
A5 paper size: (148x210 mm), 5x7 inch

Body proportions: The body is sub-divided into logical parts to help you draw the fashion figure using correct proportions, for example, you do not want your model to have long arms like an ape!

Design brief: (Client brief), the starting point of a design project is the design brief - it may be **written** or, more commonly in industry, **verbal**. To produce effective and marketable designs, the brief should outline what is required as this influences the styling.

Design concept: A creative idea that helps sell or publicize a new design, for example, a new concept in eveningwear.

Drawing from life: Sketching the body or figure poses from a live model.

Catwalk: (Runway), a narrow stage used in fashion shows which fashion models walk along to display the latest fashion creations.

Collection (clothing range): A series of garments that mix and match and complement each other.

Collage: A form of art in which various materials, for example, fabric, paper, cotton wool, sand and shells, are arranged and glued to a backing to form an artistic composition - used in fashion presentations and more often costume design.

Colourway: (Colour palette, colour story), a range of colours for clothing and fabric designs that contrast and complement each other, and are displayed together in design presentations and design collections.

Concept board: (Story board), creative ideas and designs presented together on a board or in a portfolio so that they can be presented to interested parties; the design team, buyers and clients. This helps to market or publicize an idea or commodity (a new concept in underwear, a new fashion trend, for example).

Costume design: Designs drawn up for stage, screen and television; costume is a performing branch of fashion design.

Croquis: A French word to describe a small rough sketch of the figure from which a garment or a clothing range is developed.

Croquis sketch book (US): A drawing pad used to develop designs on a rough sketch of the figure, showing the range of designs with basic colour and fabrication, but are not as perfectly finished and detailed as final presentation drawings.

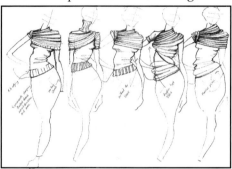

Croquis from a sketch book: Frances Howie

Design inspiration: A creative, brilliant or timely idea that stimulates the production of works of art and in this case fashion and costume clothing ideas.

Drawing skill: A skill may be defined as an ability or aptitude to perform something well; drawing skills require good hand to eye co-ordination.

Drawing style: A particular and distinctive way of drawing, (**personal** drawing style): the style and signature of drawing particular to you.

Fabric rendering: (Representation and illustration), using colouring and drawing media a fabric for a garment design is sketched to give an overall impression of fabric type, texture, print and colour. It may be presented in a flat swatch form or on a fashion figure/croquis.

Fabric swatch: (Swatch), a small sample of a fabric, cut from the fabric roll, to indicate the colour, fabric quality, texture and print. The swatches aide inspiration when creating design concepts and may be displayed in design presentations.

Fashion colours: The latest range of colours for clothing or fabric designs that contrast and complement each other. These will change twice yearly, with the seasons, Spring/Summer, and Autumn/Winter, with perhaps two extra, mid season colour stories, in addition.

Fashion designer: Designs and sketches garments to communicate ideas on paper to a design team, pattern makers, sample machinists, and buyers. They need to be able to draw well to make their designs understood, but they do not necessarily need to excel in the more stylised art of fashion drawing.

Fashion drawings: Sketches of the figure and clothing that aim to achieve an **impression of reality** not illustrate every small detail as the camera portrays. The objective is to capture an overall look, with no unnecessary details cluttering the drawings. Artistic license is normal practise, hence the fashion figure is generally longer in the legs for a more stylish and dramatic impact.

Fashion Illustrator: Gives a signature style to a *fashion designer's* creation. Using creative drawing skills, an illustrator builds on and enhances the fashion designer's fashion sketches. Fashion illustration may be used for: a fashion design presentation, an advertisement, a marketing presentation or as a journalistic visual representation, presenting not only the illustration of the garment design but the total concept. Fashion illustration is a commercial art form in its own right, a way to express and accentuate a fashion design to present to a client.

Fashion and fabric shows/exhibitions: Globally, fashion and textile trade events are held throughout the year and tend to focus on the seasons, Spring/ Summer and Autumn/Winter. **Textile** fairs are held a year ahead of the manufactured clothes reaching the stores; this allows sufficient lead time for designers to sample the fabrics for their collections. **Fashion** trade fairs and shows have a six months lead time before the clothing hits the stores. The trade fairs and catwalk shows are a central point for exhibitors, buyers, designers and the press to come together and do business - buying and selling merchandise, or forecasting and reporting future trends.

Flats (US): Working drawings, technical drawings, diagrammatics, and specification drawings, are explicit drawings of a garment design. They are drawn to scale, showing construction lines and styling details. Many companies use working drawings as their primary visual source to communicate and liaise with buyers, clients, pattern makers and sample machinists.

Fleshing out: (Rounding out), are terms used for adding body shape to a figure drawing.

Form: A shape, visible or tangible, for example, the 'human form' is the shape of the body, the '**form of a fabric**' is the effect from light as it falls on the fabric, the way the fabric falls into folds and drapes.

Haute couture: The French word, 'couture' means sewing or needlework; Haute couture is a high quality, extremely well constructed fashion garment, with no expense spared.

Layout: The arrangement and make-up of artwork; a '**landscape layout**' is a format in which the width of the illustration or artwork is greater than the height; a '**portrait layout**' is a format in which the height of the illustration or artwork is greater than the width. Some poses call for a landscape layout, for example, it is often used for men's and children's presentations, and when there are more than two images, but there are no strict rules.

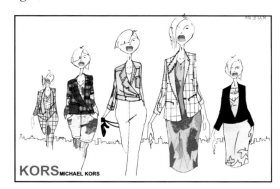

Landscape layout: Illustration Jonathan Kyle Farmer

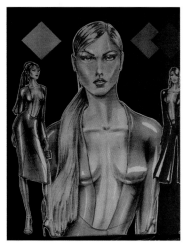

Portrait layout: Illustration Jevon Ruis

Light box: A table or portable box with a semi-transparent surface containing a powerful light underneath; used for tracing over drawings as it aides transparency.

Line: Use of line in artwork, **'boldness of line'**, a contour or outline of a design**, the 'clean lines of an illustration'.**

Mannequin: An artist's miniature wooden figure with movable joints, useful for displaying body positions, proportions and perspective. A dress form with style lines that correspond to the fit and construction lines from which clothing patterns and garments are made. A window dummy (figure) used to display clothing.

 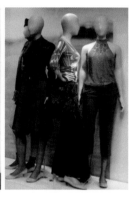

Three types of mannequins

Media: (Medium), the material or form used to make an illustration or artwork, for example, markers, pastels and wax crayons.

Mixed media: Various art materials used in conjunction with one another to form an artwork, for example, markers used with colouring pencils and gouache.

Mood: (Theme), the feeling brought about by tangible and intangible objects, images and circumstances; for example, a piece of antique cream lace, pale blue and pink colours, and soft, downy white feathers can bring about a feeling (mood) of romance.

Nine heads template: The fashion figure template is subdivided into nine head depths.

Pinking shears: Scissors that cut with a zigzag pattern to prevent the edge of fabric from fraying.

Presentation: (Boards, portfolio, fashion presentation, design presentation), the professional method used to visually display a design concept in a creative, dynamic format, enhancing individual pieces of artwork. The concept could be for a fashion range, a fashion mood or theme, fashion colours, fashion fabrics or fashion promotion. Individually, sketches can look flat and uninteresting, but if all the right ingredients are grouped together in a well planned layout, the theme will be strong and commercially successful. Designers and illustrators use many presentation techniques to enhance their artwork.

Presentation board: Ellen Brookes

Printout: Data and visuals printed out from a computer; these are useful for design presentations.

Range: (See collection).

Render: (Rendering, fabric representation, fabric illustration), illustrate fabric using line and colour to give an overall impression of fabric type, texture, print and colour; this may be in flat swatch form or on the clothed fashion figure drawing.

Resource folders: (cutting files, clipping files, swipe files, picture files and personality files) are internationally recognised names for folders collating all visual references, clipped from all sources, catalogues, booklets etc. and collated for inspiration, not copying. These visuals, used in conjunction with sketch books, are sources of inspiration for design development through to presentation.

Roughs: These are quick drawings capturing ideas and concepts in a sketch book, and usually drawn using a pencil, fine liner or marker.

Sample garment: A trial garment made from a pattern which has been interpreted from a designer's sketch.

Sketch book of rough fashion sketches and fabric swatches: Lorraine Boyle

Sketch book: (Fashion journal, fashion diary, work book and croquis sketch book), drawing pad used to sketch innovative and creative ideas, colour and fabric sensitivity. Sketch books are your visual reference data base and a valuable source of information for your design projects.

Specification sheet: (Production drawing), a working drawing or flat, drawn in a technical format (not stylised), drawn to scale, documenting measurements and details pertaining to the garment and required for production and manufacturing purposes. For example, the length from the centre back neck to the hem, item number, size and colour of buttons.

Street fashion: What the public are wearing and the way they put it together.

Style lines: The fit, shape and seam details that make up a garment.

Stylised: A drawing that is non-realistic and has a look about it that identifies it with a particular artist's way of working.

Swatch: (See fabric swatch).

Swipe files (US): (See resource folders).

Technical drawings: See specification sheet and working drawings.

Template: (Fashion template, nine heads template), a guide used in fashion drawing, which is traced over, when redrawing the fashion body.

Tone: (Value, shadows and highlights), the measure of light and dark; lightness or darkness of a colour

Torso: (Upper and lower torso), the trunk of the human body.

Vertical balance line: (V/B) an imaginary line to ensure a figure drawing is well balanced and never appears to be falling over. The V/B line drops vertically from the pit of the neck to the ground. It never bends - imagine it is like a builder's plumb line.

Working drawings: See Flats

Flats/working drawings: Beales

further reading

This selection of books and magazines will keep you informed about fashion, fabric, costume and trends. With growing public interest in fashion, most countries now have their own fashion based publications. For more information do a keyword search on the Internet and visit websites such as **Franks Bookshop,** London, **<www.rdfranks.co.uk>.**

fashion drawing and illustration

Abling, Bina, *Fashion Sketchbook*, Fairchild

Barnes, Colin, *Fashion Illustration - Techniques of Fashion Drawing*, MacDonald

Borrelli, Laird, *Fashion Illustration Now*, Thames & Hudson

Dawber, Martin, *Imagemakers*, Mitchell Beazley

Dawber, Martin, *Pixel Surgeons*, Mitchell Beazley

Drake, Nicholas, *Fashion Illustration Today*, Thames & Hudson

Ireland, Patrick John, *Encyclopaedia of Fashion Details*, Batsford

Jenkyn Jones, Sue, *Fashion Design*, Laurence King

Kumagai, Kojiro, *Fashion Illustrations 2, Expressing Textures*, Graphic Sha

Lehnert, Gertrud, *Fashion - An Illustrated Historical Overview - Crash Course Series*, Barron's

McKelvey, Kathryn, and **Munslow**, Janine, *Illustrating Fashion*, Blackwell Science

McKelvey, Kathryn, *Fashion Source Book*, Blackwell Science

Packer, William, *Fashion Drawing in Vogue*, Thames & Hudson

Ramos, Juan, *Antonio 60, 70, 80: Three Decades of Fashion Illustration*, Thames & Hudson

Stipelman, Steven, *Illustrating Fashion, Concept to Creation*, Fairchild

Sultan, Barbara, *Applied Flat Sketching for the Fashion Industry*

Tain, Linda, *Portfolio Presentation For Fashion Designers*, Fairchild

Toledo, Ruben, *The Style Dictionary*, Abbeville

drawing, media, cartoons

Buscema, John, and **Lee**, Stan, *How to Draw Comics The Marvel Way*

Edwards, Betty, *Drawing On The Right Side of the Brain*, Collins

Hamm, Jack, *Cartooning the Head and Figure*

Smith, Ray, *Artist Handbook*, Dorling Kindersley

costume, history and reference

Breward, Christopher, *The Culture of Fashion: A New History of Fashionable Dress*

Brubach, Holly, *A Dedicated Follower of Fashion*, Phaidon

Callan, Georgina O'Hara, *The Thames and Hudson Dictionary of Fashion and Fashion Designers*, Thames and Hudson

Davis, Fred, *Fashion, Culture and Identity*

Englemeier, *Fashion in Film*, Prestel

Ewing, Elizabeth, and **Mackrell**, Alice, *History of Twentieth Century Fashion*, Batsford

Howell, Georgina, *In Vogue, 75 Years of Style*, Condé Nast Book by Random Century Ltd.

Milbank, Caroline Reynolds, *Couture - The Great Fashion Designers*, Thames & Hudson

Murray, Maggie Pexton, *Changing Styles in Fashion*, Fairchild Publications, New York

O'Daniel Baker, Georgia, *A Handbook of Costume Drawing*

Ribeiro, Aileen, *The Visual History of Costume*

Steel, Valerie, *Fifty Years of Fashion*

The Fashion Book, Phaidon

fashion computing

Burke, Sandra, *Fashion Computing - Design Techniques and CAD*

Internet Sites (see *Fashion Computing* for more information): *www.elle.com, www.wgsn.com, www.style.com etc.*

entrepreneurship

Burke, Rory, *Fashion Entrepreneur*, Burke Publishing

Burke, Rory, *Entrepreneurs Toolkit*, Burke Publishing

Burke, Rory, *Small Business Entrepreneur*, Burke Publishing

Burke, Rory, *Project Management Planning and Control Techniques*, Burke Publishing

▼ fashion periodicals

Alta Moda (Italian)
Amelias
Another Magazine
Collezioni (Italian): Trends, Sport and Street, Ready to Wear, Accessori, Bambini (children), Donna, Uomo (men)
Dazed and Confused (British)
Depeche Mode (French)
Donna (Italian)
Elle (American, Australian, British, French, German, Italian, SA, Spanish publications)
Fantasy and Reality
Fashion Collections GAP (American)
Fashion Show (American)
GQ (men)
Harpers and Queen (British)
Harper's Bazaar (American, Italian)
ID
Joyce (Hong Kong)
L'Officiel da la Couture (French)
Marie Claire (American, Australian, British, French, German, Italian, SA, Spanish publications)
Mirabella (American)
NY Women (American)
Oyster
Pop (British)
Spruce (British)
Tank
Teen (American)
The Face (British)
This is a Magazine
Vogue (American, Australian, British, French, German, Italian, SA, Spanish publications): also **L'Uomo**, Bambini, Vogue Sposa Italia
Wallpaper (British)
Wonderland

▼ trade publications

Daily News Record (DNR) (Men's Fashions) (American)
Drapers - DR (British)
Fashion Dossier International (American)
Fashion Forecast International (British)
Fashion Quarterly (British)
Fashion Reporter (American)
Fashion Theory (British)
International Textiles (British)
View Trends
View on Colour
Textile View
W (American)
Woman's Wear Daily (WWD) (American)

▼ trend/fashion forecast services

Doneger Design Direction (American)
Dutch Fashion Institute
Here & There (American)
Jill Lawrence Design (JLD. INTL) (British, fashion and colour)
Lutz Keller (colour)
Milou Ket
Nelly Rodi (French, colour and global lifestyles)
Nigel French (American)
Pantone View Colour Planner
Pat Tunsky, Inc. (American)
Perclers
Promostyl USA (American)
Pro-Specs (forecast software)
Simplicite
Stylists Information Services (SIS) (American)
The Fashion Service (American)
The Wool Bureau (American)
Trend Union (American)
Trends West (American, trends and textiles)
Trendzine (on-line forecast and trends)
WGSN (Worth Global Style Network) - www.wgsn.com

index

project management series

The *Project Management Series* promotes Entrepreneurship and Project Management tools and techniques. In our competitive world the successful manager needs entrepreneurship skills to spot opportunities, and project management skills to make-it-happen.

Fundamentals of Project Management
Rory Burke
ISBN: 978-0-9582733-6-7, 384 pages

This book is a broad based introduction to the field of Project Management which explains all the special planning and control techniques needed to manage projects successfully. This book is ideal for managers entering project management and team members in the project management office (PMO).

Project Management Techniques
Rory Burke
ISBN: 978-0-9582733-4-3, 384 pages

This book presents the latest planning and control techniques, particularly those used by the project management software and the body of knowledge (APM bok and PMI's PMBOK). This book has established itself internationally as the standard text for Project Management programs.

Project Management Leadership - *Building Creative Teams*
Rory Burke and Steve Barron
ISBN: 978-0-9582733-5-0, 384 pages

This book is a comprehensive guide outlining the essential leadership skills to manage the human side of managing projects. Key topics include: leadership styles, delegation, motivation, negotiation, conflict resolution, and team building.

Entrepreneurs Toolkit
Rory Burke
ISBN:978-0-9582391-4-1, 160 pages

Entrepreneurs Toolkit is a comprehensive guide outlining the essential entrepreneur skills to spot a marketable opportunity, the essential business skills to start a new venture and the essential management skills to make-it-happen.

Small Business Entrepreneur
Rory Burke
ISBN: 978-0-9582391-6-5, 160 pages

Small Business Entrepreneur is a comprehensive guide outlining the essential management skills to run a small business on a day-to-day basis. This includes developing a business plan and sources of finance.

www.burkepublishing.com

bluewater cruising books

This *Bluewater Trilogy* includes a preparation guide, a travelogue and a checklist. Bluewater cruising has all the features of a complex project, requiring effective budgeting, procurement, scope management and time planning. Most importantly it requires effective risk management and disaster recovery for the safety of the crew and integrity of the yacht.

Managing Your Bluewater Cruise

Rory and Sandra Burke
ISBN: 978-0-473-03822-9
352 pages, 200+ photographs

This **preparation guide** discusses a range of pertinent issues from establishing budgets and buying equipment to preventative maintenance and heavy weather sailing. The text works closely with the ORC category 1 requirements and includes many comments from other cruisers who are *'out there doing it'*. This book also outlines what training courses to attend before leaving, what gear to take, provisioning strategy and, equally important, how to stow it all. So if you wish to bridge the gap between fantasy and reality then your bluewater cruise must be effectively managed.

Greenwich to the Dateline

Rory and Sandra Burke
ISBN: 978-0-620-16557-0

352 pages, 200+ photographs

This is a **travelogue** of our bluewater cruising adventure from the Greenwich Meridian to the International Dateline – sit back with a sundowner and be inspired to cruise to the Caribbean and Pacific islands. In this catalogue of rewarding experiences we describe how we converted our travelling dreams into a bluewater cruising reality.

Bluewater Checklist

Rory and Sandra Burke
ISBN: 978-0-9582391-0-3, 96 pages

Checklists provide an effective management tool to confirm everything is on board, and all tasks are completed. Why try to remember everything in your head when checklists never forget!!! This book provides a comprehensive portfolio of checklists covering every aspect of bluewater cruising. To ensure your bluewater cruise will be successful, it must be effectively managed. Checklists provide an excellent tool for this purpose - even NASA uses them!!!

 www.burkepublishing.com

fashion design series

This *Fashion Design Series* promotes fashion design skills and techniques which can be effectively applied in the world of fashion. In a competitive market it is important to produce designs that are not only pleasing to the eye, but also commercially viable.

Fashion Artist - *Drawing Techniques to Portfolio Presentation, 2ed*

Sandra Burke, ISBN 978-0-9582391-7-2, 176 pages

Fashion drawing is an essential part of the fashion designer's portfolio of skills, enabling the designer to develop creative ideas and visually communicate design concepts on paper. This book is set out as a self-learning programme on how to draw fashion figures and clothing/flats, render fabrics, create fashion illustrations and mood/story boards, and present them in a portfolio. The text is fully supported with self-explanatory drawings and artwork from international fashion illustrators and fashion designers.

Fashion Designer – *Concept to Collection*

Sandra Burke, ISBN 978-0-9582391-2-7, 176 pages

This book will help you develop your portfolio of fashion design skills while guiding you through the fashion design process in today's fashion industry. It explains how to analyse and forecast fashion trends, interpret a design brief, choose fabrics and colour ways, develop designs, create design presentations and develop collections for specific target markets.

Fashion Computing – *Design Techniques and CAD*

Sandra Burke, ISBN 978-0-9582391-3-4, 176 Pages

This book introduces you to the computer drawing and design skills used in the fashion industry. Through visuals and easy steps, you learn creative fashion computing design techniques. It includes, flats/working drawings, illustrations, fabrics, presentations and the digital fashion portfolio. Specific software includes: Photoshop, Illustrator, CorelDRAW, Freehand, PowerPoint, Gerber and Lectra Systems.

Fashion Entrepreneur - *Starting Your Own Fashion Business*

Sandra Burke, ISBN 978-0-9582733-0-5, 176 pages

This book outlines the entrepreneurial traits, creative and innovative techniques, and small business management skills you need to start, develop and operate a successful fashion business. The theory is presented in easy steps, enhanced with inspirational fashion illustrations, visuals, interviews and case studies from established fashion entrepreneurs in the fashion and creative industries.

Sandra Burke, M.Des RCA (Master of Design, Royal College of Art), has worked in the fashion industry in Britain, South Africa and New Zealand and is currently a visiting lecturer to universities in America, Britain, Australia, New Zealand, South Africa and Hong Kong.

"In writing these books I have combined my career in fashion, education and publishing to produce a fashion design series. The result is a combination of the educational requirements of fashion programmes with the practical application of fashion design techniques used in the fashion industry."

www.burkepublishing.com